EGYPT

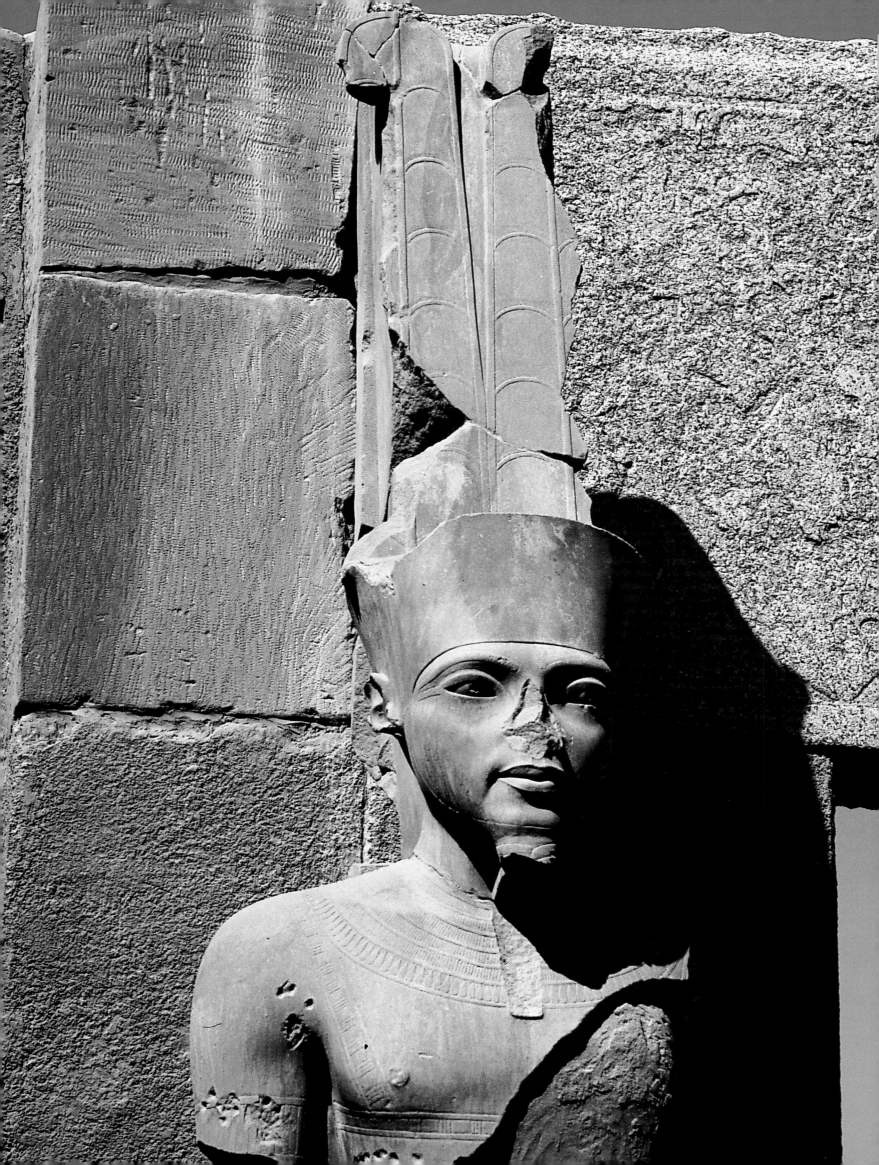

WOLFGANG AND ROSEL JAHN

EGYPT

Nile, Desert, and People

Translated by
Manuela Kunkel and Ian Portman

THE AMERICAN UNIVERSITY IN CAIRO PRESS

DEDICATION AND ACKNOWLEDGMENTS:

We acknowledge the generous help towards our study trips which we received from Egypt Air in Frankfurt and Oft Reisen in Stuttgart.

Dr. Ahmed R. Sheta, press attaché of the Egyptian embassy in Bonn was also supportive.

An unforgettable trip on Lake Nasser we owe to Mr. Mostafa al-Gendy.

On the excavation site at Abu Mina we enjoyed the professional guidance and hospitality of Dr. Peter Grossmann, head of the German Archeological Institute in Cairo, who provided us with important leads.

With his scientific advice in the field of Egyptology and a critical examination of the manuscript, Prof. Dr. 'Ali Radwan helped us enormously.

To all these we owe our thanks.

Roswitha and Dr. Edouard Lambelet, Mahmoud 'Abd al-Aziz and Mostafa 'Abd al-Aziz offered us invaluable help on all the fourteen journeys to Egypt which we made following our six-year stay in Cairo. In particular, we must single out the advice we received over many years from Dr. Edouard Lambelet.

In gratitude, we dedicate this book to these, our friends.

English translation copyright © 1998 by
The American University in Cairo Press
113 Sharia Kasr el Aini
Cairo, Egypt

First published in Germany as *Ägypten: Die Kulturen der Pharaonen, Christen und Muslime im Wüstenland am Nil.*
Copyright © 1997 by Chr. Belser AG für Verlagsgeschäfte & Co. KG, Stuttgart and Zurich

Dar el Kutub No. 11370/97
ISBN 977 424 466 4

Printed in Germany

Illustration on page 1:
The minaret of Azbak al-Yusufi (fourteenth century).

Illustration on page 2:
Amun, King of the Gods, with the features of a pharaoh.
This splendid statue of the god Amun was erected by none other than the famous pharaoh Tutankhamun, who also lent it his features. It was a conciliatory offering to Amun and his priesthood, who had been removed from power by Tutankhamun's predecessor Akhenaten during his short-lived religious revolution, when he had declared the sun-god Aten the sole deity. At Akhenaten's death the experiment came to an end, and Amun regained his position as king of the gods.

Contents

Introduction

Egypt:
Created by the Nile
Determined by the desert
Shaped by its people

To think of Egypt is to summon up images of pyramids, temples, and tombs. Echoes of ancient names–Khufu, Ramses, and Nefertiti–ring in the mind's ear. The inner eye feasts on images of unparalleled artistry: the timeless diorite statue of Khafre, elegant wall paintings in the tomb of Nefertari, the funerary mask of Tutankhamun. Perhaps the palm-fringed Nile springs to mind, or the exquisite Islamic monuments of medieval Cairo, or even the overgrown mega-city of today's Cairo.

Yet Egypt is, before all things, desert. Were it not for the Nile, this immense territory in the east of the Sahara would be perhaps the hottest, driest wasteland in the world.

For thousands of years, the Nile, the longest river in Africa, has flowed northwards from the great lakes at the heart of the continent, swollen each summer by the waters of the Blue Nile, and bringing with it fertile, black silt from the mountains of Ethiopia. This immense flood has brought life to the hostile desert and made Egypt possible.

Nile water and the dark, musky river mud–these were the two essential elements which, in prehistoric times, allowed agriculture and hence civilization to develop here.

What is not immediately apparent to the visitor to Cairo is the extent to which Egypt depends on this agriculture which the river makes possible.

Only in recent decades has manufacturing industry begun to play a serious role in the national economy, which is still largely based on tilling the soil. Even now, in many parts of Egypt, farming methods have changed little since the times of the pharaohs.

When we gaze at the mighty monuments of these ancient kings, we would do well to remember the sources of all their power and wealth: the often despised but hard-working peasant farmer–the fellah–and the bureaucracy which organized an ingenious and effective irrigation system and regulated it under a system of law.

God-kings, government, peasant-farmers: all this was brought into being in a scorching desert by the only river in Africa to flow north to the Mediterranean sea.

Deserts cover most of the land mass of Egypt. They are vast and often shaped dramatically by heat and cold, wind and water. Even today, most of Egypt is relatively inaccessible.

East of the Nile rises the mountainous and geologically complex Arabian desert; to the west, gravel plains give way to immense, rocky steppes, sudden escarpments, deep depressions, and huge seas of sand which form the Libyan desert.

In this solitude, vegetation is scarce and animal life scarcer. The sparse human population comprises mostly Bedouin who live a frugal existence with their herds of goats and camels.

But the seemingly empty desert provides at the same time a fascinating record of the development of the planet and of human society. Fossils of marine and land plants and creatures abound, along with the stone tools of early humans.

A glance at a map makes clear what the desert means to Egypt. Scarcely four percent of the land is arable, and two-thirds of this are accounted for by the Nile delta. The Nile valley–the longest river-oasis in the world–and its offshoot, the Fayyum, comprise virtually all the rest. The few conventional oases in the desert are so tiny that, often, they are not marked green on maps. Yet these oases represent fascinating landmarks in the economic and cultural history of Egypt.

Those traveling on a Nile cruise see clearly how the desert presses in on inhabited Egypt. It broods threateningly behind the fields and the palm trees, pressing in on the green strip of life. The desert is occasionally distant, sometimes so close that dunes spill down into the water. The life of the people of Egypt has always taken place against the backdrop of this contrast between fertile land and the desert. Living quarters were almost always made from sun-baked mud bricks. Even the pharaohs' palaces were built this way. Eventually, these bricks would be recycled, added as fertilizer to the fields. The monumental stone buildings which the ancient Egyptians erected for eternity were sited in the desert; today new cities are being constructed away from the Nile valley to conserve valuable farmland.

The desert had an enormous influence on the development of the ancient Egyptians' death cult. Funerary temples, tombs, and pyramids were built in the western desert, the land of the setting sun and gateway to the realm of the dead.

In early times, Egyptians would have noticed that bodies left in the desert remained remarkably preserved in the hot, dry climate. Perhaps this inspired them to conceive the notion of an afterlife. Later, priests developed elaborate rituals and techniques of mummification to keep bodily remains intact.

This same theme returns in Christian and Islamic times. Despite a theoretical prohibition by some schools of Islamic thought on funerary monuments, the City of the Dead outside Cairo bears witness to the importance Egyptians attach to a 'proper' burial.

In ancient times, Egypt was isolated from its neighbors by seas and by vast tracts of wasteland. This contributed to the development of one of the oldest high cultures in the world, since the civilization which grew up along the Nile remained for a long time undisturbed by outsiders. The fertile, readily-irrigated soil ensured a regular supply of food. So conditions were in some respects ideal for the growth of a major culture. Yet it is still remarkable that the whole of Egypt united at such an early date–c.3000 bce. The pharaohs held together a state which stretched over a thousand kilometers from north to south.

The desert also had a profound influence on the growth of early Christianity, and led to developments which, in turn, shaped Western Christian belief and practice. The first anchorites lived in the Egyptian deserts, and the first monasteries were founded here, where monks might find space and peace to meditate and where they felt more secure in times of persecution.

Just as nature determined the conditions for civilization, so has that civilization transformed the land of the Nile. Especially in modern times, a revolutionary transformation has taken place. The push into the desert has begun in earnest. Prospectors invade remote corners of the desert, seeking gold, minerals and, above all, oil and gas.

Projects aimed at greening the desert have brought about a great transformation. In 1964, when President Nasser laid the foundation stone of the Aswan High Dam, he inaugurated a drive towards more controlled water usage which has enabled two or even three crops a year to be grown in some areas.

President Sadat began building cities in the desert, which are attracting increasing numbers away from the overcrowded valley and delta. More recently, in 1996, President Mubarak opened the Toshka canal from Lake Nasser to the oases of the Western Desert. This is the first step in a gigantic project aimed at increasing the area of Egypt under cultivation from four to thirty percent.

Let us return to the beginnings of the Nile valley. From impenetrable swamps, teeming with birds, crocodiles and hippopotamuses, the ancient Egyptians reclaimed agricultural land, which is farmed to the last corner. Ever more sophisticated irrigation techniques widened the bed of the river and reduced its flow, while slowly the delta grew further into the Mediterranean sea. Thus, the ground was prepared for cultures and empires, which flowered and disappeared.

The cultural history of Egypt began long before the pharaohs, and reaches back well into the Stone Age. As archeologists increasingly examine the soil of Egypt, using more scientifically sophisticated techniques, they are uncovering ever earlier remains of pre-dynastic societies and adding these to the already rich treasure trove of remains from the Islamic, Christian, Roman, Ptolemaic, and pharaonic periods. One beneath the other, layer upon layer of remains from early civilizations record history and prehistory back five thousand years and beyond.

As Egyptian cultures grew and prospered, they brought into being essential elements of civilization which we take for granted today. From Egypt come the first calendar, the earliest script, the oldest known lovesong, the first decorated stone monumental building, the tallest tomb. Egypt was also the first nation to be completely Christianized, and it has the oldest Islamic University. Five places from various periods have been declared World Heritage sites: Memphis, capital of the Old Kingdom, together with its associated necropolis, the modern city of Luxor with its temples and tombs, all of the Nubian temples from Abu Simbel to Philae, the early Christian pilgrimage center of Abu Mina, and the ancient Islamic quarter of Cairo.

Even so, to see Egypt as a museum is to miss the point. Egypt is an ancient but at the same time a very young country, overflowing with life. The past lives on in the present; the monuments of old are part of daily life today. All is interconnected–the present explains the past and vice-versa. Like the Nile, Egypt is an endless and contrasting stream of life.

And Cairo, that megalopolis at the junction between Upper and Lower Egypt, has become at once the focus, mirror, and kaleidoscope of Egyptian life, incomparable in its diversity.

We will have succeeded in our aim if, in the pages which follow, we have been able to capture and reflect some of that extraordinarily vibrant spirit.

City of Cities

Medinat al-Mudun, the city of cities. This was how Cairo appeared to the fourteenth-century Arab historian, Ibn Khaldun. He also termed the city "capital of the world" and "crown of the world." A fairy tale from the *Thousand and One Nights* enthuses: "Who has not seen the city of Cairo has not seen the world." Especially in its early days under the Fatimids, Cairo could dazzle the beholder. At the caliph's court there was a peacock to be admired "whose eyes were made of rubies and whose feathers were from gilded enamel which shone in all the colors of a living bird; a palm tree of gold decorated with jewels and magnificent pearls lying in a golden container; the dates were gem stones which depicted the fruit in its various stages of growth …" And of the courtiers in procession: "The rich garments rivaled the splendid bridle: On the silver- and gold-lined saddles sparkled gem stones while chains of gold and ambergris lay around the horses' necks …" (O.V. Volkoff, *Cairo, 1000 Years*).

Just as successive dynasties have determined the look of the city for over 1000 years, so traditional domestic attitudes remain deeply embedded in the psyche of today's Egyptians. Neither modernization nor population explosion has made serious inroads into this. And in some old alleys we feel like J.J. Ampère, a visitor in the year 1884: "At every step … one meets an old acquaintance, thanks to the wonderful story of Shehrazade … Out of any one of these latticed windows a perfumed cloth might still fall at 'Aziz' feet, at the same time a pretty hand and the eyes of a gazelle might appear behind the balcony screen …"

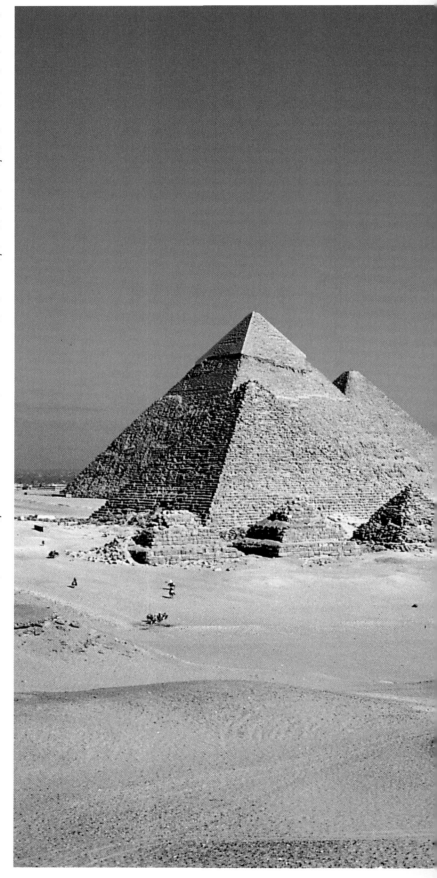

The City

To the west of Cairo, from a sea of sand kept in motion by the desert wind, rise the Pyramids of Giza. For nearly five thousand years, they have looked down onto the Nile valley. On clear days, beyond the sprawling, smoky city, one can see all the way to the Muqattam Hills, whence the innumerable stone blocks for their construction were brought. The pyramids looked out on the first large settlements to the north of today's city, where the delta begins. They witnessed the constant recycling of building materials as new cities preyed on the old, using them as quarries. In this process, the pyramids themselves were not spared. The city just kept on spreading.

In the middle of the last century, a building boom started with the erection of a European-style city. Satellite towns developed and grew together. The population expanded ever faster and the conurbation grew denser, taller, and broader. Today, the city has reached the base of the Pyramids plateau: 4,500 years of history clash ineluctably.

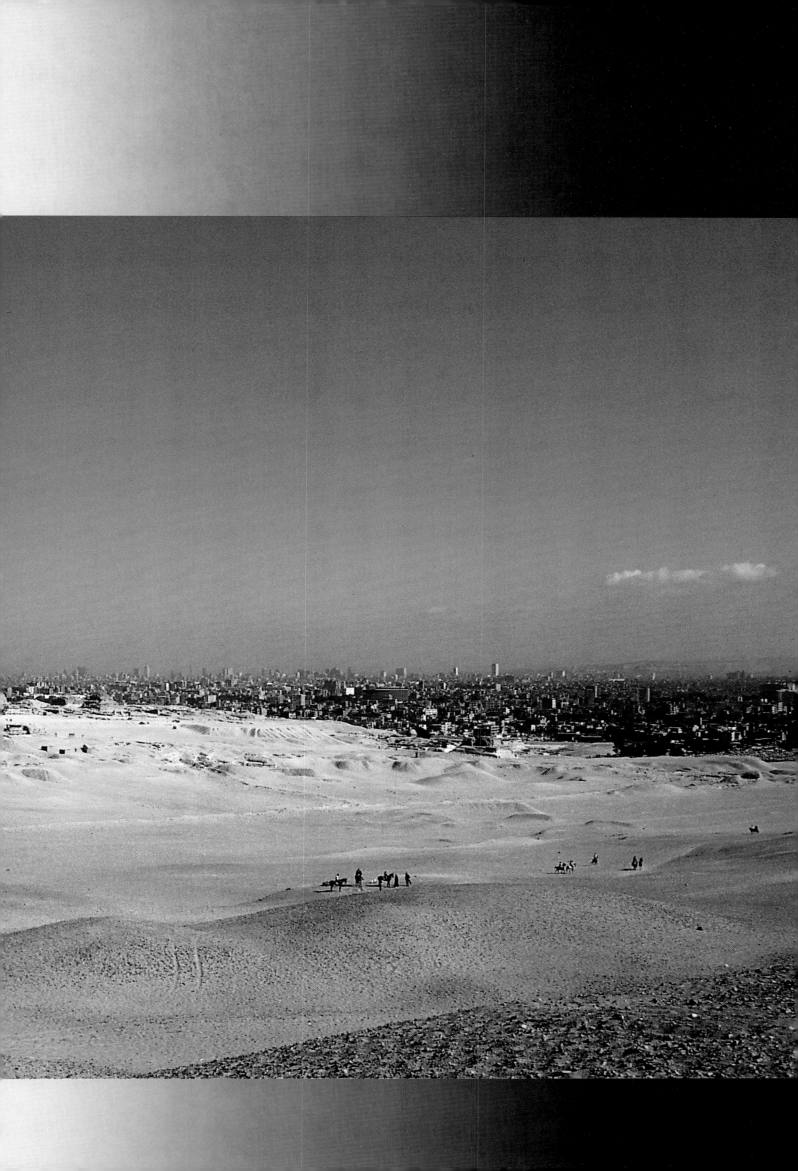

Left: The Mahmal—a pyramid-shaped top protects the kiswa, the covering for the Kaaba, on the leading camel of the former pilgrimage caravan to Mecca.

Below: Religious dance of a dervish. Today, these traditional, mystical dances are being revived. They are performed regularly in the refurbished tomb of al-Ghuri in the old city.

Opposite page: Mamluk mausoleum domes (from left to right): Tashtimur (from 1334), al-Sultaniya (about 1350). Barquq (1411), Qaytbay (1474).

Misr – Cairo is Egypt

When you ask Egyptians traveling to the capital where they are going they will answer: "Masr." (Or "Misr," if they are speaking classical Arabic). In Arabic, Misr means Egypt, but also Cairo. For most Cairenes, however, it means more: not only the city and Egypt, but simply their world. Despite all their criticism of their country, few would contemplate living anywhere else.

Misr was once an insignificant and widely scattered settlement at the beginning of the Nile delta, about halfway between the pharaonic cities of Memphis in

the south and On (Old Heliopolis) in the north. This area in which the narrow Nile delta forks off into a fertile alluvial land has been settled for at least 6,500 years. Here, where Upper and Lower Egypt meet, the unification of the two kingdoms of the south and the north was achieved. From this grew the cultural empire of the pharaohs.

The course of the Nile has always determined the foundation of settlements in this area. When ancient Heliopolis was built, it fronted a broad branch of the Nile, and at Memphis, the river flowed round several small islands. The Nile could change its course within a few decades. When the Romans built their fortress at Babylon, south of what is now Cairo, the Nile still lapped against the outer walls, and the strategic island

of Roda enabled a crossing to the west bank of the Nile. The river's bed moved more and more to the west, leaving new fertile land. East of the Nile, new cities were founded: al-Fustat (640), al-Askar (750), al-Qata'i (879). They were all built on the banks of this important waterway except for al-Qahira (969), which lay astride the Khalig al-Misri, a canal which forked from the river just south of Old Cairo. The Khalig was dug in pharaonic times, and formerly ran all the way to the Red Sea.

The foundation of al-Qahira marked the origin of modern Cairo. More and more people crammed into this new metropolis, which soon swallowed up earlier settlements. The river silt created more new land, forming new islands such as Gezira, on which the suburb of Zamalek was later built. The landscape constantly changed its aspect.

From the Middle Ages until the nineteenth century, an inland port occupied the area of modern Bulaq. Here, the Nile has shifted about one thousand meters to the west. The built-up area stretched northward, enclosing the river from both sides. In 1800, Cairo counted 200,000 inhabitants. One hundred and twenty years later, this number had more than quadrupled; ten years after that, there were more than a million people, and in 1980 there were nearly nine million. Today, with perhaps sixteen million inhabitants, Cairo is the greatest metropolis in Africa.

Far too late, long after the black soil had been sealed irretrievably by countless concrete buildings, came a government decree prohibiting building on fertile land. Only a few fields, which seem curiously strange in the middle of the city, have managed to survive. But ever more gardens fall victim to property speculators, while magnificent villas are demolished to make way for skyscrapers. Despite the new settlements which surround Cairo in the

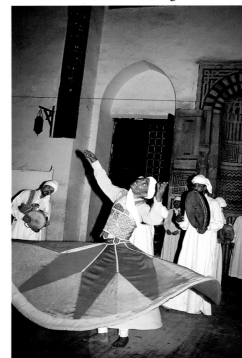

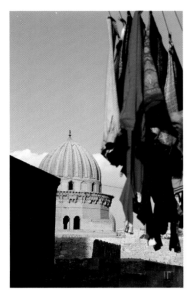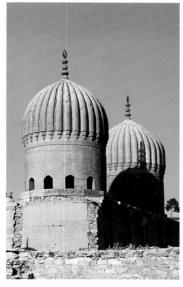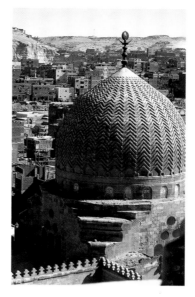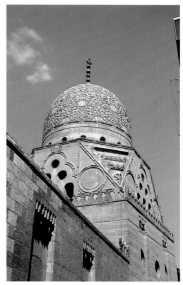

desert, the hunger for land within the city remains unassuaged.

Yet the Nile always flows: an indispensable lung for the life of the monstrous city. And from this stream of water millions of people are nourished. In the modern era, since water seems to flow endlessly out of faucets, it has been used wastefully. With the raising of the Aswan High Dam, the Nile in Cairo has finally been brought under control and the river no longer overflows its banks. In any case, there are no longer any fields here that rely upon on its flood.

So it is all the more surprising when, through the constant honking of car horns, you hear the shuffling of water buffalo hooves. Stoically, the gamusa plow their way through the hectic traffic, on their way to graze or wallow in a canal on the outskirts of the city. A peasant follows on a donkey, his legs rhythmically moving up and down, while the staccato of the donkey's feet can be heard drumming the asphalt. Even today, peasant women in black accompany their goat herds in some parts of the capital. The animals methodically eat grass and the plants on the grass verges but don't turn their noses up at trash or even plastic. In the evening, the animals return, disappearing between the multi-story buildings of modern Cairo. Their route leads to a small urban settlement with all the accouterments of a country hamlet: simple shops, various workshops and, of course, besides goats and donkeys, chicken and sheep, kept in inner courtyards and on rooftops.

Hidden behind the modern twelve- to fourteen-story blocks, several of these old villages still thrive. A few decades ago they were in the midst of fields which were swallowed up by the expanding city. The high-rise ring closes ever tighter around these villages. Meanwhile, new 'villages' spring up, even in the modern quarters, as the rural population moving to Cairo reproduce some semblance of their village life on the flat roofs of apartment blocks. There, pigeon houses are built, small animals and poultry are reared and a clay oven is set up to bake traditional round bread.

Misr—once, some 1,350 years ago, a small village near al-Fustat—has bequeathed its name to a world metropolis and indeed to the whole land of Egypt. Nowadays, in place of Misr al-Fustat, the district of Old Cairo, Misr al-Qadima, sprawls.

Egypt's world is mirrored in the different faces of its capital. Rural life exists within the modern city. Here, too, the green Nile valley meets the desert. Among the city crowds we find immigrants from all over the country. Established quarters, such as the traditional Islamic city (where we find the Khan al-Khalili bazaar), maintain their identity within the European-style metropolis. Many parts of the city with differently-developed social structures coexist, indeed thrive through their interdependence.

The history of the modern metropolis is, at the same time, the history of Egypt. Merely a glance at Cairo's diversity and variety makes it clear why Cairo means Egypt to an Egyptian.

In the light of this diversity, the thought occurs: what does Cairo mean to the world? The Egyptian Museum presents, through its innumerable pieces, the antique culture of the entire country. Besides its wealth of pharaonic treasures, the city also offers the most significant collections of Islamic and Coptic art. And the old Islamic city and the necropolis of Memphis have been declared world cultural heritage sites, while even in antiquity the Pyramids of Giza were considered one of the seven wonders of the world.

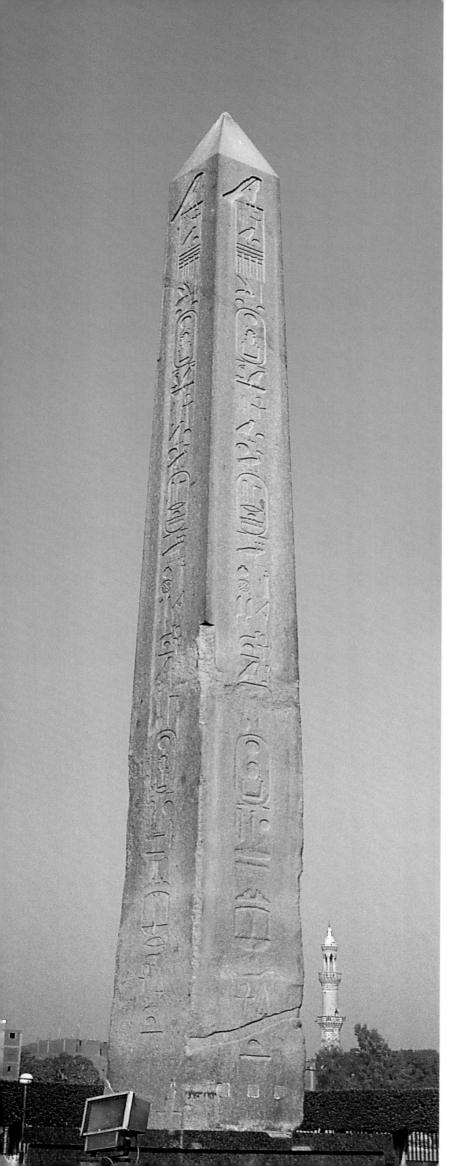

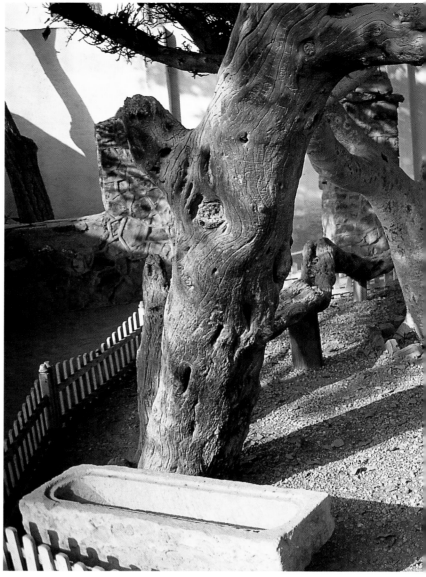

From Pharaonic Sun-sanctuary to a Miraculous Vision of the Virgin

Situated at the tip of the Nile delta, at the junction of Upper and Lower Egypt, the area now occupied by greater Cairo has always been a strategic point. People have lived in this area for at least 6,500 years. During the twenty-ninth century bce. the sun city of On grew up in what is nowadays the quarter of al-Matariya. On survived until Ptolemaic times, when it was named Heliopolis by the Greeks. A lonely relic of ancient Heliopolis is the 20-meter obelisk of Senusert I (1971–1926 bce), whose gilded pyramidion once shone in the sun (left). Here the Egyptians worshipped at the sun-sanctuary of the creator-god Atum-Re, a granite pillar which would have been touched by the rays of the rising sun.

It was the priests of On who first codified the state religion of ancient Egypt. On became the center of theology, astronomy, architecture, and medicine. One of its high priests was Imhotep, architectural genius and builder of the first pyramid.

According to the Bible, Joseph's father-in-law Potiphera was a priest in On, and Moses is supposed to have stayed with the scholars of the city. During Roman times, the Holy Family passed through the by-then deserted Heliopolis. According to legend, they rested under Mary's Tree (above) in Matariya. Legend tells how Jesus watered cuttings of balsam with holy water which then grew into a tree. This tree is in fact a partially-dead sycamore planted, in all probability, in the seventeenth century ce. The ancient Egyptians supposedly worshipped a holy sycamore on this spot, beneath which the goddess Isis was supposed to have suckled her son, Horus.

In spring 1968, people reported the appearance of the Virgin Mary above the dome of St. Mary's Church in Zaytoun (above right), which has since

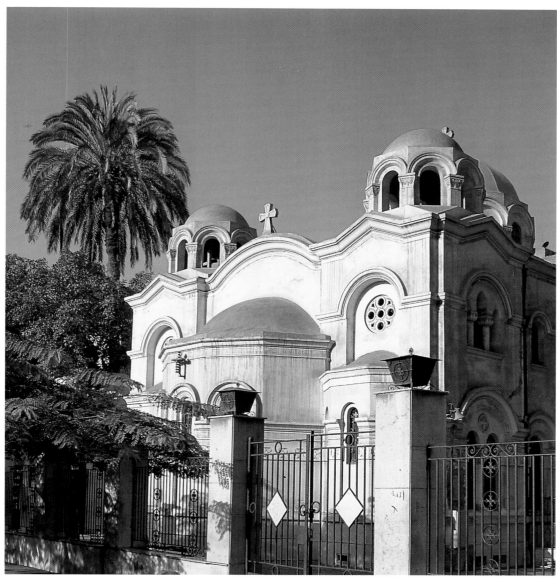

then become a place of pilgrimage.

In the monastery of St. George, we find pictures of the saint in his role as dragon-slayer. According to tradition, George, a cavalryman, was beheaded under the orders of the emperor Diocletian in Alexandria in 303 ce, for resisting the emperor's persecution of Christians.

To honor this legendary martyr, every August the Copts celebrate his moulid in Mit Damsis in the delta. This symbolic depiction of his struggle against evil recalls a struggle between good and evil in pharaonic mythology. Old Cairo now covers Kheri-aha, the battle-ground of the divine brothers, Horus and Seth, who were bitter enemies. In the complex and shifting Egyptian cosmology, the many manifestations of Seth usually represented evil. The relief at the temple of Edfu (far right) depicts one of the numerous legends in which Horus defeats Seth—here represented by a hippopotamus.

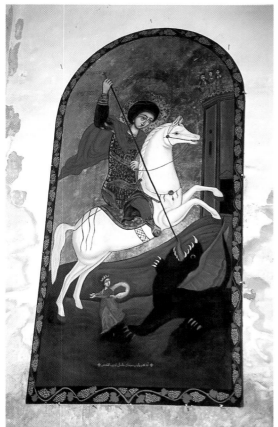

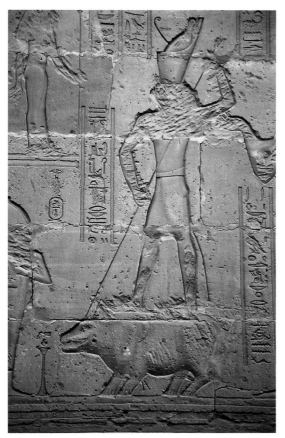

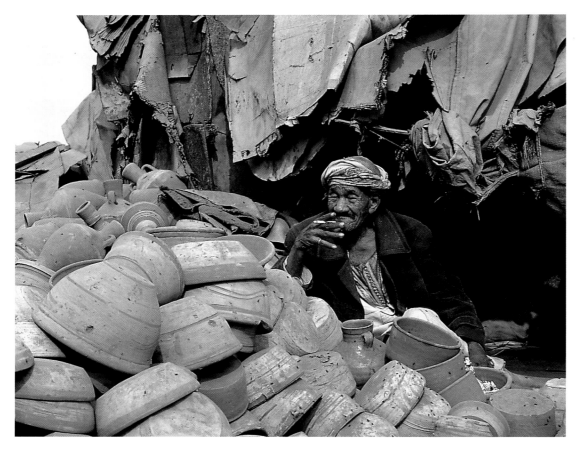

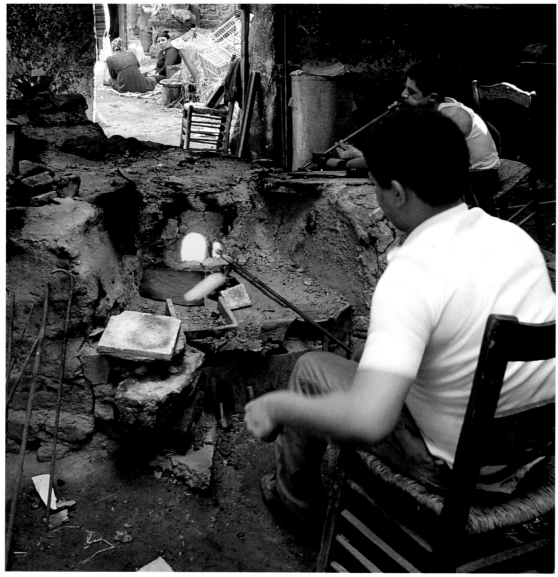
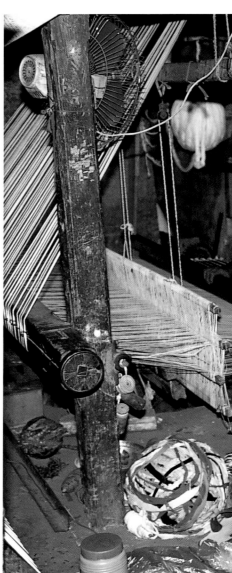

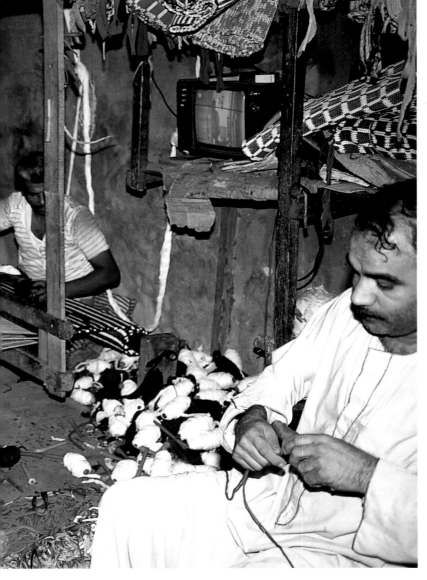

Al-Fustat — Vanished Metropolis of Crafts and Trade

The area once occupied by Fustat is nowadays a wasteland of rubble to the north east of Old Cairo, dotted here and there with potters' kilns (*above left*). Nothing now remains of the splendor of the first Islamic capital of Egypt.

Alexandria was the capital of Egypt when, in 639 CE, the Arabs under 'Amr Ibn al-'As left Medina to conquer Egypt, the richest province of the Byzantine empire. At the apex of the delta, next to a native settlement, the Romans had build a fort. By the seventh century it was a Byzantine fortress called Babylon. The army of 'Amr Ibn al-'As attacked and, after months of siege, overran it.

The Arab military camp north of Babylon grew quickly. The name Fustat derives from the Arabic word for entrenched camp. It its center, 'Amr erected the first mosque on Egyptian soil. Today, his mosque bears little resemblance to the one that he built, although a few elements remain. Al-Fustat became the provincial capital of the Ummayad caliphs of Damascus. For more than five hundred years, it was considered one of the wealthiest cities in the Islamic world. Fustat was mostly famous for its high quality glass, pottery, fabrics, copper, and gold.

Only potters and their wares (*above center*) are still found in modern Fustat, but in other parts of Cairo traditional crafts are practiced. Beside the mosque of Qaytbay for example, one can watch the glass blowers forming hot, liquid recycled glass (*bottom left*), and elsewhere see a hand loom in action (*bottom right*). The tapestries from the Wissa Wassef school are also woven using traditional techniques (*above right*).

15

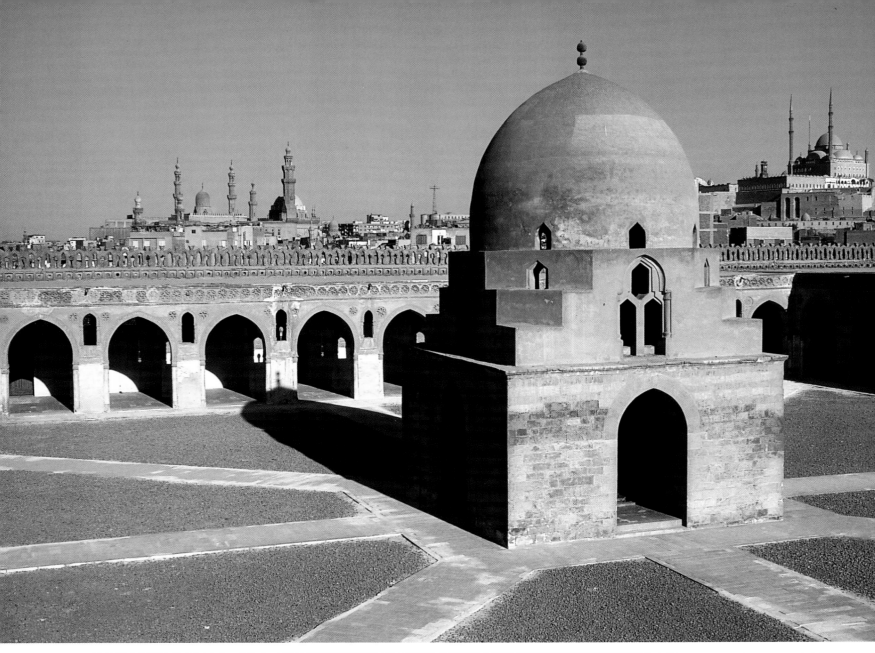

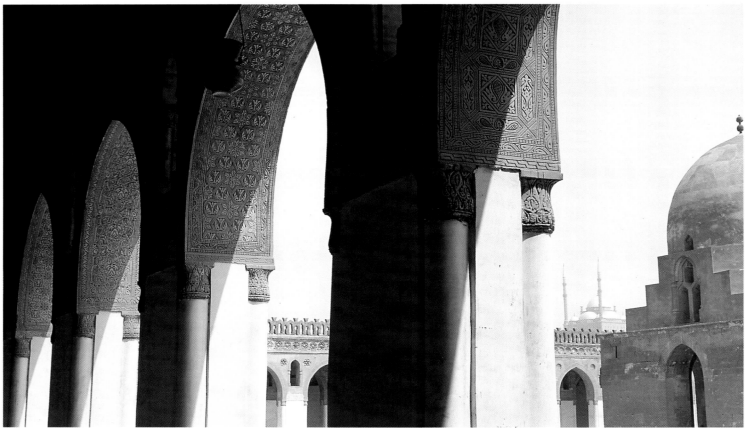

The Mosque of Ibn Tulun

Ahmed Ibn Tulun is said to have been an incorruptible man of honor, well educated, generous, pious, and just. He was born in 835, the son of a former Turkish slave, and was appointed governor of Egypt by the 'Abbassid caliph of Baghdad. He managed to make himself the sole ruling emir and founded a short-lived Egyptian dynasty. To the northeast of the previous cities al-Fustat and al-'Askar, he built his new capital al-Qata'i. The only building which survived of this magnificent city is the mosque which Ibn Tulun erected in its center. The architecture of this splendid court mosque with its square layout (*above left*) was new in Egypt. Here, for the first time in Egypt, an arcade was built using brick columns—two hundred years before this became an element of gothic style in Europe. The arcade is covered with geometric intertwined floral stucco decoration. This ornamentation was called Arabesque by the Europeans (*bottom left*; in the background notice the Muhammad 'Ali mosque).

Unique in Cairo is the spiral minaret with exterior steps (*right*). It was a copy of the minarets in Samara, Ibn Tulun's home city, which were themselves supposedly modeled on the ancient Babylonian *ziggurats*. Only the top part of the minaret, the fountain and the wooden pulpit were added later; almost everything else has been preserved. During Tulunid times, however, the mosques would have been decorated lavishly with gold, marble, and rare woods.

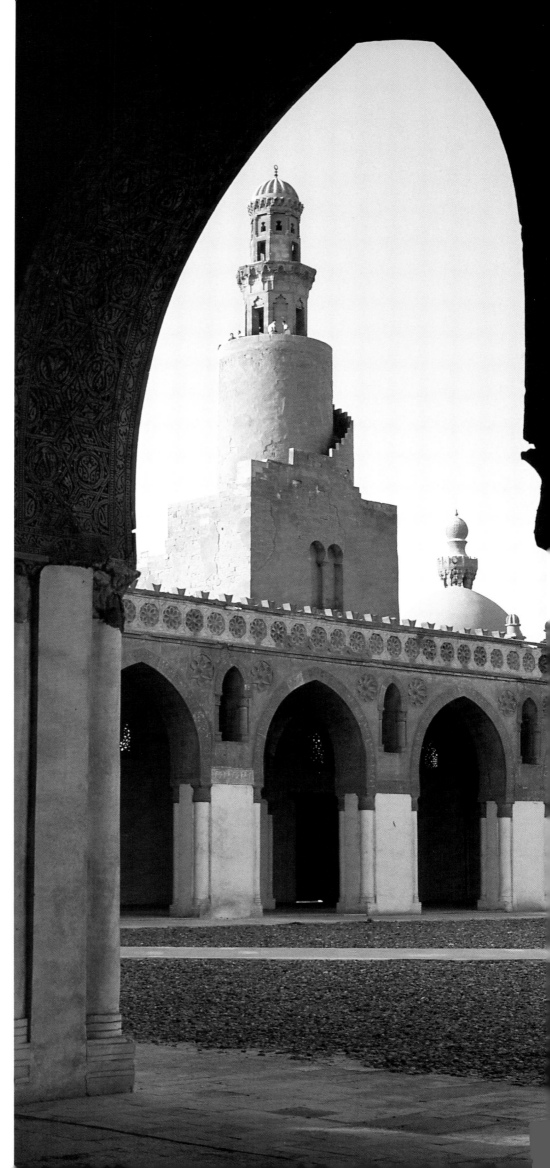

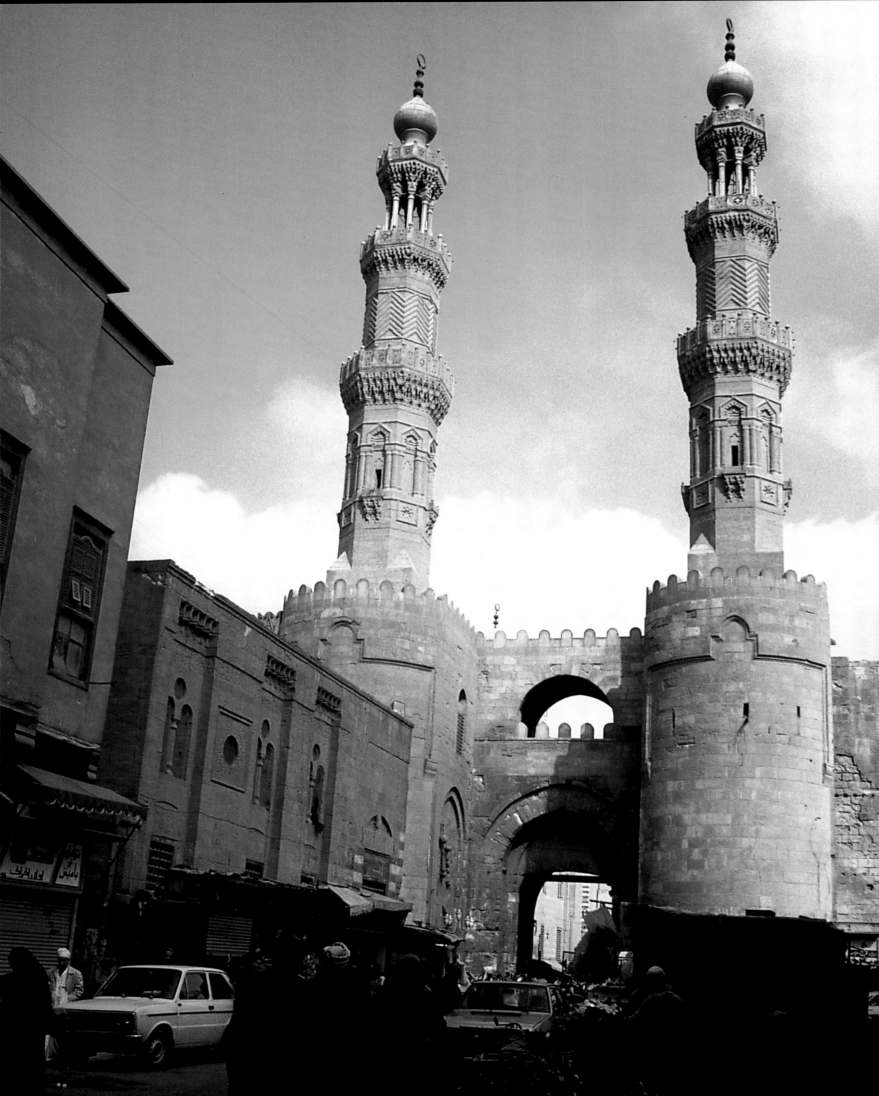

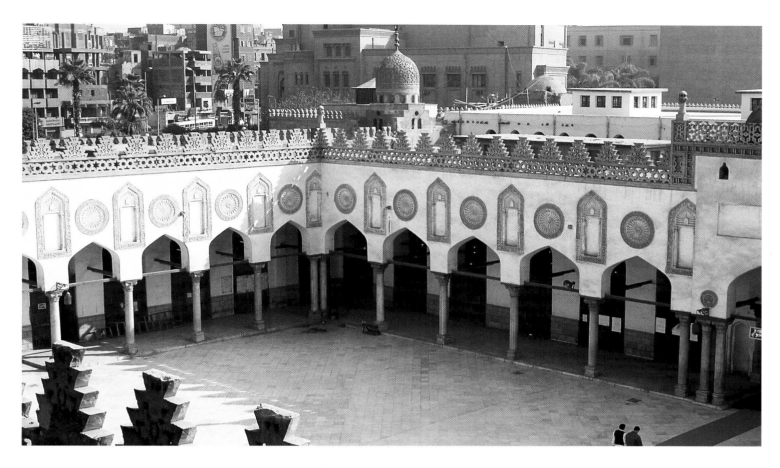

Al-Qahira – a Fatimid City Foundation

Each year, for the celebration of the Prophet Muhammad's birthday, Cairo is decorated with chains of lights, and huge, brightly-colored cardboard dolls are set up (*right*) under which various sticky sweets and pastries are displayed. Traditional sugar dolls are given to girls and sugar horses to boys.

The Fatimids, who came from the area now occupied by Tunisia, considered themselves the direct descendants of Muhammad's favorite daughter Fatima and were Shiites, in contrast to the orthodox Sunni Egyptians.

Their gifted leader, Gawhar al-Siqilli, conquered Egypt in 969 CE and immediately set about building an extensive palace for the caliph and his family, who shortly took up residence. The new royal capital was named al-Qahira, 'the victorious,' the Arabic name which the city still bears. At the end of the eleventh century, the old wall made of mud bricks was extended by a monumental stone construction designed by Armenian architects. Two gates, Bab al-Futuh—the gate of the conquest (1087), and Bab Zuwayla (1092) (*left*), named after a Berber tribe, formed part of these ingenious and powerful defense works.

Bab Zuwayla was the city's southern gate. It opened on to

the then flourishing neighboring city of al-Fustat. The two minarets were added much later in 1420 when the al-Mu'ayyad mosque was built. The twenty-nine hectares once occupied by the Fatimid palace are today occupied in part by the Khan al-Khalili bazaar. Between 970 and 972, Gawhar built the mosque of al-Azhar, which means 'the most flowering' (*above*). During the two hundred years of Fatimid rule, it served as an institute for education in the Shiite faith and as a center of evangelism to Sunni Muslims and the Coptic population. The first lecture was given in 983, which makes al-Azhar the oldest Islamic University. Today, students come to study philosophy, religion, mathematics, and other subjects from all over the Islamic world. Although the mosque complex has undergone numerous extensions and restorations over the last millennium, the court with its pointed arcade is still largely original (*above*).

19

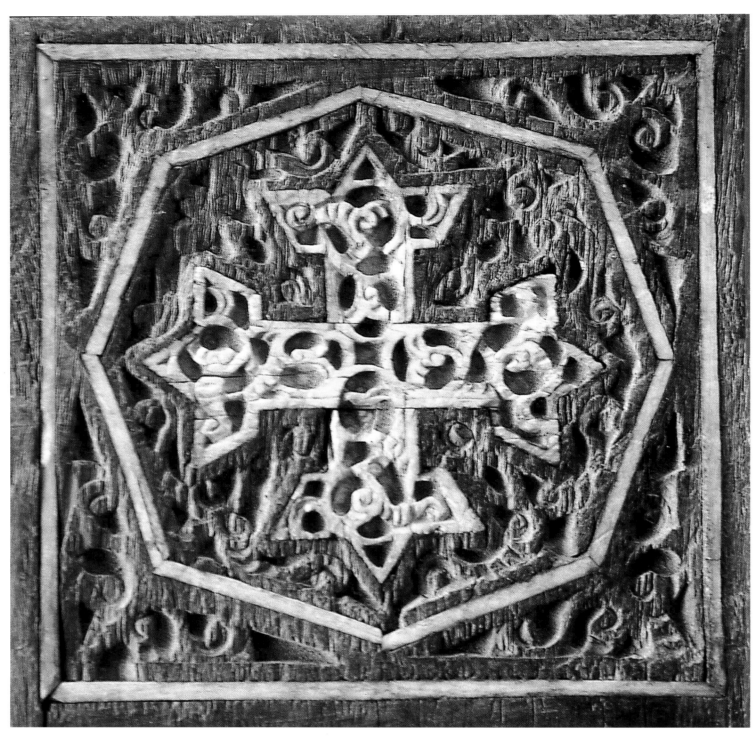

Al Mu'allaqa — the Hanging Church of the Copts

The Coptic Church of the Holy Virgin is one of the oldest churches in Cairo, dating from the seventh century. It is also called *al-Mu'allaqa,* 'the suspended,' because it is built above the narrow, inner courtyard of the southwest gate of the Roman fortress of Babylon.

The quarter of Misr al-Qadima (Old Cairo) has always had a large Christian community, and a Jewish settlement is said to have been established before the Christian era. Nowadays, Coptic and Greek churches as well as the synagogue still stand side by side. Egyptian Christianity has its roots in Alexandria, where the evangelist Mark is said to have spread the gospel to Jewish and Greek inhabitants, thus making Egypt the first Christianized country in the world. In 451, at the Council of Chalcedon, the Monophysites of Egypt separated from the patriarchate of Constantinople to become an independent church. In this, one of the many disputes which split the early Christian world, the Egyptian church insisted on the absolute oneness of Christ with God.

The word Copt comes from the Arabic *qibti,* from the Greek *Aigyptos,* thought in turn to derive from the ancient Egyptian term for Memphis.

The square Coptic cross has distinctive broad ends. The photograph above shows details of this cross from inlay-work on an old door (original size about 3cm). Traditionally-minded believers tattoo such a cross on the right wrist.

Under the Fatimids, Copts enjoyed more rights than the Sunni population, and numerous Coptic buildings were erected. At the same time Coptic artistic style, which developed from ancient models, enlivened Fatimid architecture. In the tenth century, the Mu'allaqa church was rebuilt. The basilica is richly decorated with arabesques and inlay-work (*bottom right*). Arcades with pointed arches resting on antique columns subdivided the five naves (*top right*). All the columns were originally painted; today only one of them bears a recognizable figure: that of a woman, possibly the Byzantine empress Eudoxia (*far right*). The ebony wall, richly inlaid with ivory in the twelfth to thirteenth centuries, also bears icons of saints added in the eighteenth century. The iconostasis beside the altar is dedicated to John the Baptist. The columns of the marble pulpit from the eleventh century are continually touched by the devout in a gesture honoring the twelve apostles. Nearby, the traitor Judas is symbolized by a black column.

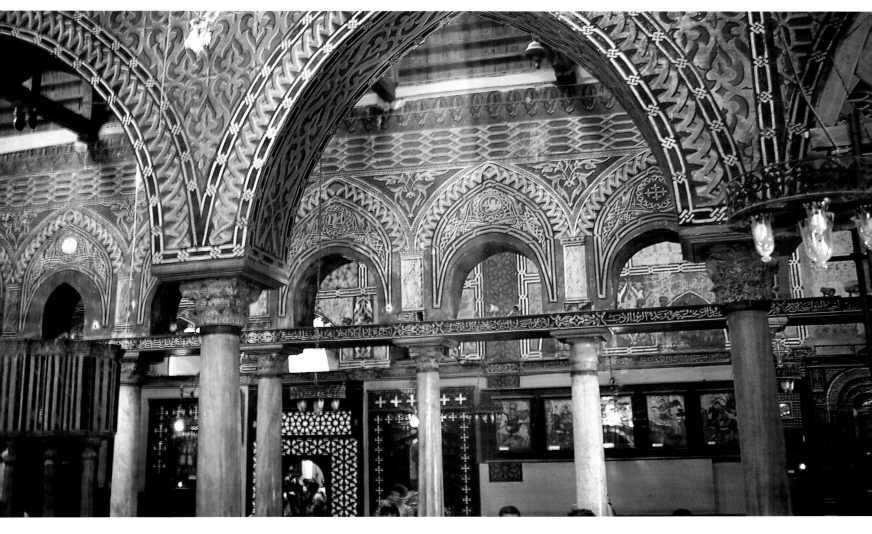

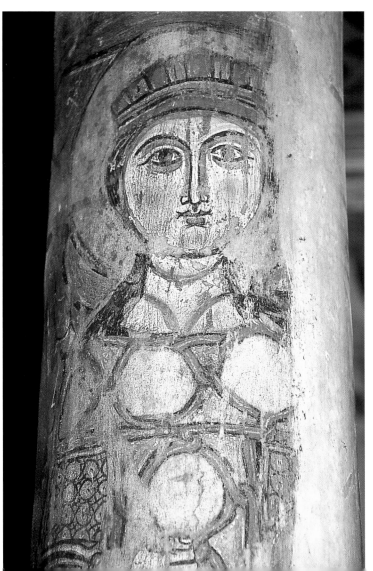

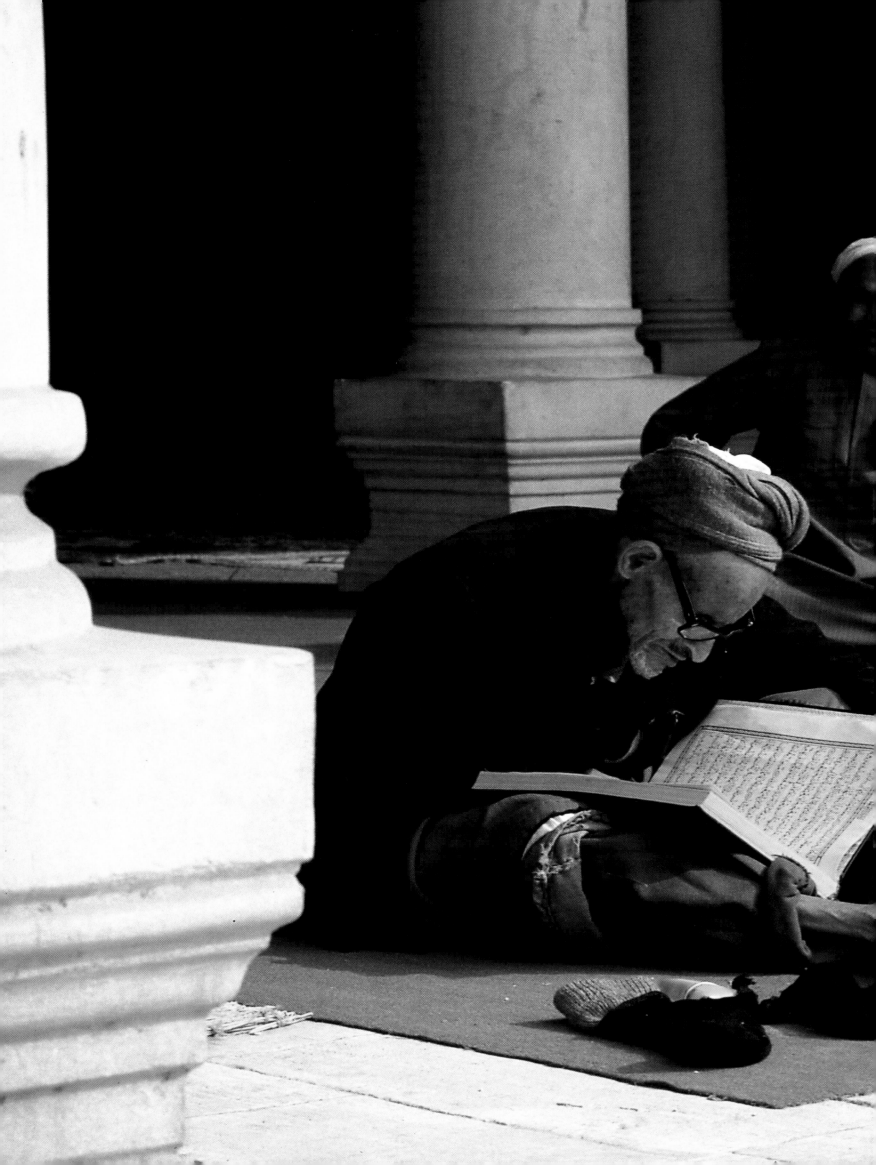

Previous pages
An Oasis of Silence
On stepping into the mosque
one sheds the bustle of the city.
The oasis of silence within the
walls invites many to study the
Qur'an here.

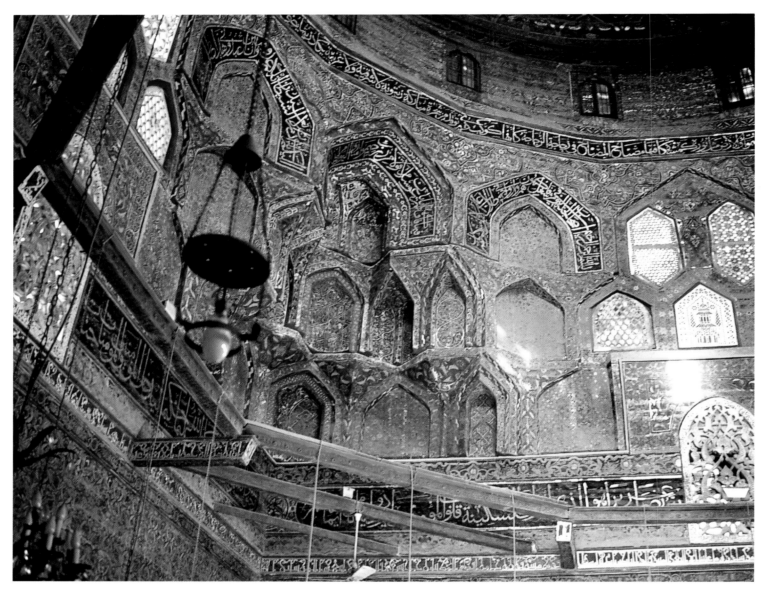

Salah al-Din and the Ayyubids

Coming from Damascus, the Kurd Salah al-Dunya wa-l-Din Yusuf ibn Ayyub, known in Europe as Saladin, replaced the reign of the Fatimids in Egypt and founded the Ayyubid dynasty (1171–1250). He became Sultan of Cairo and Damascus, vanquished the crusaders and conquered the holy land. Despite a stay of only eight years in Cairo, he made an enormous impact on the city. As a protection against the crusaders he started erecting a wall around the neighboring cities of al-Qahira, al-Qata'i, al-'Askar, and al-Fustat. Substantial stretches of this massive wall can still be seen today. In 1176, Salah al-Din also started building work on the Citadel, using Frankish prisoners-of-war as laborers. He took some stone from the smaller pyramids at Giza. This led quickly to rumors about the spirit of a pharaoh haunting the Citadel at night and seeking revenge for the desecration of his grave. For a long time after that, every disaster which came upon the citadel or the city was thought to have its origin in the curse of the pharaoh. After thirty years of construction, the fortress was completed by Salah al-Din's nephews. Salah al-Din, being Sunni, opposed the legacy of Shiite faith which the Fatimids left and, as a mark of his break with the past, changed the layout of mosques built under his reign: four columned halls (*iwan*) were now used as the teaching rooms for the four Sunni schools of law: Hanafi, Malaki, Shafi'i, and Hanbali, named after their founders. Salah al-Din built the first *madrasa* (Qur'anic school) at the tomb of the orthodox scholar Imam al-Shafi'i in the southern cemetery.

The domed mausoleum which now stands there was erected by Salah al-Din's nephew, al-Kamil, in 1211. Until today, it remains a significant place of pilgrimage. This monumental building subsequently underwent many changes. In the fifteenth century, Sultan Qaytbay erected a new dome, its niches decorated with stalactites; the rich paintings are from the eighteenth century (*above*).

One of the few examples of original Ayyubid architecture is the madrasa-mausoleum which the famous sultana Shagar al-Durr commissioned for her husband al-Salih Nagm al-Din Ayyub, the last Ayyubid sultan. Only a little is preserved of this building complex from the thirteenth century. In the wall of the madrasa beneath the old minaret, a decorated gate leads to the Khan al-Khalili bazaar (*right*). These remnants of Ayyubid architecture form a significant cultural link between Fatimid building style and the later work of the Mamluks.

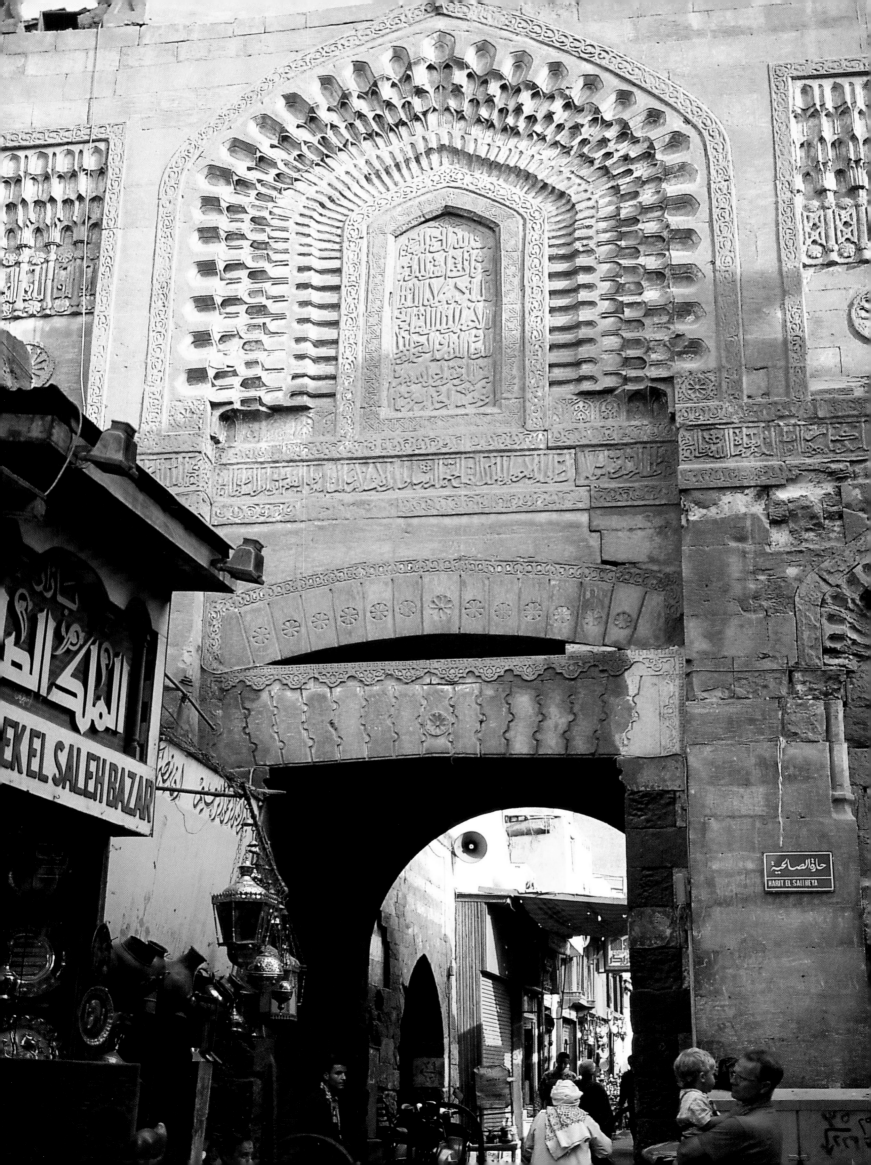

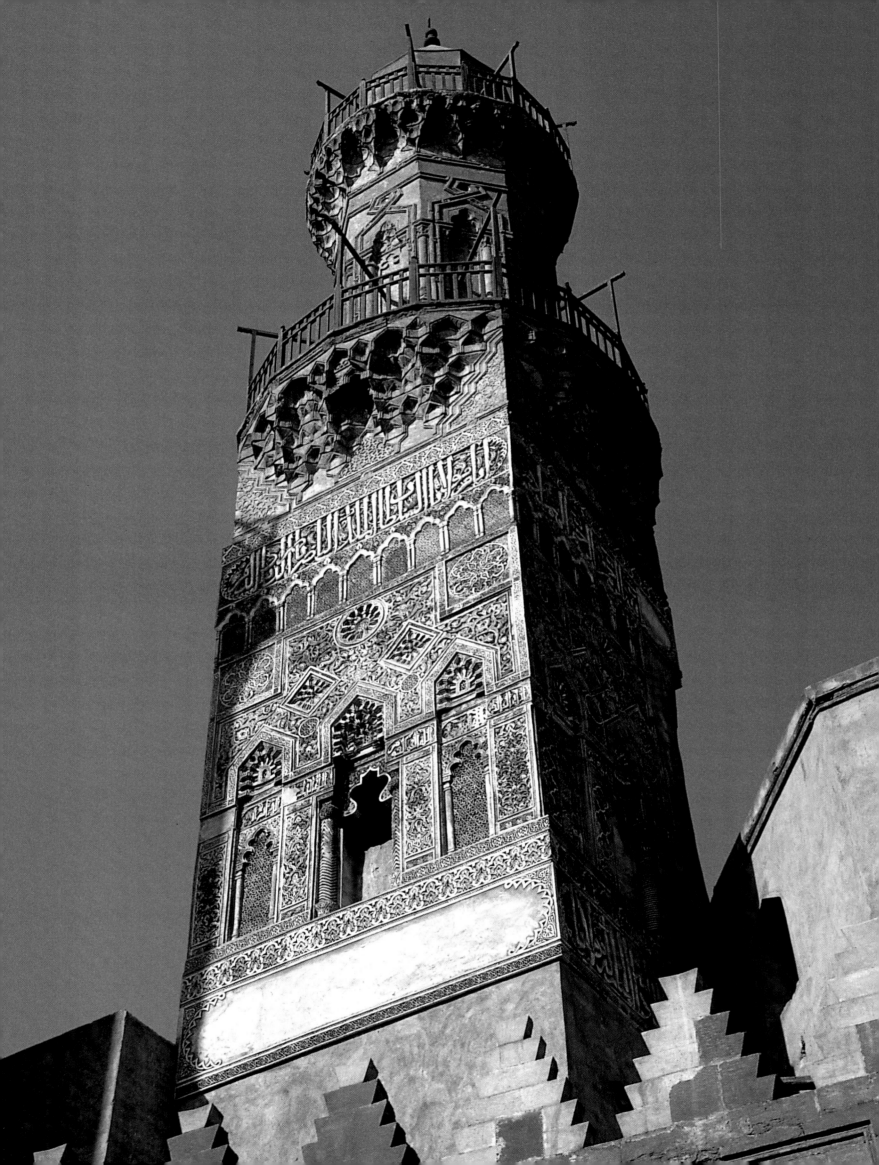

Crescent and the Cross – the Mamluks

The madrasa-mausoleum of sultan al-Mansur Qalawun, built in 1285, is a brilliant example of Mamluk architecture. The magnificent windows and the stucco façade show elements of the Gothic style which Qalawun saw in Syrian churches during the struggle against the Crusaders (*right*). Many Syrian artists came to Cairo and helped with the erection of beautiful works of architecture.

German and French crusaders, who intended to found a Christian empire in the Levant, were encircled by the Muslim states and were in a state of perpetual siege. The Muslims in Spain were under similar pressure, under threat of expulsion by the Christians. The Andalusian Muslim heartland was finally overrun. But in the east, the Muslims were victorious over the European intruders at Acre (1291)–the Christian stronghold in the Middle East. As the victors' trophy, the gothic portal of St. Andrews church in Acre was transported to Cairo and was integrated in 1304 into the madrasa of Sultan al-Nasir Muhammad as the entrance gate. The graceful stucco work of the madrasa's minaret betrays an Andalusian style (*bottom left and right*) and is indeed the work of Spanish artisans. At the end of the thirteenth century numerous

Muslim architects and artisans who had fled from the Christians in Spain found a new home in Mamluk Cairo.

If the Mamluk period (1250–1570) was significant for its architectural and military achievements, it was also a period of power struggles, intrigues, and poisoned chalices. The average reign of a sultan was under five-and-a-half years. The Mamluks were a caste of military slaves, mostly Turks, Circassians, and Greeks, who served the Ayyubid rulers of Syria and Egypt. As successful commanders-in-chief they gained more and more power, and finally toppled the Ayyubids and founded their own dynasty. A Mamluk youth would be attached to a body of men serving a particular *amir* (commander). After training and a period of probationary service, the Mamluk would rise in the ranks and himself be put in charge of young slaves. A successful soldier could hope to become a free man–even an amir, and enter the deadly struggle for absolute power.

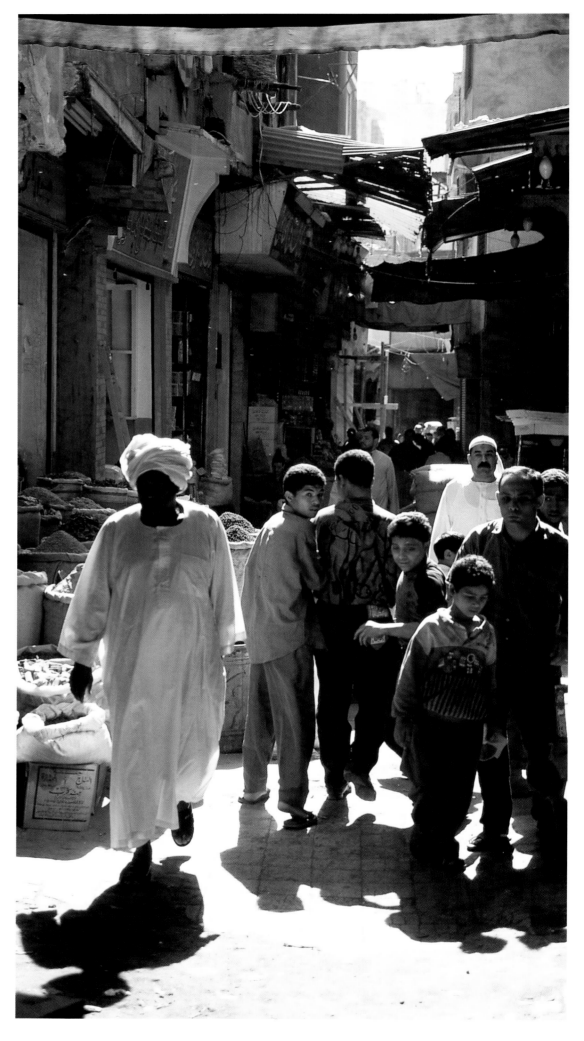

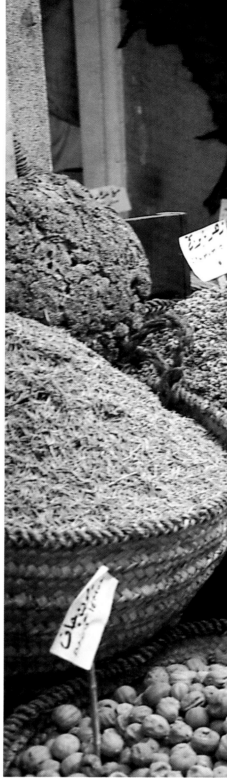

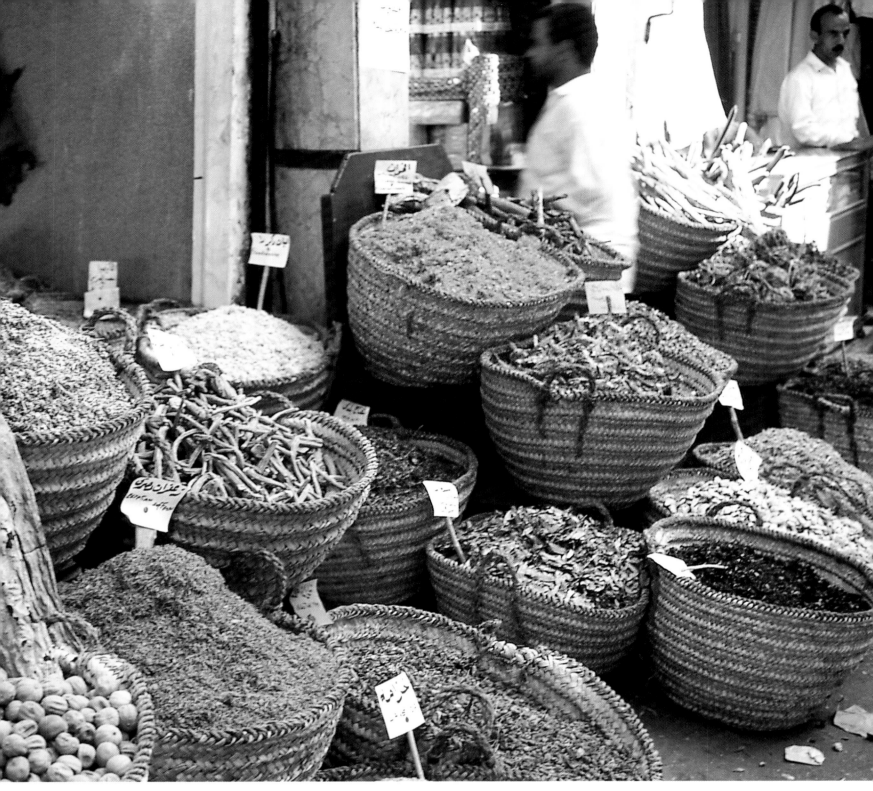

Oriental Markets of the Middle Ages

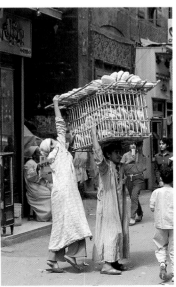

Tourist advertising for the land of the Nile is nothing new. At the end of the thirteenth century Sultan Qalawun published an invitation to the world, inviting everybody "to come to a country where one needs to bring nothing, because it is a paradise on earth." The numerous ancient *suqs* (bazaars or markets) testify to the prosperity of medieval Cairo. One of the city's most important bazaars, the Khan al-Khalili, dates back to the late fourteenth century. It was built by amir Jarkas al-Khalili, Sultan Barquq's master of the horse (*far left*). The spice market (*above*) was world famous. Besides cinnamon, nutmeg, saffron, pepper, balsam, and cloves, *mumia* powder, powdered mummy-flesh mixed with pitch, was popular among Europeans. There were two grades of mumia: white mumia was the cheaper, but the black mumia (held to originate from preserved virgins' corpses) was thought to have stronger healing powers. Powdered human flesh has long since vanished from Cairo's markets, but peasant women still offer their daily produce and street traders still hawk oven-fresh rounds of *baladi* bread. They usually bring the bread to market by bicycle on palm-stalk frames which they carry on their heads while weaving through the traffic, a seemingly miraculous feat of balance (*right*).

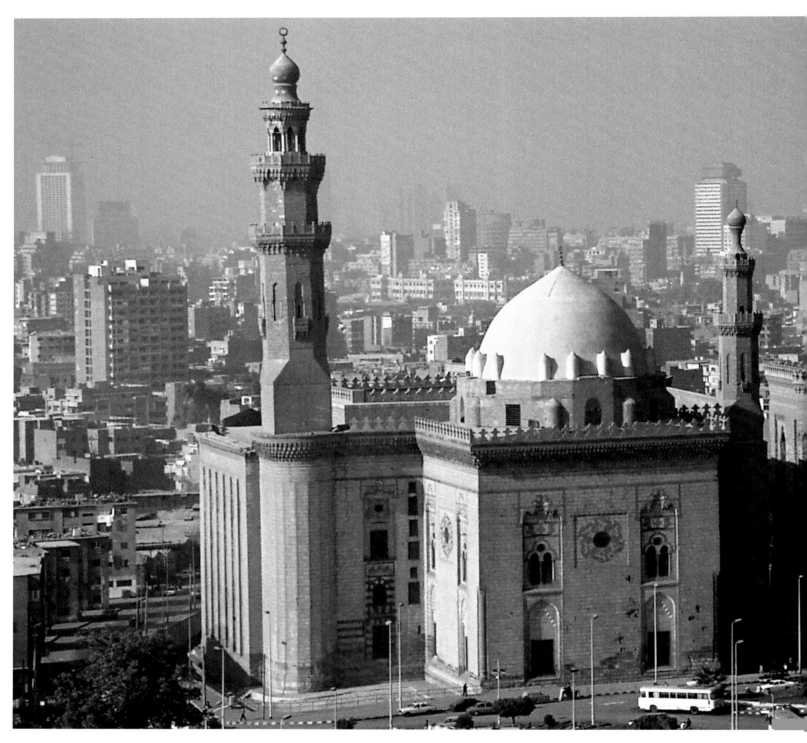

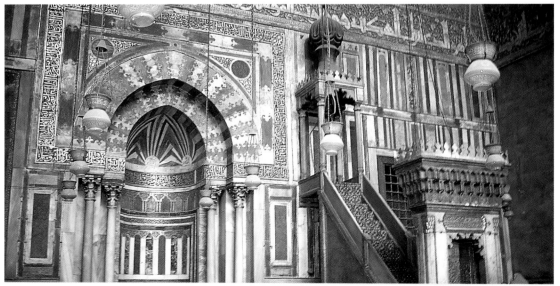

The Mosque of Sultan Hassan
Many of today's mosques were
founded in Mamluk times
(1250–1517). A good example is
the Sultan Hassan mosque
(*above*), erected in 1356 at the
foot of the Citadel. It is the most
marvelous Mamluk monument
and, at the same time, one of the
biggest mosques in the world.
The Rifa'i mosque beside it, to
the right in the picture, dates
from the beginning of the
twentieth century.
Sultan Hassan belonged, like his
famous father, al-Nasr Muham-
mad, to the Bahri Mamluks, a
name which derives from *bahr*,
meaning river, and which recalls
the first barracks of the Mamluks
on the Nile island of Roda. One

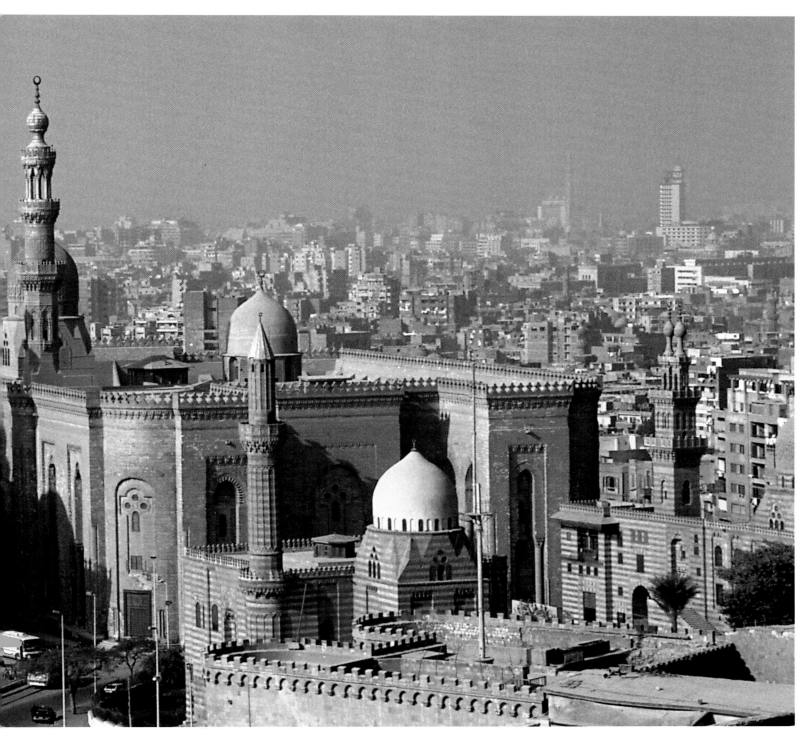

of the reasons why Sultan Hassan could afford this splendid building was the fact that the royal treasury was filled during the plague-epidemic of 1348 with the wealth of the deceased. Seven years later, the mosque was finished. It had the highest minarets in the city. One, however, collapsed and was replaced by a minaret of more modest proportions.

Sultan Hassan had an enormous mausoleum built for himself adjoining the mosque but was not buried there because his body was never found. The interior decoration ranks among the masterpieces of Islamic art, crowned by the richly decorated *qibla* wall (the wall which is oriented towards Mecca), with the magnificent *mihrab* (prayer niche) and *minbar* (pulpit) (*left*). This dignified scene is the solemnizing of a marriage contract. The court of the mosque has filled with relatives, friends of the engaged, and happy children. The signing ceremony called *katb al-kitab* takes place before an *imam*, and they all read the *fatiha* (opening verse of the Qur'an) together. The wedding party—often celebrated with great pomp—is usually held the following day at home (*right*) or at a club or hotel.

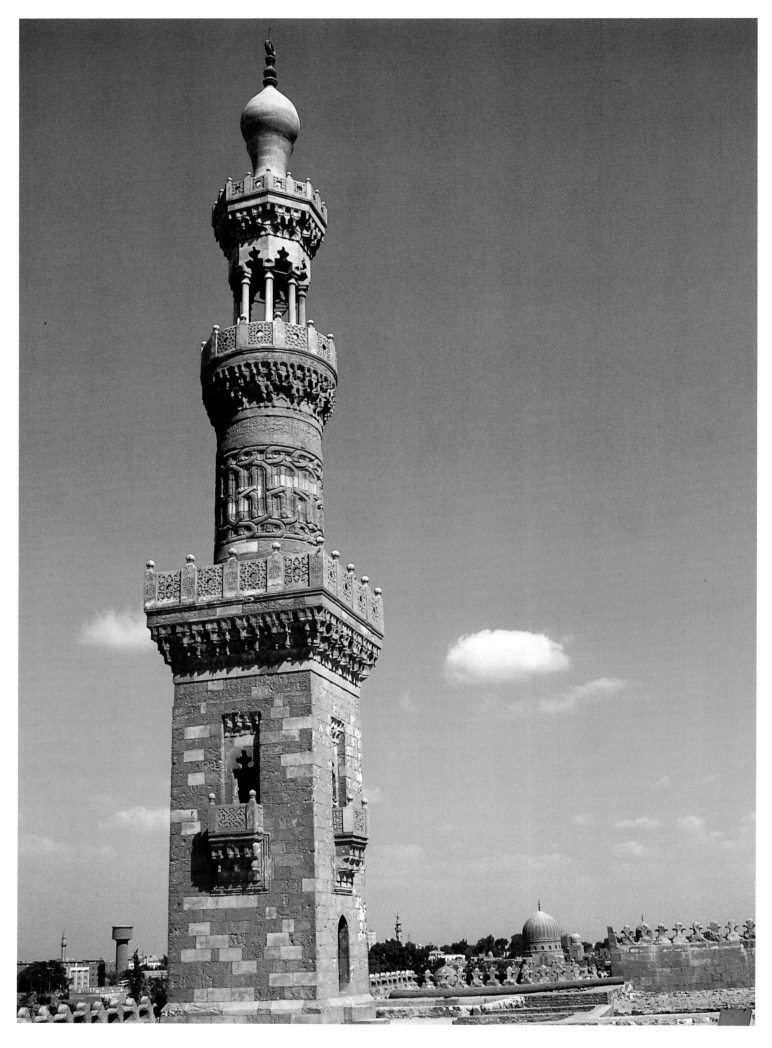

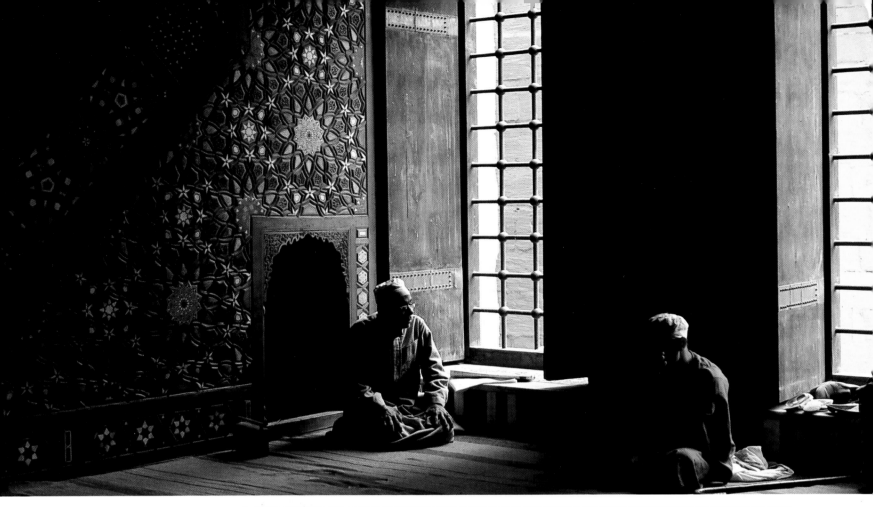

Circassian Mamluk Masterpieces in the City of the Dead

The former desert area which lies below the Muqattam hills to the east of Cairo has always been used as a cemetery. Because it is higher and therefore drier than the old city settlements of the flood plain, it preserved human remains better. Perhaps this is the reason behind the legend that those who are buried here will rise some day without having to render account for their sins. It is a place of many early Christian and Islamic legends.

The cities of the dead have always been filled with life–long before they were swallowed by the metropolis. Following a very old tradition, the relatives of the deceased–particularly the women–visit the graves regularly and spend the night there. Some tombs are virtual houses in which grave-guards sometimes live with their families. Many are now occupied by squatters. The tombs of significant Islamic saints were considered especially holy and people frequented them to seek blessings.

The Mamluk sultan Farag ibn Barquq arranged to be interred close to these places of pilgrimage. According to his plan, a complete settlement was to emerge around his mausoleum–the very first attempt to colonize the desert. The magnificently-conceived

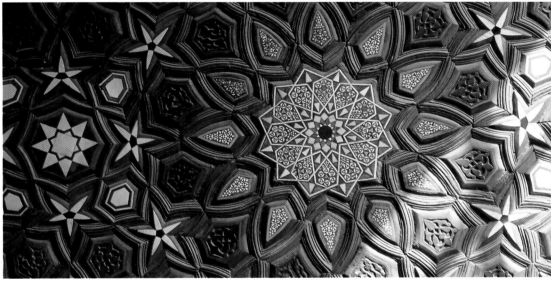

funerary complex, completed after Barquq's death in 1411, enclosed a mosque and a dervish monastery besides the two family mausoleums. High above the mosque, which is built on a square plan around a court, rise two ornate minarets (one of them in the picture on the left).

Besides Sultan Barquq, two other Circassian sultans determined the silhouette of the northern city of the dead: al-Ashraf Qaytbay and al-Ashraf Barsbay. The long mausoleum of the Barsbay mosque (1432), which also contained a madrasa, a dervish monastery, and two wells, now contains the magnificent Mamluk minbar (prayer pulpit) (*top*).

The subdued sunlight falling through the high windows lends the ornate ivory inlay work a surprising lightness (*above*). In the architecture and decoration of the mausoleum of Qaytbay (1472–74), late Mamluk culture achieves its zenith. The perfect

stone-fretwork of the dome has never been surpassed in Cairo (*see top of page 11*).

"How beautiful is the dome, which is decorated by a web of ornament like lace made of stone …"
(G. Ebers, 1885.)

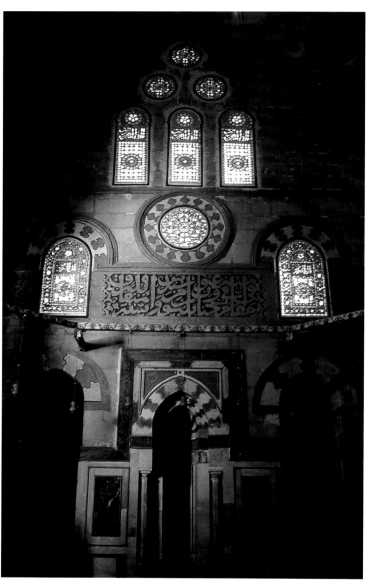

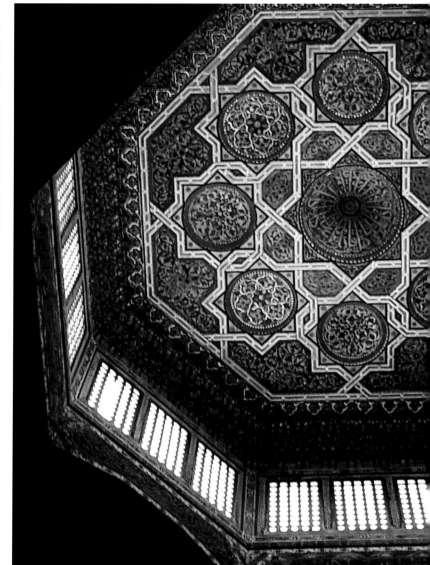

Monuments from the Times of A Thousand and One Nights

The oldest manuscript of the *Thousand and One Nights* dates from late Mamluk times. Many of the stories in this collection originated in India and traveled through Persia and Baghdad to Cairo, where they mingled with local fairy tales and legends and took on the trappings of court life under the Circassian Mamluks. These former military slaves from the Caucasus seized power in 1382, and their control lasted until 1517. The Mamluk sultans, who lived in the greatest luxury, were known as unjust and cruel; they enriched themselves at the expense of the people and neglected the maintenance and expansion of the irrigation system. In the middle of the fourteenth century, following the plague, a famine broke out. The economy grew ever weaker and the decline of the Mamluks set in. Despite all this, Islamic culture blossomed. Natural sciences and the arts were promoted; sultans and amirs commissioned superb works of glass and metal, and the most magnificent Qur'an illuminations in the Islamic world were produced in Egypt at that time.

Architectural monuments of incomparable beauty were erected, since each military ruler wanted to outdo his predecessor. One of these jewels is the mosque-mausoleum of Qajmas of 1480–81, close to Bab Zuwayla. Qajmas al-Ishaqi, a highly respected amir, was head stable-master for Sultan Qaytbay. This was an important position, because horses played a significant role in the Mamluks' social order. Because land in the city had become scarce by that time, the architect had only a small, triangular plot at a crossroads for his building. The mosque was erected above shops. A Qur'an school, which formed part of the complex, was connected by a bridge from the opposite side of the street and the four side *liwans* of the mosque were reduced to niches. The fine inner decoration (*above left*) was crowned by an octagonal lantern (*above center*). The stained-glass windows are probably an Ottoman restoration.

The last Circassian sultan left such magnificent monuments

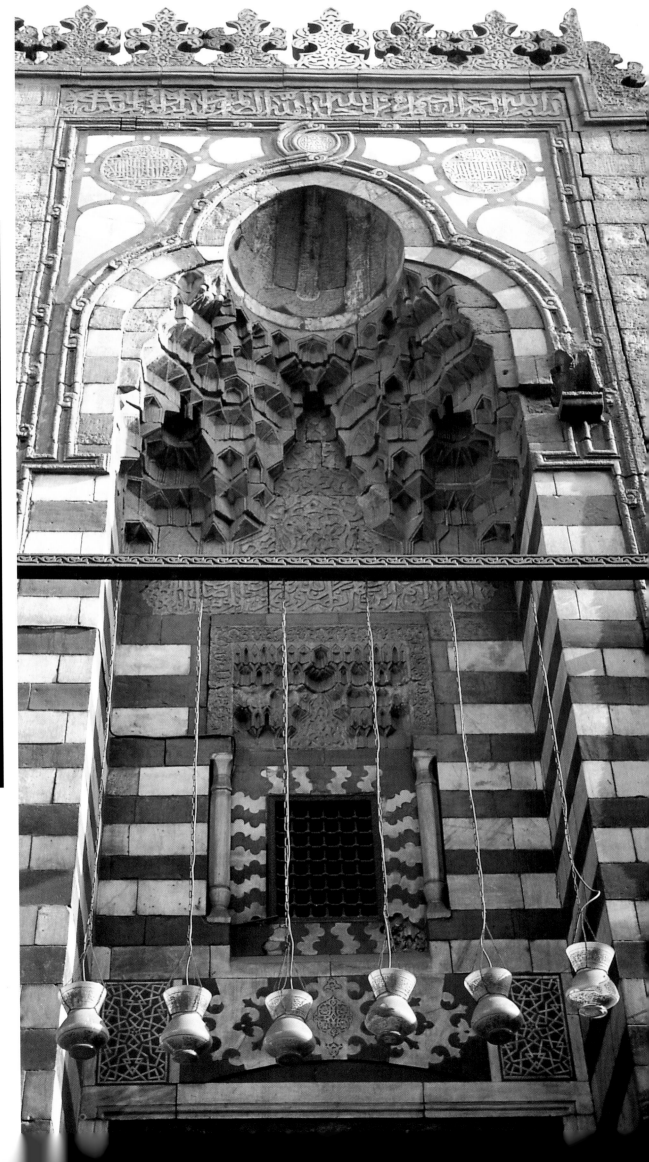

that today the Ghuriya quarter bears his name. Sultan Qansuh al-Ghuri, who reigned from 1501 to 1516, died in battle against the Ottoman Turks. His body was not recovered, so his mausoleum lies empty. Immediately beside what today is al-Azhar street, the madrasa and the mausoleum (*right*) stand opposite one another—the massive but elegant monuments date from 1503–5. The street between them was once a roofed silk bazaar—even today there are stalls selling cloth. The mausoleum was connected to a dervish monastery (*khanqah*), which is now a cultural center where performances of dervish dances can be seen.

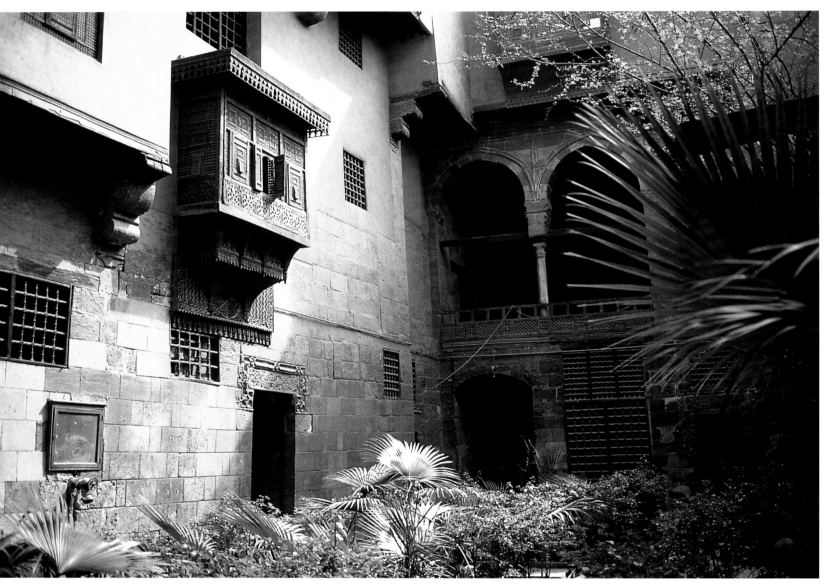

Life Under the Ottomans

The Ottomans left surprisingly few traces in Cairo. Typical of their architectural contribution are drinking fountains (see page 38) and houses. The most beautiful example of the lifestyle of the rich is Bayt al-Suhaymi (*bayt* means house). Actually it is two houses, dating from 1648 and 1796, which have been joined–a common practice.

The house shields itself from the noisy street with an imposing wall; even when the main gate opens, the interior is hidden by a bend in the corridor.

The courtyard (*left*) greeted the visitor like a green oasis, in which the twittering of birds accompanied the babble of a splendid fountain. On the verandah (*tahtabush*) which overlooked the garden the host entertained his guests. A perforated wooden wall of interlocking turned wood (*mashrabiya*) divided them from the women's garden. The house is decorated with beautiful tiles and North African inlay work. The house was strictly divided into a public part for visitors and a private area on the upper floors (the *harem*). For men not of the family, the harem was out of bounds. Women would, however, often receive female

friends in their baths. In public they hid their faces, which had the advantage of protecting their pale complexions from sun and wind. Full veiling was a privilege of the rich; working women could not afford this kind of luxury.

The mashrabiya windows of a large house shielded the life of the harem, allowing the women to look out through small hinged flaps without themselves being seen. The mashrabiya filters the strong sunlight and allows air to circulate in the room.

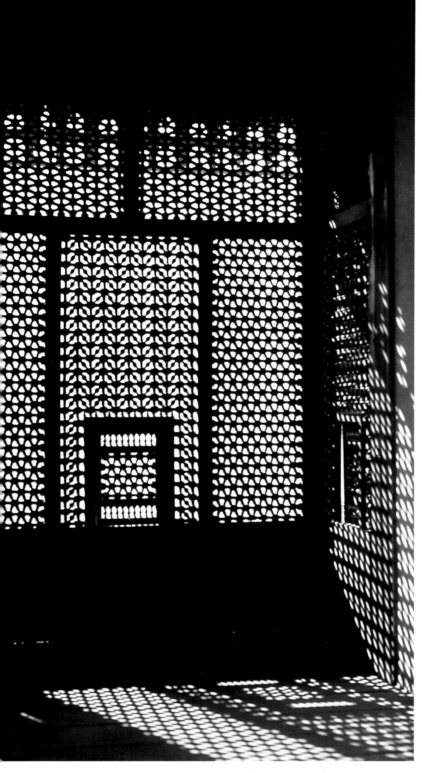

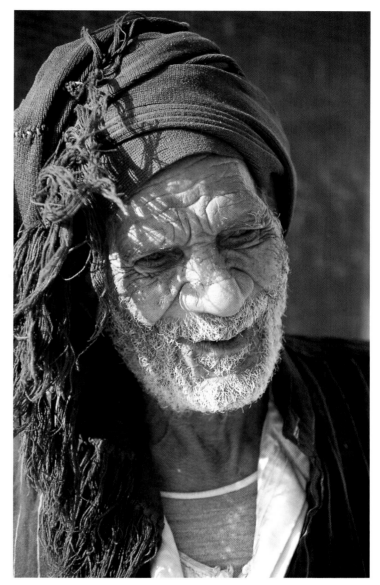

A water pot was often put to cool in a niche in the mashrabiya. In fact, *mashrabiya* derives from *mashrub*, which means 'a drink.' Bayt al-Suhaymi remains in excellent condition for a house of its age, partly because it has been continuously inhabited.
A guardian now lives in this calm house with its green garden in the middle of the busy city (*right*).

After the Turkish sultan Selim I made Egypt an Ottoman province, a Turkish pasha resided in Egypt, but the Mamluks retained much of their power and status.

During Napoleon Bonaparte's campaign in Egypt at the end of the eighteenth century, he waxed enthusiastic over the ancient culture of the pharaohs but considered that under the Turks the country had sunk to the lowest point in its history. The population had dropped to barely three million, (compared to eight million inhabitants fifteen hundred years earlier). Even the capital had shrunk by two-thirds.

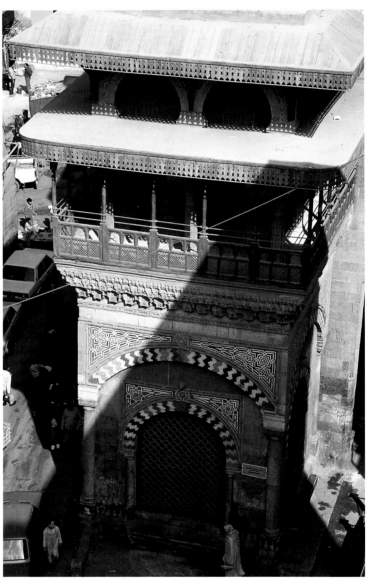

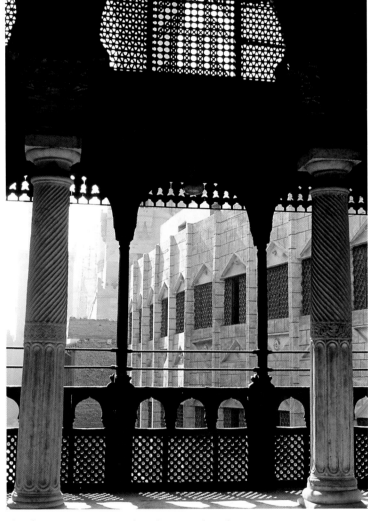

Public Fountains

During the almost three hundred years of Ottoman occupation (1517–1805) the cultural life of Cairo was virtually paralyzed. The elite, still largely Mamluk, enriched itself ruthlessly at the expense of the general population, but to atone for their sins, the wealthy established charitable foundations. Mostly these were *sabil kuttabs*, public drinking fountains with integrated Qur'anic schools where instruction was free.

This specifically Egyptian establishment was often attached to a sacred building, but could also stand alone like this sabil kuttab, built by Amir 'Abd al-Rahman Katkhuda in 1744 (*above left*). This wealthy Mamluk officer was a renowned promoter of the arts and Cairo owes to him the restoration as well as the building of numerous monuments, such as the Barbers' Gate in al-Azhar mosque.

The fountain was erected at the junction of a street, with its back attached firmly to the neighboring house. The walls of the *sabil* were lined with Syrian faience. Water carriers regularly emptied their huge pots into the big basin, so there was always water available for people to take home. Lessons for the children were held in the airy first floor (*above right*).

The architecture of the sabil kuttab derives mainly from the old Mamluk style, the stalactite decoration being typical. But in many details it shows late Ottoman influence, obvious in the new floral ornamentation, a motif which the Ottomans adopted from the Mongols.

The Blue Mosque

The Aqsunqur Mosque in Cairo is also named the Blue Mosque because of its interior, which is richly decorated with blue tiles (opposite page). Built in 1347, the mosque was restored in 1654 under the Turkish governor Ibrahim Agha Mustahfazan. The *qibla* wall and the mausoleum of Ibrahim Agha are lined with the famous *iznik* tiles. Typical of this Ottoman style are the slim representations of cypress trees and the clumps of flowers with slim jagged leaves, known as *saz*.

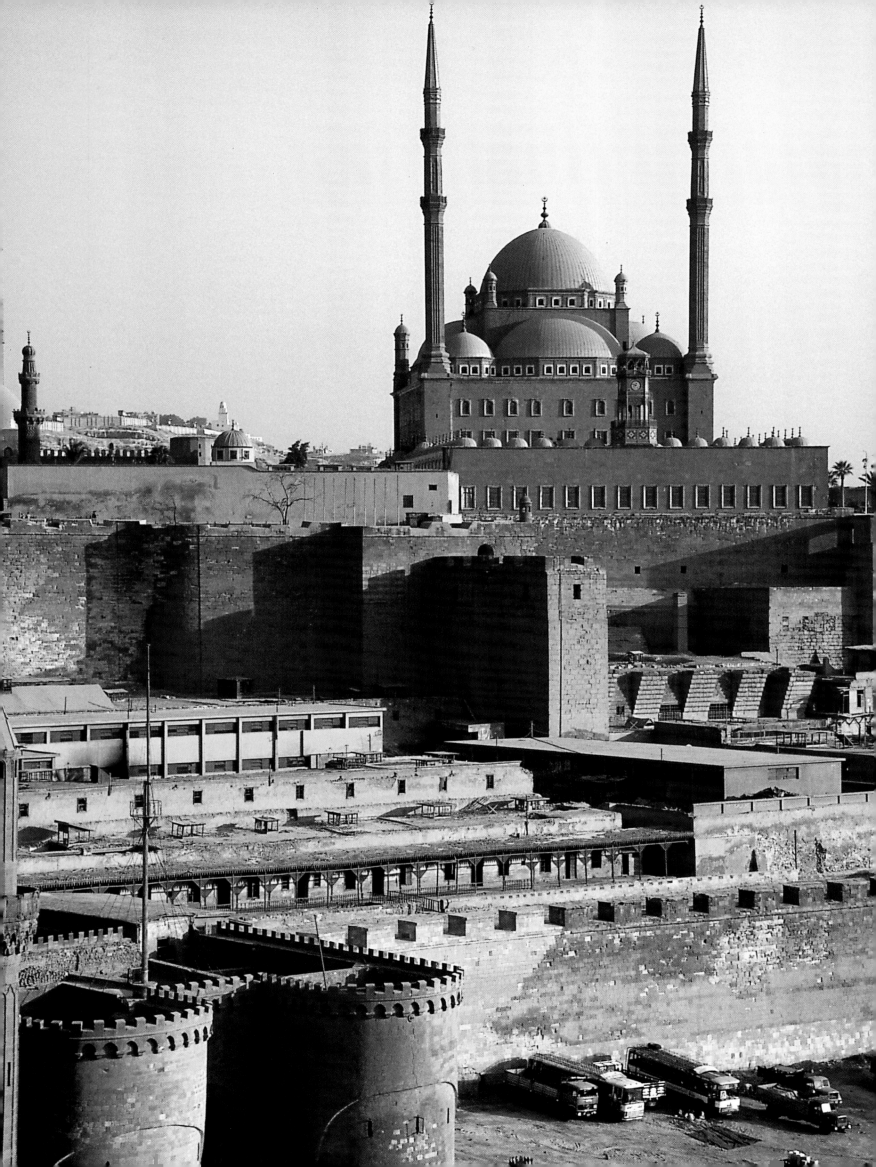

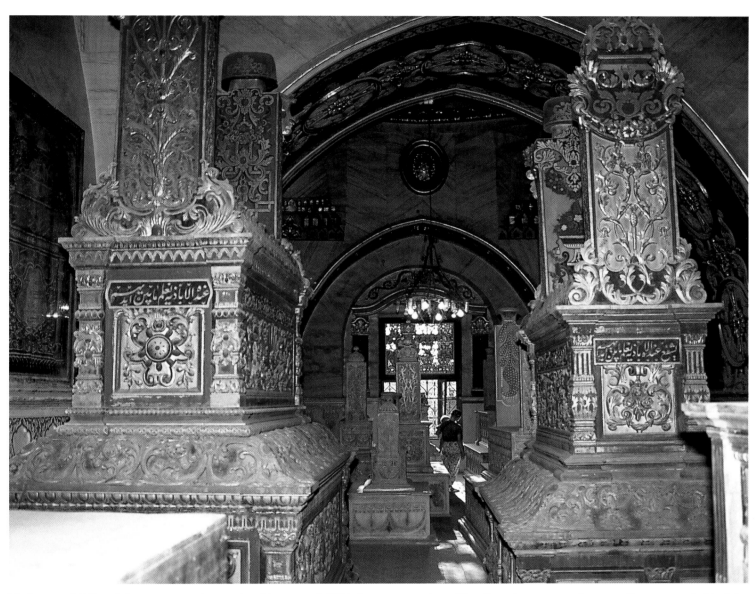

Muhammad ʿAli and the Cairo Citadel

On a hill below the Muqattam escarpment rises the Citadel with the mosque of Muhammad ʿAli, also known as the Alabaster Mosque.

Although its silhouette is untypical of Cairo, this monument, completed in 1848, became the landmark of the city (*left*). It remains the most prominent building in Cairo and can be seen even from the Pyramids on a clear day.

The building of the citadel was started under the Ayyubid Salah al-Din in 1176. Only parts of the Eastern wall of this original structure remain. Apart from a few interruptions, the citadel was the royal residence until 1874. It has been changed many times, the older parts being dismantled and reused.

When the Albanian Muhammad ʿAli became pasha of Egypt, he built the Alabaster Mosque, which contains his tomb, on the ruins of the old Mamluk palace. It is virtually a copy of the grandiose Yeni Valide mosque in Istanbul. The two needle-shaped minarets are 83 meters high, while the vast main and numerous side domes emphasize the size of the monument.

In the Hosh al-Basha mausoleum of the Muhammad ʿAli family (1820) (*above*), about forty relatives and descendants of Muhammad ʿAli are buried, among them King Farouk (reigned 1936–52). The heads of the sarcophagi carry the specific headgear of the deceased—crown, turban, the hair of the ladies, or the tarboosh. The red woolen tarboosh (or fez), originally the headgear of Turkish soldiers and civil servants, was a feature of Cairo streets for hundreds of years, disappearing only after the revolution.

The dynasty which Muhammad ʿAli founded lasted around 150 years. His political tactics were as cruel as they were effective. With one stroke he rid himself of the still-powerful Mamluk elite. He invited about 480 *beys* to a celebration in the Citadel, then trapped and massacred them in the ascending passage behind the two half-round towers (*opposite*). Muhammad ʿAli opened Egypt to the West, and the French lifestyle became fashionable. Under his successors, new parts of the city were built in the French style. Old Cairo and its inhabitants, however, were neglected. Many of the Islamic monuments had to make way for modernization. But industrialization began and the agricultural economy made great progress.

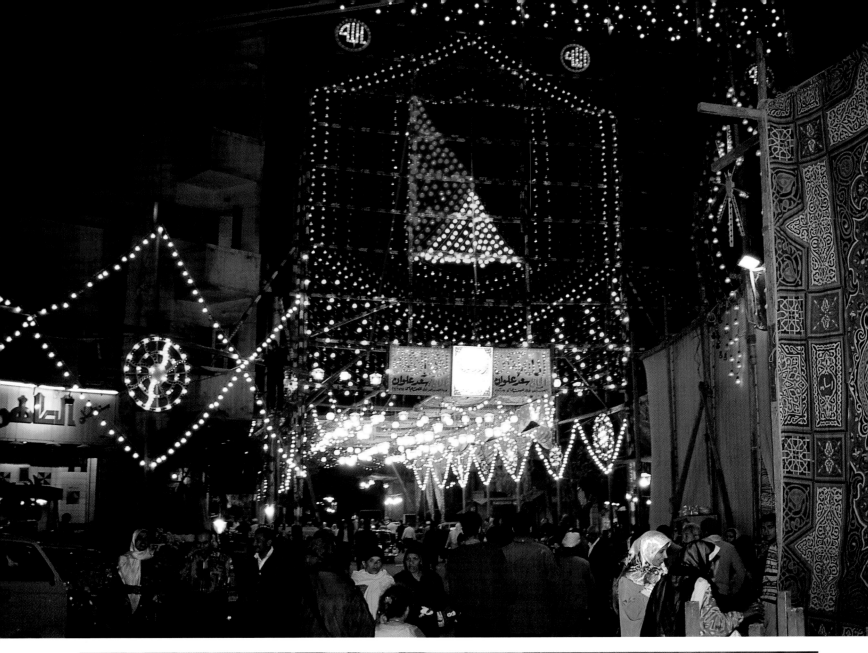

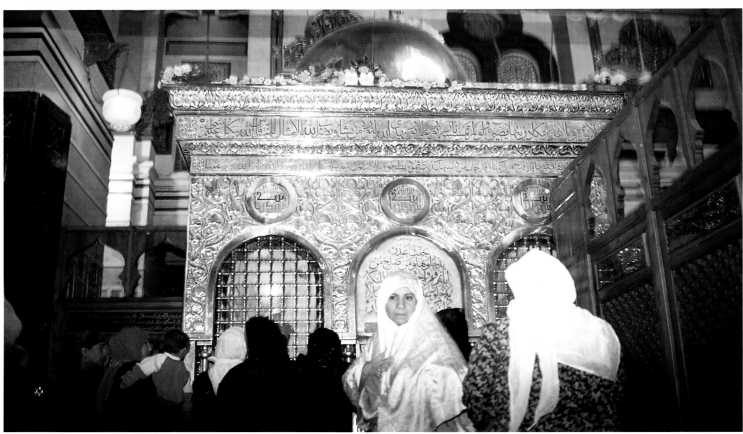

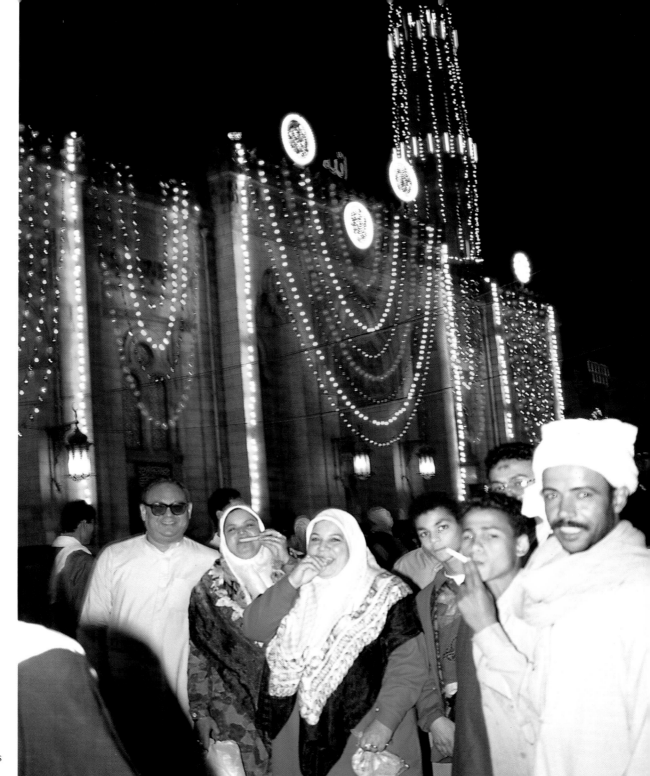

The Moulid of Sayyeda Zaynab
From afar, the colorful, blinking chains of lights shine out of the dark (*above left*); they change color constantly and form different shapes, ending at the slim minaret of Sayyeda Zaynab mosque (*right*). From all over Egypt people come for the fifteen days of the traditional *moulid* (feast) of the granddaughter of the Prophet Muhammad. Visitors camp out throughout the neighborhood. The moulid of Sayyeda Zaynab is, after that of her brother Hussein, the biggest in Cairo. But many other moulids can be found throughout the country. Almost every large village honors a sheikh and celebrates his birthday each year. The moulid of Ahmad al-Badawi in Tanta, for example, supposedly draws about three million visitors. Copts also celebrate their own moulids.

Some moulids supposedly have their origins in pharaonic customs. The big moulids climax with processions on the *laila kabira* (big night). The celebration of Sayyeda Zaynab goes back to the time of the Fatimids (969–1171), when numerous Islamic relics were brought to Cairo to consolidate the Fatimids' predominance. But relics of Sayyeda Zaynab herself never reached Cairo. It seems that another Zaynab, a cousin of Sayyeda Nafisa, rests in the sarcophagus, which is surrounded by a magnificent silver shrine donated by Indian Muslims (*bottom left*).

Strictly separated from the men, many women come here, hoping for *baraka* (blessing and luck) through a visit to the shrine. The current mosque was built in 1884 in neo-Mamluk style. The nights of the moulid are marked by the *zikr* of dervishes from both Cairo and the provinces. Each Sufi order has its own colors, flags, and specific form of zikr—a special dancing rite to bring the participant closer to God. The dervishes stand closely together in tents or crowd outside and sway under the rhythm of the *riqq*, a tambourine-like instrument. Some chant, "Allah, Allah, Allah"; others the confession of faith, "la ilaha illa-llah" (there is no god but God). These incantations are accompanied by swaying the head and twisting of the body. This zikr delivers them slowly into a religious ecstasy as they experience the mystical immanence of God.

By nature I am a story teller– Naguib Mahfouz

"Despite everything, I will remain an optimist till the end of my life. And I will not, like the philosopher Kant, say that good will triumph only in the next world. No–it is victorious on a daily basis; perhaps evil is weaker than we imagine …" Naguib Mahfouz wrote these words for his acceptance speech when he was awarded the Nobel Prize for Literature in 1988. Since an attack on him by a young terrorist in 1994, he can no longer use his hand to write. "When good things happened they were good, when bad things happened they were bad. She would be able to deal with both." This line from *Midaq Alley* mirrors the philosophy of Mahfouz. As a significant contemporary Arabic writer, he has created a specifically Egyptian prose, mostly independent of European influence. The old city, not far from the Khan al-Khalili Bazaar, where he grew up (*bottom left* and *top right*), is the setting for many of his works. "A brotherly sentiment bound everybody in the area together." (*The Black Cat*). Here he used to sit in the coffee houses—until the attack—watching people go about their business, writing, and listening to simple people talking about the daily blows which fate dealt them.

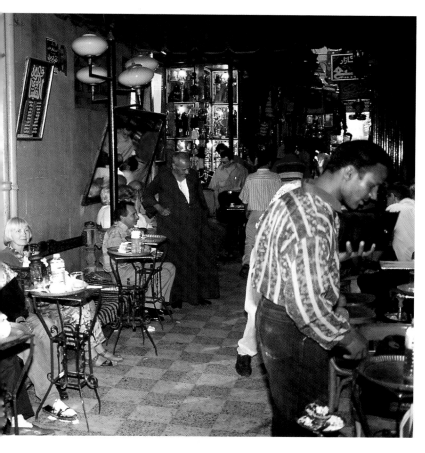

Fishawi's (*above center*) is one of the coffee houses in which Mahfouz was regularly seen and where old guest books boast the names of other great writers such as Jean-Paul Sartre and Simone de Beauvoir.

Mahfouz is an attentive and patient listener. And he is—in the oriental tradition—a great and enthusiastic storyteller. His subtle characterizations and descriptive powers reveal the psychological, intellectual, and political structures of Egyptian society.

One of Naguib Mahfouz's most famous works is the novel *Midaq Alley*, published in 1947. This tiny, nowadays inconspicuous, blind alley which lies between al-Azhar Mosque and the bazaar quarter probably dates back to Fatimid times:

Many things combine to show that Midaq Alley is one of the gems of times gone by and that it once shone forth like a flashing star in the history of Cairo ... Although Midaq Alley lives in almost complete isolation from all surrounding activity, it clamors with a distinctive and personal life of its own. Fundamentally and basically, its roots connect with life as a whole and yet, at the same time, it retains a number of the secrets of a world now past.

Through thick and thin, the water-pipe is a constant companion:

The men exchanged looks in silence, and the vacuum was filled with the gurgling sounds of the water pipes ... The narghile and its tobacco had no taste for them ... the gurgling of the water pipes could be heard in the dying light of the alley like a succession of mocking laughs. (*Fear,* in *The Time and the Place and Other Stories*).

Contact with the modern world brings dramatic changes and inevitably leads to conflict. Nevertheless, people seek an accommodation with the new circumstances:

We submitted to the facts, and this submission brought a sort of contentment. (*Half a Day,* in *The Time and the Place and Other Stories*).

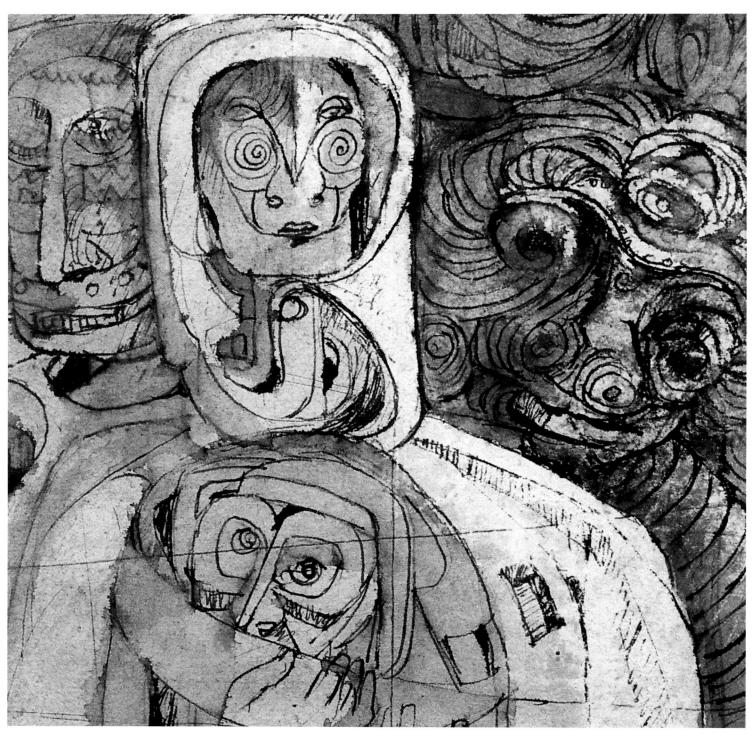

Egypt's Modern Art

Abd al-Hadi al-Gazzar and Hamed Nada are two icons of Egypt's modern culture. Both were born in Alexandria, al-Gazzar in 1925 and Hamed Nada in 1924, and grew up as friends in the Sayyeda Zaynab quarter. Both were students of Hussein Yussuf Amin, a pioneer of an independent Egyptian school of art.

The first Faculty of Fine Arts was founded in Egypt in 1908 with the help of the French sculptor Guillaume Laplani. The break from Western models was promoted again and again by new groups of artists from the 1920s on. Perhaps the decisive breakthrough came in 1946, when Yussuf Amin founded the Contemporary Art Group, to which al-Gazzar and Hamed Nada also belonged. These two artists were infused with the traditional life of the Sayyeda Zaynab area, its old customs and the moulid, and the magic and superstition of the community. These traditions became their artistic themes.

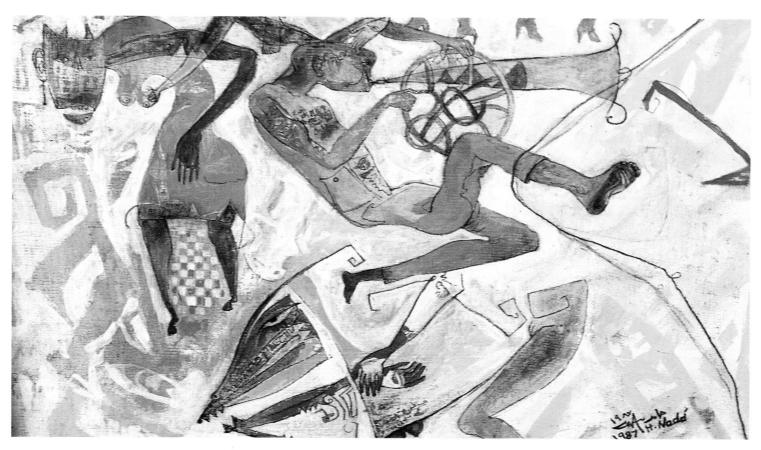

The life of many people is lived against the backdrop of an omnipresent world of demons, called *jinn*. According to one Islamic tradition, there are innumerable spirits with both good and evil natures. In this drawing (*left*) from 1965, al-Gazzar shows that even the modern human being is surrounded by jinn. Many pictures by Hamed Nada overflow with allegories and magical symbols (*above*), which can be understood readily by Egyptians, although foreigners may find them puzzling. In her picture (*right*), the artist Ehsan Nada has employed the old custom of putting a crocodile and a lizard as protectors of the house above the door. The development of Egypt's modern fine arts has been characterized by the incorporation of ancient mythology, old customs, Islamic calligraphy, and traditional Coptic elements, as well as by a critical analysis of contemporary social and political currents.

Egyptian artists nowadays present their work as a broad palette of individual styles. One modern art gallery was for a long time housed in the gently-rocking Nile houseboat of Dr. Ragab's Papyrus Institute in the center of Cairo.

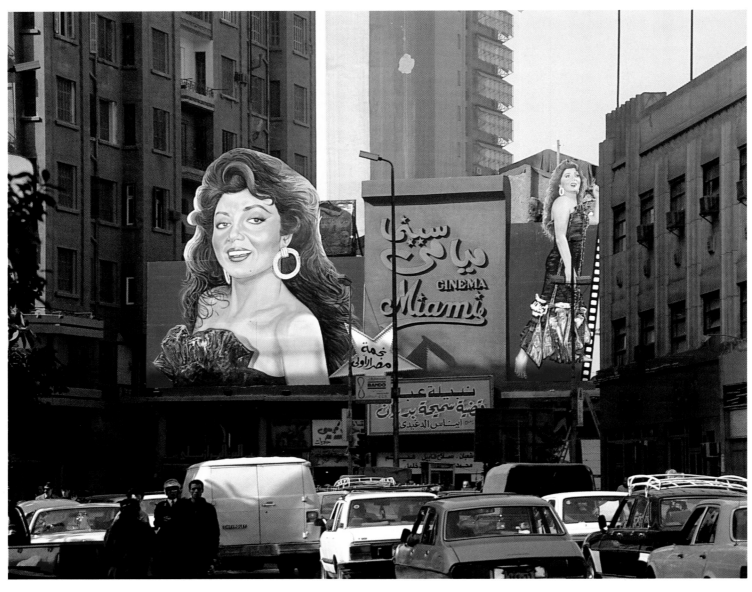

The image shows a Cairo street scene with painted cinema billboards, including the "CINEMA Miami" sign with Arabic text, above a busy street filled with cars and pedestrians.

Cairo – the Never-ending Story

"Every visitor finds it difficult to leave Cairo. It unfolds like a never-ending story," wrote Robert Erving. Many visitors nowadays feel quite the opposite: after a visit to the Egyptian Museum, the Citadel, the bazaar, and the pyramids they are relieved to turn their back on it. Everywhere people, people, people! Cairo numbers perhaps sixteen million inhabitants. The roar of the traffic never ceases. But right in the noisy center (*above left*) one can still, surprisingly, enjoy the relaxing calm of the Nile. It is an easy matter to hire a felucca, which glides noiselessly over the water, the powerful sail driven by a cooling breeze.

The city lives by and through the most obvious contrasts. The cultural creations of five thousand years stand side by side, seemingly unrelated to one another. At every step the visitor finds the beautiful next to the ugly, kitsch beside high art, rubble piled up against a magnificent building, a bouquet of flowers by a pile of trash.

Not only do such contrasting elements lie side by side, they interpenetrate and become a whole. They make up an interlocking world in which everything is constantly moving, where at one time this and at another time that aspect shines through. There is no winner and no loser.

Despite the pollution, the sun bathes Cairo in warm, golden light and so unifies everything. But when there is no sun, on some winter days, we experience another city: "Winter in Cairo is cold and without secrets. The sky makes no music" (Naguib Mahfouz).

If the Citadel is the landmark of Islamic Cairo, modern Cairo is marked by the 187-meter-high Cairo Tower, built in 1957 under Nasser (*right*). Young people in particular enjoy its viewing platform, which offers views over the Nile (*above right* with the new Opera House). On clear days one can see the pyramids of Giza.

In May and June flowering trees turn yellow, blue, and red between the high-rise buildings, and sometimes flamboyant blossoms line whole streets. On the way to the airport stands the Indian fantasy palace of Baron Edouard Empain (*far right*), modeled on a Hindu temple. At the beginning of this century this extraordinary Belgian entrepreneur built a new 'sun city,' Heliopolis (not to be confused with the ancient Heliopolis), on a desert plateau.

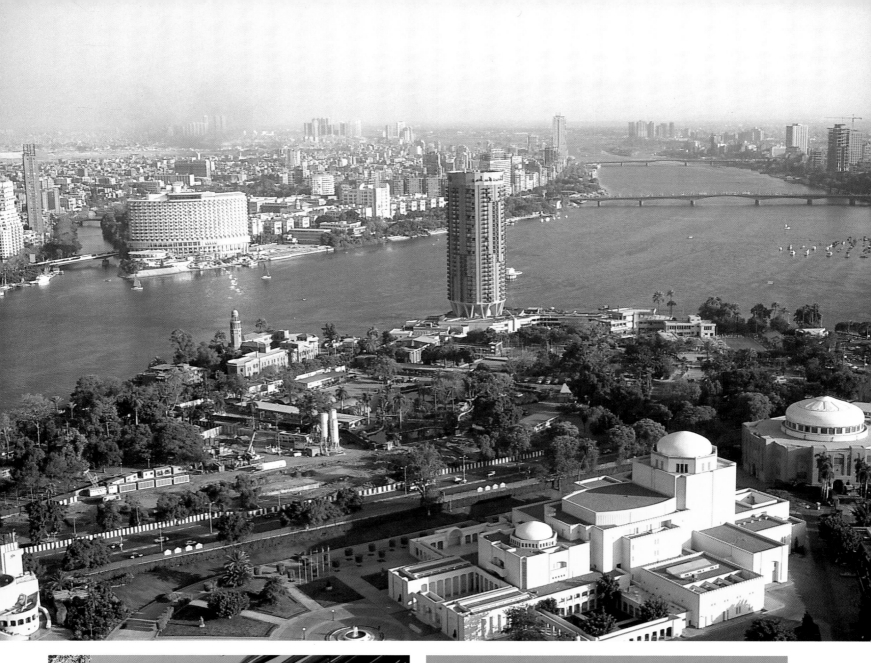

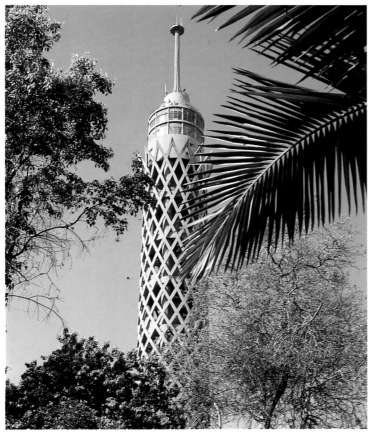

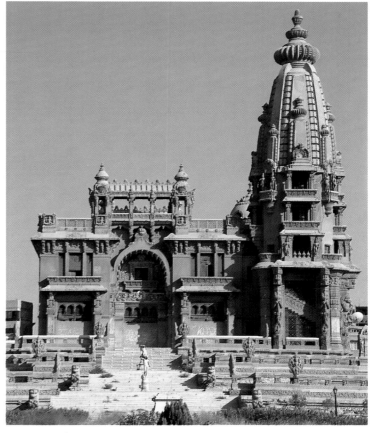

The Nile Delta
and the Fayyum

Night flight to Egypt. Above the black-shrouded Mediterranean the clear sky sparkles with stars. All of a sudden, far away, there is a sparkling also on the ground—quickly coming closer—the lights of Iskandariya. Alexandria: the city named after the great conqueror, flowering metropolis of Hellenistic philosophy, literature, mathematics, and science. In antiquity, this city had the greatest library in the world, and possessed one of the Seven Wonders of the World—the Pharos lighthouse. Alexandria: stage for Caesar and Cleopatra, the focus of early Christianity. Cosmopolitan Alexandria of the late nineteenth and early twentieth century, "city of diadochi and epigones," according to the writer Alef Sossidi.

As soon as the lights of the city disappear behind and below the plane ... can this be true: a starry sky on the ground? Everywhere shining dots, in between bigger and smaller clusters of dots, sometimes connected to become lines of light—as far as one can see. The starry sky seems to be mirrored on the ground. A view of the Nile delta from the air at night reveals that this is one of the most densely-populated agrarian regions in the world. Less than half an hour later, the scattered lights swell into a glittering sea; here is the shining band of the Nile and the illuminated Citadel. The descent to Cairo is the shining climax of a night flight to Egypt.

"In their traditions and customs the Egyptians often do things differently from other people. For example, women buy and sell at the market and engage in trade while the men sit at home and weave."

Thus Herodotus reacted to Egypt's markets in the fifth century BCE, in contrast to the practice in Greece, where only men did the buying and selling and the women sat at home at the weaving stool. On the male weavers, Herodotus was mistaken. It is true, however, that the market-women in ancient Egypt were independent traders. In the markets in the delta today a large part of the trade in vegetables and fruit is carried on by peasant women. And, as in pharaonic times, women balance baskets on their heads.

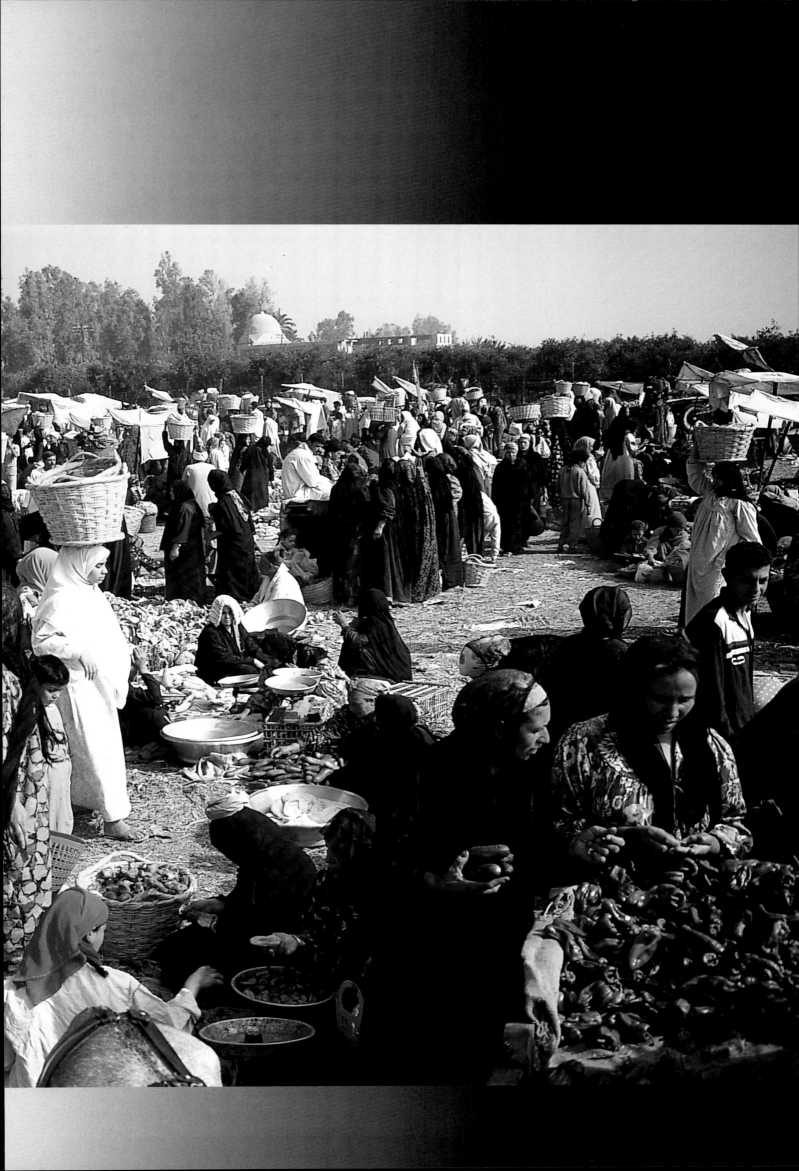

The Nile Delta — the Fertile Land

"The part of Egypt north of the Moeris lake (in the Fayyum) was once a swamp … this land has emerged recently, a gift of the river." So wrote Herodotus, the fifth-century bce Greek traveler sometimes called the father of history, who recognized that the delta, like virtually all fertile land in Egypt, is a gift of the Nile. About 30 million years ago, in the mid-Tertiary Period, the ancient Nile poured into a rift, where the eastern part of Egypt had shifted away slightly from the rest of the land mass. Over millions of years, the ancient river gouged a gigantic canyon—in places up to 2,500 meters deep—into the bed-rock. At the end of the Miocene era (between 23 and 5 million years ago), the bed of the Mediterranean Sea rose and dried up. The delta of today was a bay which filled up when the Mediterranean again became a sea in the Pliocene era (between 5 and 2 million years ago). Here, year after year, the Nile deposited its black Ethiopian silt and thus the delta grew slowly into the Mediterranean. This went on until 1964, when the Aswan High Dam was built. In Herodotus's time the Nile split into five branches, to which he added two canals to reach the magical number seven. Nowadays there are just the Damietta and the Rosetta branches.

(Rosetta, or Rashid in Arabic, is where the famous stone with its bilingual inscription was found which made it possible for J. F. Champollion to decipher hieroglyphic writing in 1822.)

The fertile land may be a gift of the Nile but its cultivation was the work of the ancient Egyptians who, at the same time, founded the oldest high culture on earth. Thick papyrus swamps, full of crocodiles, hippopotamuses, water birds, mosquitoes, and other pests, had to be cleared, canalized, and embanked to make the land workable. The distribution of water and the creation of water rights led to a highly organized administration, which became the foundation of Egyptian culture. Barely four percent of Egypt's land is fertile, and two-thirds of this lies in the delta, which was the economic center of Egypt from early times. Already in pharaonic times, all the usable land was cultivated.

The scarcity of usable land explains the scarcity of uncultivated areas with original flora and fauna in the Nile valley and the delta. An exception is the lake region in the north of the delta, which is a vital migration area for European waterbirds and an El Dorado for duck hunters.

Considering the importance of the delta, the traveler might wonder why there are no monuments here. Once, temples and cities rose in this part of Egypt which may have dwarfed even the gigantic temples in Luxor and Karnak. But the archeologist runs into great difficulties in the delta. The old sites lie buried under Nile mud, have sunk into the ground water, have been built upon, demolished, robbed, or used as quarries — in short, they have been utterly destroyed.

The dense population of the delta, the lack of building material and the reuse of ancient mud-bricks walls as fertilizer, together with the high groundwater level, are the principal reasons for this. Nowadays, the delta is characterized by rapidly-growing cities, increasing industrialization, wide roads with chaotic traffic,

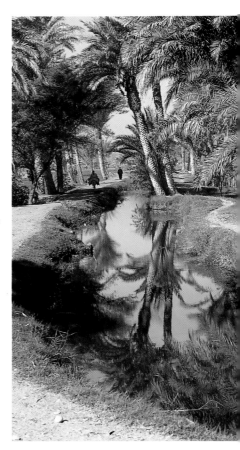

and vanishing agricultural land. The Aswan High Dam contributes to this situation. Since there is no longer any mud in the water, the Mediterranean takes back through erosion what the Nile once deposited on Egypt's northern shore.

The Fayyum — Egypt's Garden

The ancient Egyptian pa-yom ('the sea'), from which the Arabs derived al-Fayyum, is a remarkable depression in Egypt's Western desert. Once (not quite accurately) called the largest oasis in the world, the Fayyum was a favorite hunting ground for pharaohs of the Old Kingdom, and boasted the first regulated reservoir in the world. Today it is a rich source of pharaonic, Greco-Roman, Coptic, and Islamic monuments, but it is also of great interest to paleontologists and archeologists of prehistory. Gebel al-Qatrani, which forms the northern boundary of the Fayyum depression, contains numerous fossil layers from several eras.

In the Oligocene era, about 35 to 30 million years ago, the areas which are now dry were subtropical or tropical river and coastal landscapes, with rich forest flora and fauna. Many early apes also lived here. The *oligopithecus*, for example, stands between the narrow-nosed old-world monkeys from Africa and Asia and the broad-nosed new-world monkeys from America. Another monkey, *aegyptopithecus*—a common ancestor of the apes and man—has been found in the Fayyum. In addition, the remains of predecessors of elephants and rhinoceroses have been found.

Much later, when the landscape dried out, a huge lake was left in the Fayyum depression, which has entered history as Lake Moeris; its much-reduced remnant is the Lake Qarun of today. On the banks of Lake Moeris, traces of Old Stone Age homes have been found, while Neolithic tools are, to the distress of the archeologists, the much-prized souvenirs of tourists.

The attractions of the swampy land around Lake Moeris were obvious: there were numerous waterbirds and animals of all kinds, in addition to a thriving population of crocodiles. There were so many crocodiles in the Fayyum that the region's capital became the place of worship for Sobek, the god with the crocodile head. The Greeks called the city Crocodilopolis.

The Fayyum as an agricultural area came into being only under the pharaohs of the Middle Kingdom and afterwards, particularly the Ptolemies, who built canals, dams, and locks, lowered the water level, and reclaimed land. The great significance of the Fayyum for the pharaohs is also attested by two brick pyramids from the Middle Kingdom at al-Lahun and Hawara. To the Hawara pyramid of Amenemhet III belongs the famous temple labyrinth of which, unfortunately, hardly anything is left.

The regulated water flow of the Bahr Yusuf ('Joseph's Canal') entering the depression means that the Fayyum is not a true oasis, but is in fact also dependent on the Nile. Nevertheless, this green spot has the characteristics of an oasis by virtue of its geographical position, almost completely surrounded by desert, as well as in the character of its people.

In order to be able to grow the many varieties of agricultural products, it is necessary to irrigate the soil. In contrast to the rest of the country, canal irrigation dominates in the Fayyum: the natural slope in the depression makes this possible. Characteristic of the Fayyum are the great, gravity-driven waterwheels which irrigate this, the 'garden of Egypt.'

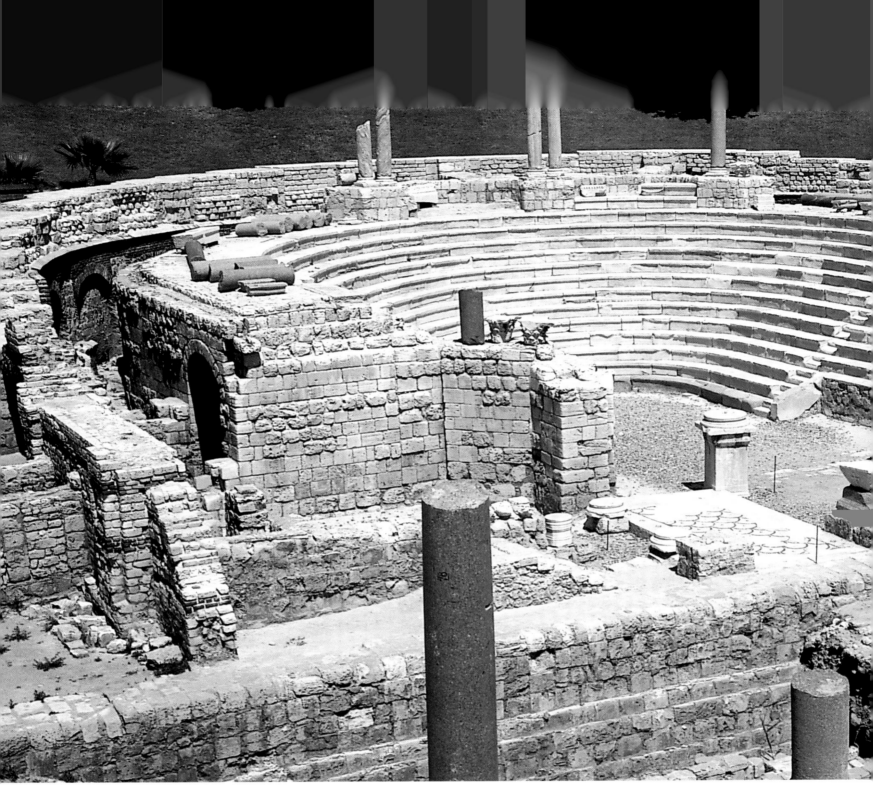

Alexandria

Where do the ruins of the legendary white marble palace of Cleopatra lie? Where is Alexander the Great's grave with its precious sarcophagus, supposedly made of gold? Again and again researchers and divers try in vain to discover these secrets of classical antiquity. The water level of the Mediterranean is now about four meters higher than it was a thousand years ago; many ancient sites have been built over and so it is not easy to find traces. It was by pure chance that, at the end of the 1960s, while workers were demolishing an old Turkish fort in the center of Alexandria, Roman remains were discovered. Three levels of

a centuries-old Muslim cemetery had to be removed. The meticulous work of the archeologists was rewarded in 1964 with the excavation of a small Roman theater which probably dates from the second century CE (*above left*). So far, this is the only discovery of its kind in Egypt and, at the same time, the oldest remaining secular structure in Alexandria. The white marble of the thirteen rows of seating was brought from Europe; the columns are of Aswan granite and green marble from Asia Minor. Up to eight

hundred spectators could sit in the roofed theater, which was probably mostly used for musical performances. It remained in use until the seventh century.

As excavations continue, remains of workshops and shops have been discovered, as well as houses, a school house, and Roman statues (*above right*). All this, however, constitutes a fragment of what was once a focal point of Greek and Roman antiquity. Remains from the earlier, Ptolemaic period are even scarcer. The founder of the city was Alexander the Great, in whose honor the city is named. According to Homer's Odyssey the great conqueror took the

long route to Persia, following in the steps of Menelaus. In 332 BCE, on the southern shore of the Mediterranean, he found in a ruined prehistoric harbor ideal conditions for building a capital and port city. There was not only a protected natural harbor but also a water route to the Red Sea, which went first via the western branch of the Nile (East of modern Alexandria), then joined a pharaonic canal.

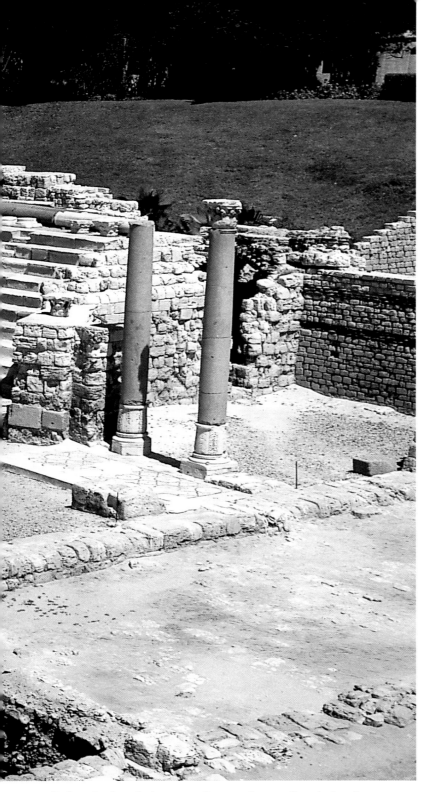

Before the foundation stone for this Greek city was laid, however, Alexander was already pressing on with his expedition of conquest. After Alexander's untimely death, Ptolemy I Soter, one of his finest generals, was granted the Egyptian colony and built the city, which became the most important economic center in the Mediterranean.

Under the Ptolemies, Alexandria became the Egyptian capital, superseding Memphis, and remained so until the Arab occupation in 642 CE. Early in the Ptolemaic era, Alexandria became the cultural and spiritual metropolis of the Greek diaspora. The Museion academy with its attached observatory was a beacon for scholars from throughout the civilized world; the library contained altogether 900,000 precious manuscripts. The most significant writers and teachers of antiquity were here—Euclid, originator of geometry, Eratosthenes, who in 276 BCE made an amazingly accurate calculation of the circumference of the earth, the physicist Archimedes, to name a few. With the death of Cleopatra the Great (51–30 BCE) the Ptolemaic empire and the last Egyptian dynasty ended, but her name, linked to that of Julius Caesar,

Mark Anthony, and Octavian (Augustus), has not only entered history but also inspired the world's literature.

In Roman and Byzantine times, Alexandria was the world's center for philosophy and theology. For over nine hundred years, from 279 BCE, the famous lighthouse, the Pharos, shone out across the harbor. One of the Seven Wonders of the World, it rose to 150 meters, and boasted an ingenious lighting system of mirrors which reflected the sun during the day and torches at night. Over the centuries, earthquakes took their toll and finally toppled the tower in the fourteenth century. The debris was used to construct a fort for the Mamluk sultan Qaytbay in 1480.

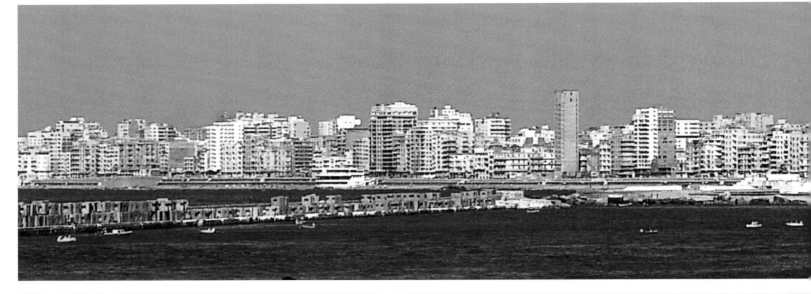

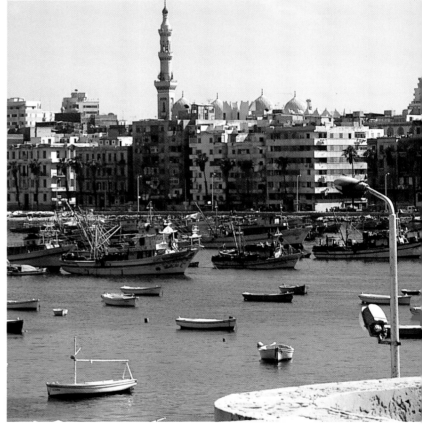

Al-Iskandariya

Al-Iskandariya, the Arabic name for Alexandria, always brings to mind summer by the Mediterranean, when, during the long school holidays, everybody who can afford it flees the heat of Cairo. Meanwhile, hotels, private chalets, and apartments stretch ever further from the once-posh bathing center of Agami, westward along the edge of the turquoise water as far as Marsa Matruh, almost at the Libyan border.

Along the 25-kilometer corniche of Alexandria, many families enjoy bathing at beaches with names like San Stefano, Miami, and Cleopatra. Iskandariya was—until the first half of this century—the 'Pearl of the Mediterranean.'

Alexandrians were proud of their city with its magnificent villas and European facades. The top photograph shows the city's incomparable corniche.

By the beginning of the nineteenth century, the population of al-Iskandariya had shrunk to five thousand citizens. But then Muhammad 'Ali restored it to new splendor and made it the biggest port city in Egypt. At the same time, he opened it to Western influence.

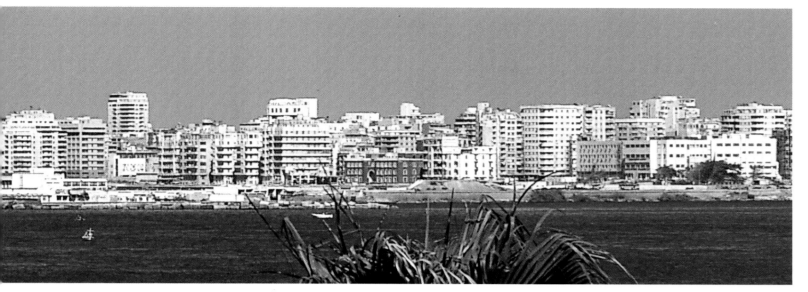

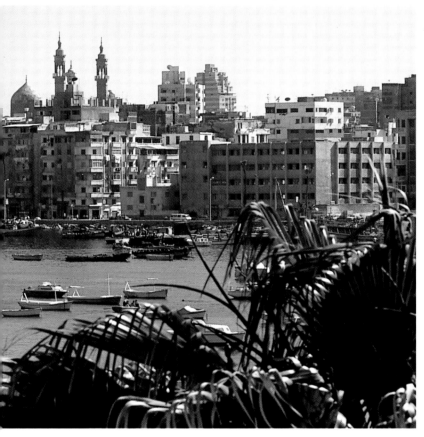

In 1867, Mark Twain observed: "In a certain way it recalls Paris by night." And in 1881, Crown Prince Rudolf of Austria-Hungary missed the oriental flavor: "With its stereotypical buildings of the West, at every step you recognize the intruder." Even today one has to look for the authentically

Egyptian. Were it not for the minarets sticking out of its skyline, one could imagine oneself in a European Mediterranean city (*below center*). Al-Iskandariya–still a magic word for lovers of antiques, which filled the magnificent Alexandrian villas until the sequestration campaigns of 1952. The well-known 'Attarin quarter has many second-hand

dealers, their shops stuffed with furniture in the Egyptian empire style, antique silver, and fine glass, but also kitsch of every kind. And

in the lamp-seller's alley (*right*) one may still come across some rare pieces from the city's heyday.

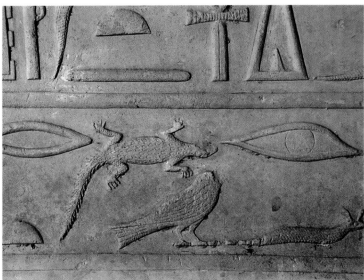

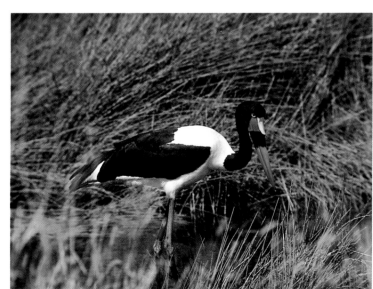

Five Thousand Years of Biology
There is probably no country in the world besides Egypt in which biologists can look so far and so precisely back into recorded history. This is because ancient Egyptians integrated nature in many ways into their religion and their lives. At the same time, they were often precise observers, representing life forms in a scientifically accurate manner, so today we can easily determine the animals and plants depicted on the temple and tomb walls or on papyri.

In many scenes of desert life (for example in the tomb of Ptah Hotep, *above left*) the desert hedgehog *paraechinus* is depicted. Two varieties are extant in modern Egypt. More common today is the smaller big-eared hedgehog, *hemiechinus auritus,* from the delta (*above right*), which apparently arrived later from Asia Minor.

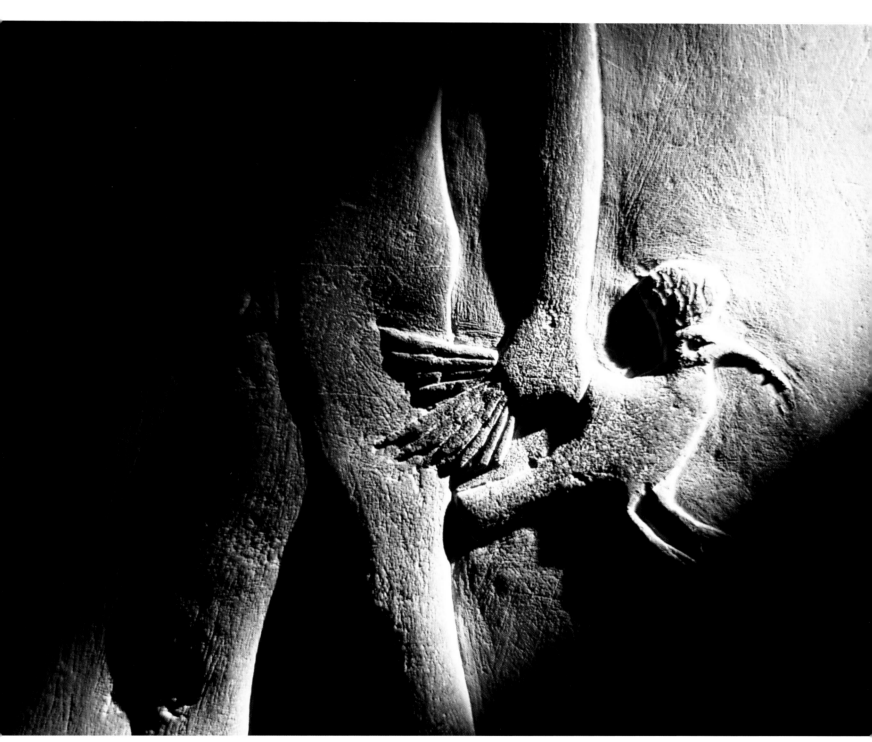

One should not, however, be misled by the detailed depictions of the ancient Egyptians into false conclusions about which species existed here in antiquity.

Artists seem to have incorporated into their repertoires life forms which seemed interesting for their appearance or habits. We know very little, for example, about the reptiles—except for crocodiles and snakes—since reptiles were depicted in an undifferentiated, lizard-like style. It is thus

unusual to find, in the white chapel of Sesostris I, a clearly-drawn dabb lizard (*center left*), a plant-eating reptile, three varieties of which still occur in Egypt. The splendid *uromastix ocellata* (*center right*) is from Sinai. This hoopoe, from the magnificent tomb of Ptah Hotep (*above*) still occurs in Egypt

today, as do the breed of pelicans shown here in the tomb of Mereruka (*opposite, bottom left*). On the other hand, the beautiful saddle-bill stork *ephippiorhynchos senegalensis* (seen *opposite bottom right* in Tanzania), probably retreated south from Egypt by the third millennium BCE.

Tanis – Zoan – Sann al-Hagar

If one has seen Karnak one cannot believe the Egyptologists when they maintain that the whole of Karnak, with all its splendor, would fade beside the splendor of the monuments of the delta if they were still to be found.
[Brunner-Traut, Ägypten]

Tanis, called Zoan in the fourth book of Moses and nowadays known as Sann al-Hagar, has been the most productive of all ancient sites of the delta. In the delta, however, the archeologist encounters many problems. As at the edges of the Nile valley, tomb robbers have emptied the tombs, later builders have abused temples as quarries, or monuments have been destroyed or have fallen down in earthquakes. In the densely-populated delta, however, many structures were demolished to make space for new ones, while other antique buildings sank into the mud as the ground level rose.

In the delta, archaeologists must dig deep. The mud bricks of ancient structures were used as compost–the so-called *sibakh* soil–which contains up to 12 percent ammonium, nitrates, and potash.

Fortunately, the bare mound of ruins at Tanis rises above a stepped landscape at the northeastern edge of the delta and has survived.

Tanis had a long history. The hill, originally rising out of a swamp, was inhabited from very early times. But its great moment came only after the end of the New Kingdom. The pharaohs of the Third Intermediate Period, powerful only in Lower Egypt, developed the city as their capital as they carved out a political and economic empire in the Levant. The cities of their predecessors (such as the Ramesside capital, Piramesse) were plundered, and in Tanis a promiscuous mixture of building parts from the Old, Middle, and New kingdoms jostled exotically together. Everything had to be built on a massive scale. French Egyptologists found on a huge rubble field (*left*) the remains of the largest colossal statue ever known in Egypt. One eye alone was forty-two centimeters broad, and the big toe measured sixty centimeters. But of all this magnificence hardly anything remains upright, and some of the huge faces of sculptures are well on their way to becoming raw stone blocks again (*right*). The French excavators were lucky. The tomb monument to Pharaoh Psusennes I was not only undamaged but contained five graves as well as golden jewels almost the equal of those of Tutankhamun. Bringing the monuments to Tanis in the end did not stop their wandering–many pieces are now scattered all over the world in various museums and private collections.

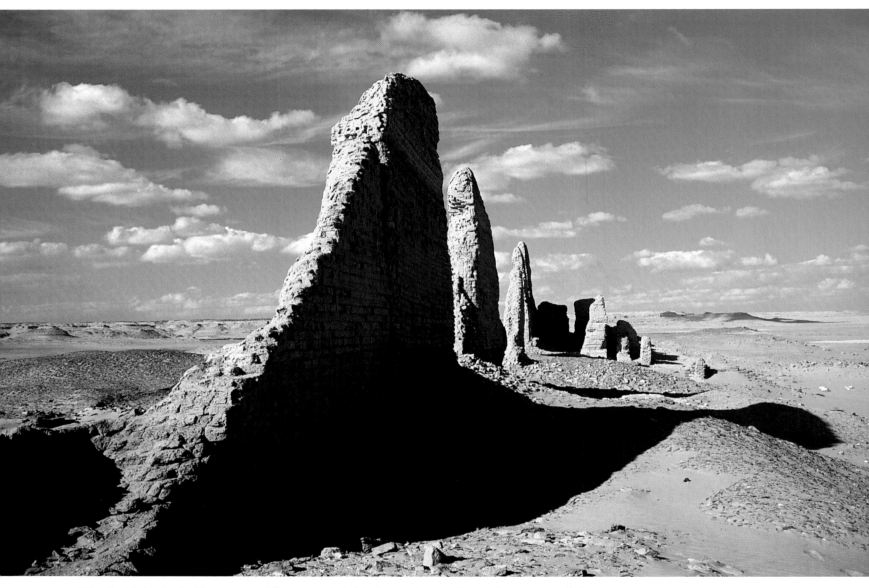

Dimai – Ruins in the Desert

Between Lake Qarun and the escarpment of Gebel Qatrani strange 'shark's teeth' stick out of the wasteland (*top*). On closer inspection these jagged points turn out to be ruins of impressive brick walls. They are the remains of the Greco-Roman city of Dimai.

The nearest inhabited area, the Fayyum, can barely be seen far to the south. Lake Qarun, at the edge of the Fayyum, is all that is left of the ancient Lake Moeris, which once reached the gates of Dimai and which watered the surrounding area.

There were times when the water level was several meters higher, as can be seen at the Middle Kingdom temple on the edge of Gebel Qatrani, Qasr al-Sagha. Dimai marked the beginning of the caravan route to the western oases of the Libyan desert and had a Ptolemaic temple devoted to the crocodile god Soknopaios (Sobek to the ancient Egyptians) and a procession path with recumbent lion-headed sphinxes.

But as the water receded southward, Dimai became uninhabitable and fell into ruin. Remarkably, the white mudbrick walls have withstood erosion for over two thousand years.

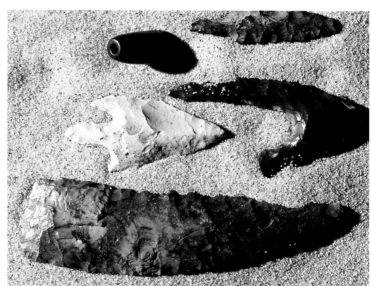

The Desert – a History Book

The desert is a catalog of the history of nature and humankind. Pages from this book open unexpectedly for the desert wanderer. Fossilized sea-urchin shells, mussels, and corals show that the desert at Siwa (*above left*), was once underwater. These shark teeth found at the edge of the Fayyum were embedded in an Eocene layer and are therefore about 35 million years old (*above right*). At Bahariya, what seems to be a mirage: the desert is littered with the branches and trunks of fallen trees. But this is no illusion: the wood is petrified and ancient. Geologists believe these trees must have grown further south and been uprooted by wild storms, then carried here on the flood, where they came to rest in a shallow lake. After this lake dried out, they petrified and now bear witness to the natural history of 28 million years ago.

Flintstone arrow heads and stone beads of the Neolithic age (*below right*) furnish proof of human activities in areas which are nowadays uninhabitable. They come from an era when the Sahara was wet enough for men and animals to live there.

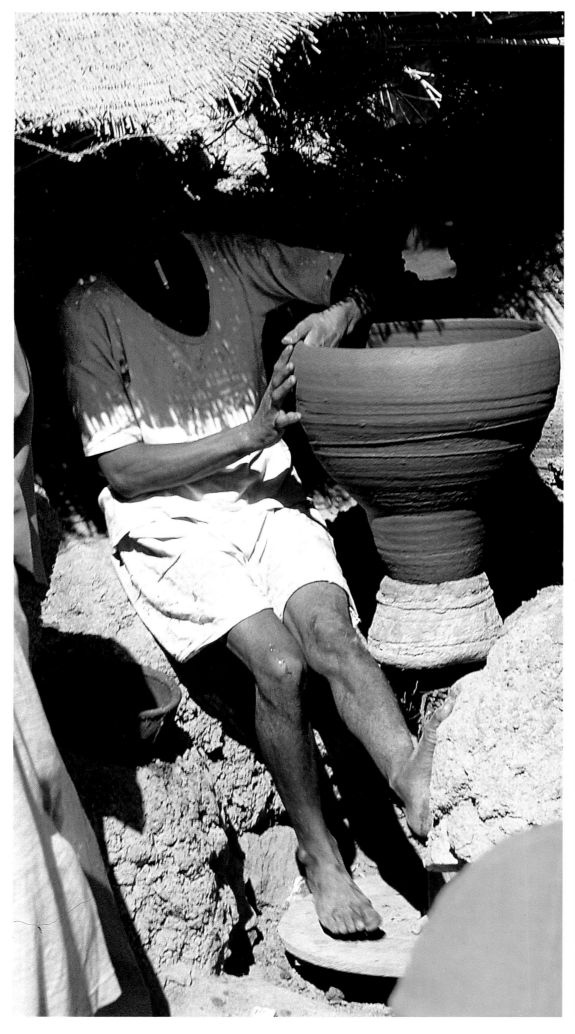

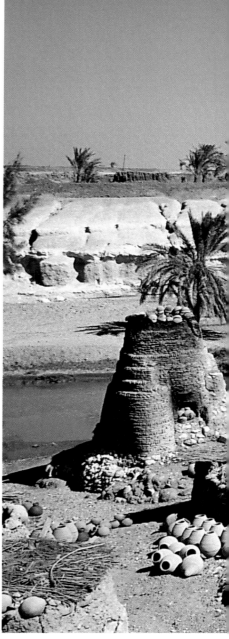

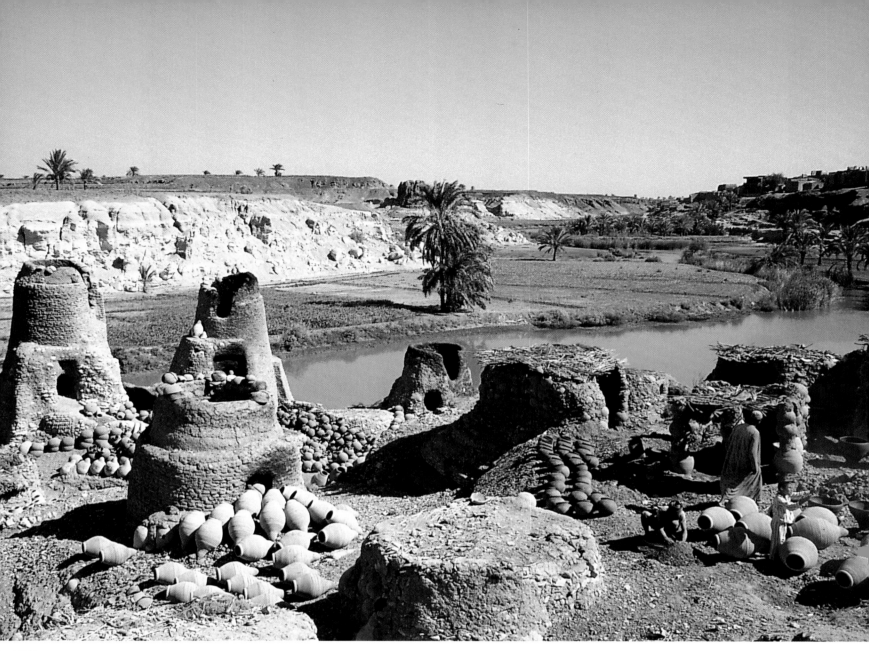

The Potters of Nazla

The Bahr Yusuf, which today forks off the Nile north of Asyut, waters the entire Fayyum. This waterway also provides a livelihood for the potters of Nazla. Their settlement is built above the broad river depression of Masraf al-Wadi. The whole area is filled with a sweet fermented smell when chopped straw, which is mixed in with the mud to add body, swells with water. On the wooden potter's wheel, a large water vessel takes shape under trained fingers (*opposite page*) just as its ancestors have done at this spot for millennia. Here they are mostly traditional, unglazed water vessels: the big amphora-like *zir* pots and the rounded *bukla* with their little handles (*above*), which are typical of the Fayyum oasis. After the formed pots have dried thoroughly in the sun, they are stacked in tower-like kilns which are sealed with mud. The firing takes several days. Since the heat is not particularly high, the resulting pot is not very hard.

Neither is the vessel watertight: the chopped straw in the mud leaves fine pores which allow a small amount of water to percolate and evaporate, thus keeping the water inside cool. In the streets of Egypt's towns and cities in summer, cool water may be found in such vessels, even though the day may be scorching hot. The *zir* pots at the famous old waterwheels on the Sinnuris canal in the Fayyum (*left*) are cooled further by the spray thrown up by the wheels.

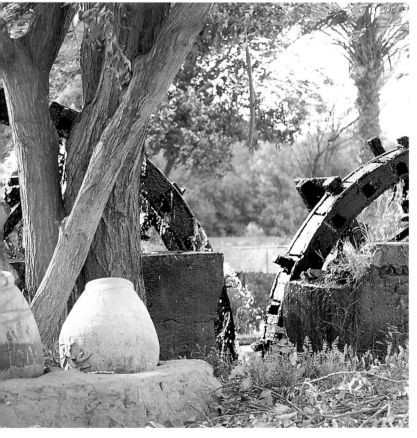

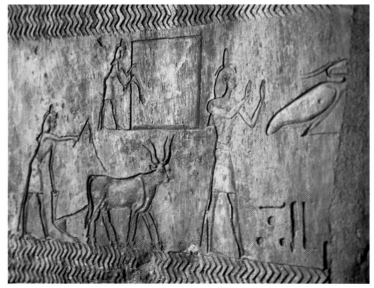

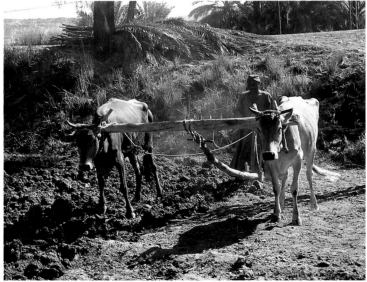

The Fayyum — Granary of Egypt
The view over the ripe grain-fields of the Fayyum brings to mind the legendary granary of Egypt from the story of Joseph in the book of Genesis (*above left*). The ancient Egyptians cultivated two kinds of wheat and several kinds of barley on the Nile flood plain. During the Roman period, Egypt became the granary of Rome, and Alexandria was the biggest grain market in the known world. At the beginning of the modern era, Muhammad 'Ali introduced new strains of wheat, and also promoted the cultivation of cotton.

For five thousand years, agriculture has been the basis of life in the Egyptian economy— and in some cases farming methods remain the same. The sharp-angled plow (*opposite page bottom left*, from the tomb of Osorkon II in Tanis) is used today (*opposite page bottom right*) just as in antiquity.
Many ancient, labor-intensive irrigation techniques remain in use. The fields are flooded and dammed for forty days (*above right*). Afterward, the *fellah* sows seed into the wet mud and then awaits harvest time without any additional irrigation. The cattle egret helps the farmer by ridding the fields of mice and insects. Here, in a scene typical of the

Egyptian countryside, a *fellah* wades through an irrigated field followed by white egrets.
While the delta had always been the agricultural mainstay of Egypt, the Fayyum became agricultural land only under the pharaohs of the twelfth dynasty, particularly under Amenemhet III with the regulation of the influx of the

Bahr Yusuf. Because of its favorable climate, the Fayyum rapidly grew into the second most important agricultural center, a position it retains to this day.

The Western or Libyan Desert

The Sahara–*bahr bila ma'*, the sea without water, is also known in Arabic as *al-safra'*–the yellow one. For many Muslims, the desert is God's garden, "out of which the All-Gracious One has removed every disturbance, a place where one may live in peace and contemplate." For the ancient Egyptians of the Nile, the Western Desert was the empire of the dead, an area hostile to life whence rapacious tribes attacked the fellahin of the Nile. Criminals fled and still flee there, striking fear into the hearts of the valley dwellers. For Coptic monks, the desert was not only a hiding place from persecution but a place that afforded them the opportunity for undisturbed meditation– a practice that has been maintained from earliest Christian times.

The attentive desert traveler passes through a history book of nature and of human society. In the middle of the endless emptiness lie the enchanting oases: Bahariya, set among hills; Farafra, with its dreamlike palm gardens; Dakhla, sheltering the medieval city of al-Qasr; Kharga, with its ancient ruins; Dush, the smallest oasis, nestling between sickle-shaped dunes; and Siwa, the remote pearl in the west whose magic drew Alexander the Great. All are tiny green patches of life in a vast and hostile landscape.

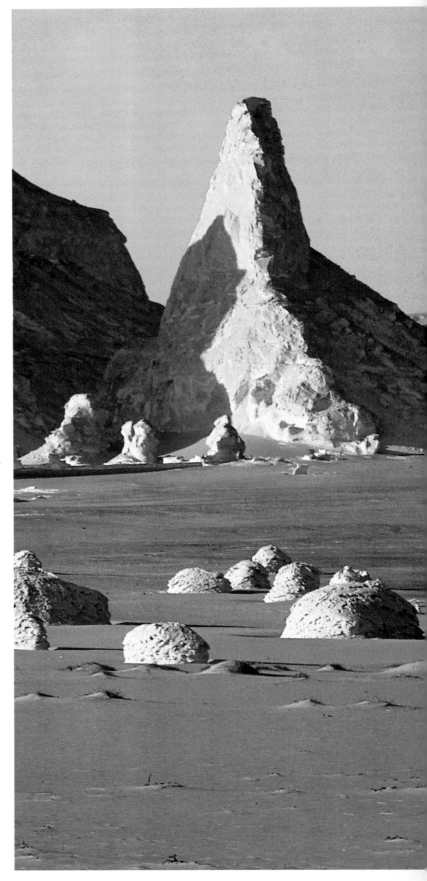

The White Desert is a dramatic display of erosion. Heat, cold, wind, and water are slowly shifting a whole layer of Eocene chalk north-eastwards and, in the process, have formed sometimes breathtaking chalk sculptures. A tour on a mild winter day in absolute calm through this bizarre landscape seems like a walk in a different world and is a unique experience.

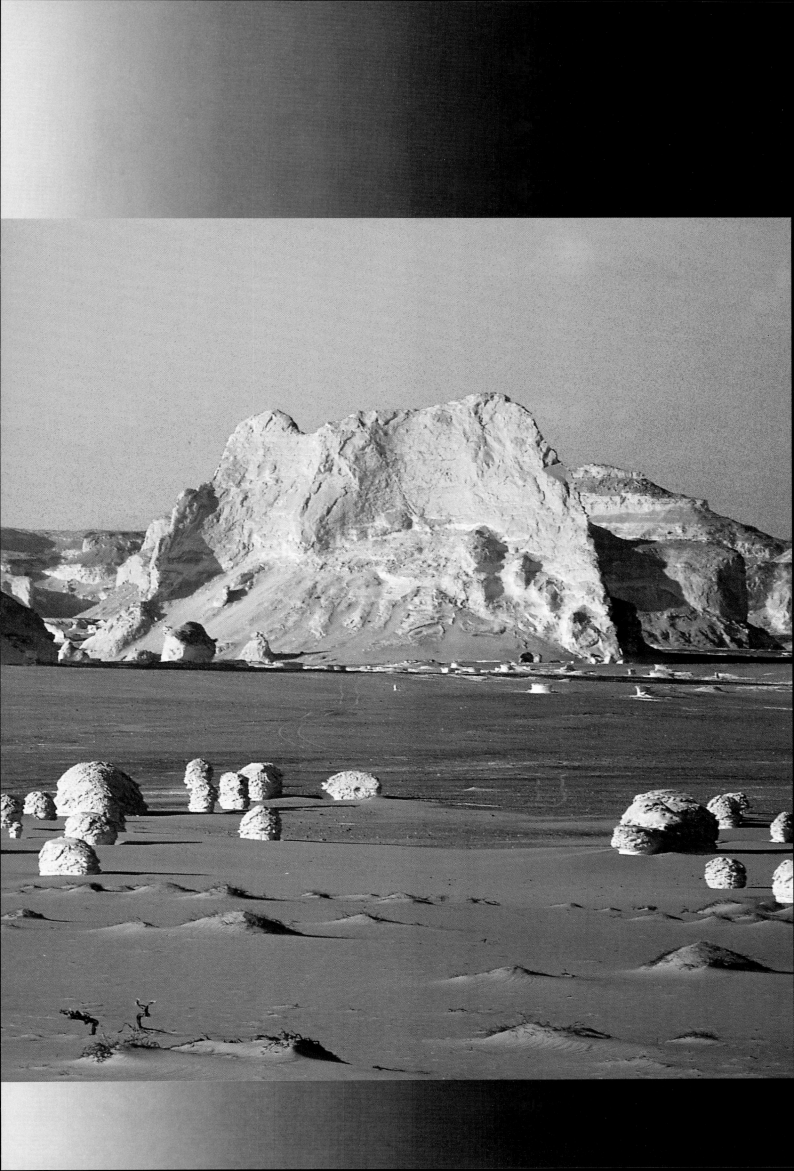

The Egyptian Sahara

The Sahara, at the eastern edge of which lies Egypt's Libyan Desert, is the greatest tropical desert in the world. On the African continent between the Tropic of Cancer, which passes through the south of Egypt, and the Tropic of Capricorn, a climate dominates that is marked by hot daytime temperatures and strong cooling at night. The northern part of this area is extremely dry. Egypt, with a daily average of eleven hours of sunshine, is one of the sunniest countries in the world. This leads not only to extremely high temperatures but also to a paradox: although the country receives more heat from

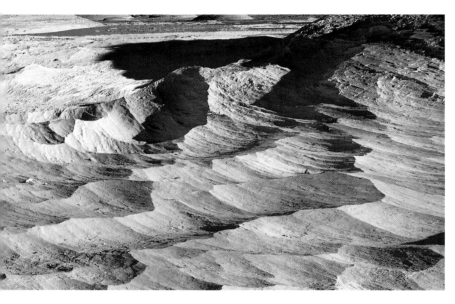

the sun than the western Sahara, it has lower average annual temperatures. The reason is the strong radiation of ground heat at night, promoted by the unusually clear, dry air. In summer, temperatures in the Western Desert can be hot. At Aswan temperatures above 50° C have been reported. In winter, however, it can be bitterly cold before sunrise, and frost on car windows is not unusual.

Ecologically more significant is the ground temperature, which can easily reach 60° at midday in summer—heat that no insect can survive unharmed. Just 10 cm below the surface of the sand, however, the temperature will be only 35°; the strategy of every desert beetle and other animals, therefore, is to dig in.

Equally remarkable is the fact that just a few centimeters above ground level the temperature drops to 55°, and at the height of the head of a human adult, the air temperature is only 40°. This strong temperature gradient is responsible for mirages in the desert.

In the northern Sahara the average rainfall is 100mm, and in the central Sahara it is less than 20mm, but in the area of Dakhla Oasis in Egypt's Western Desert, only 0.3 mm has been recorded in recent years. Rain here is such a rare phenomenon that many inhabitants maintain it never actually occurs. Nevertheless, although the Egyptian Sahara is in general extremely dry, prolonged periods of rain are possible. In 1874, the desert researcher Gerhard Rohlfs was surprised by rain lasting two days in the middle of the desert between the oases of Dakhla and Siwa—and he named this particular stretch of land the Rain Field.

Stone and sand characterize every desert. But beyond the dreary plains of gravel or dust, rise steep and lonely mountains, or the land may be cut by a deep depression. Bizarre rock formations occur in the middle of a vast emptiness, or canyon-like wadis with breathtaking rock-falls: all are geological formations with a tale to tell of the formation of our planet.

In its present shape, the Western or Libyan Desert is still relatively young. At only 100 million years old, the Nubian sandstones of the Cretaceous period that cover vast areas in the south are among the oldest formations. Truly ancient stone, from the Precambrian era, is found only in the extreme south and southwest. The granite of Aswan is a famed if very small outcrop, from which,

for example, the obelisks of Queen Hatshepsut were chiseled.

A huge plain at the center of the Libyan Desert is covered with calcium carbonate from the Eocene period, about 50 million years ago, from which the older chalk rocks of the White Desert project. Petrified marine animals such as sea urchins, mussels, and oysters show that this area once was covered by a shallow sea. Some plains are strewn with nummulites—the calcium shells of amoeba-like foraminifers. A few sandstone deposits remain from the Oligocene period, containing the occasional piece of petrified wood. Further north, the geological formations grow more recent. Toward the great Qattara Depression, Eocene formations blend into Miocene chalk deposits, which are finally covered by Plio-pleistocene layers, formed two million years ago. In the Nile valley these take the form of the black, fertile Nile mud; in the desert sterile sand.

For a detailed description of the desert we can usefully employ some of the terms that the Bedouin use to distinguish between some twenty different types of landscape, which often represent ecologically significant environments. The most important of these are:

Serir is the often extremely monotonous gravel desert. Gravel and pebble plains form the bulk of the Sahara. They are often completely free of any vegetation, which only adds to the sense of loneliness of the desert.

Hamada describes the rock desert in which chalk or sandstone plateaus may fall in spectacular cliffs at the edge of depressions, common in the Western Desert. In cracks and depressions, plants often root, since scarce water gathers here. A characteristic plant in this type of desert is the caper bush, which, under favorable conditions, produces beautiful white flowers.

In flat, low-lying areas, mud can gather after rare but heavy rainfall. The Bedouin call these mud-flats *balata*; often a wide variety of plants grow here, even acacia trees.

Of especial ecological significance are *wadis*, the dry valleys that gouge themselves into rock plains or mountains. They range from barely noticeable grooves to deep gorges with steep walls and the dried-out courses of waterfalls difficult to climb. Often these waterways developed many thousands of years ago, when the climate of the Sahara was much moister. The rubble carried away by strong floods—anything from huge boulders to fine sand—forms all kinds of layers in which a wide range of plants can take root, particularly as underground water is common here. Accordingly, one finds in this environment more than elsewhere signs of a very varied animal life.

A nightmare for every desert traveler is the *nafash*, the powder desert. Chalk or gypsum have eroded to such a fine powder that vehicles as well as travelers on camel and on foot can be swallowed whole.

Our common notion of what a desert looks like is described by *raml*, the sandy desert. Although it does not make up most of the Sahara, sand occasionally forms into gigantic plains stretching from one horizon to the other: on the journey from Farafra to Dakhla, *raml* is visible from the road—certainly meriting the description *bahr bila ma'*.

Like islands of life, the few oases are strewn among the expanses of desert. The ancient Egyptian word *uahat* became 'oasis' in Greek. *Uahat* originally meant a hollow or basin, and describes the geological situation of most of the oases quite well: they are steep-walled depressions that taper out toward the south in the stepped landscape of the desert. When ground water is close to the surface in these depressions, the leaves of luxuriant palm groves are mirrored in the precious water.

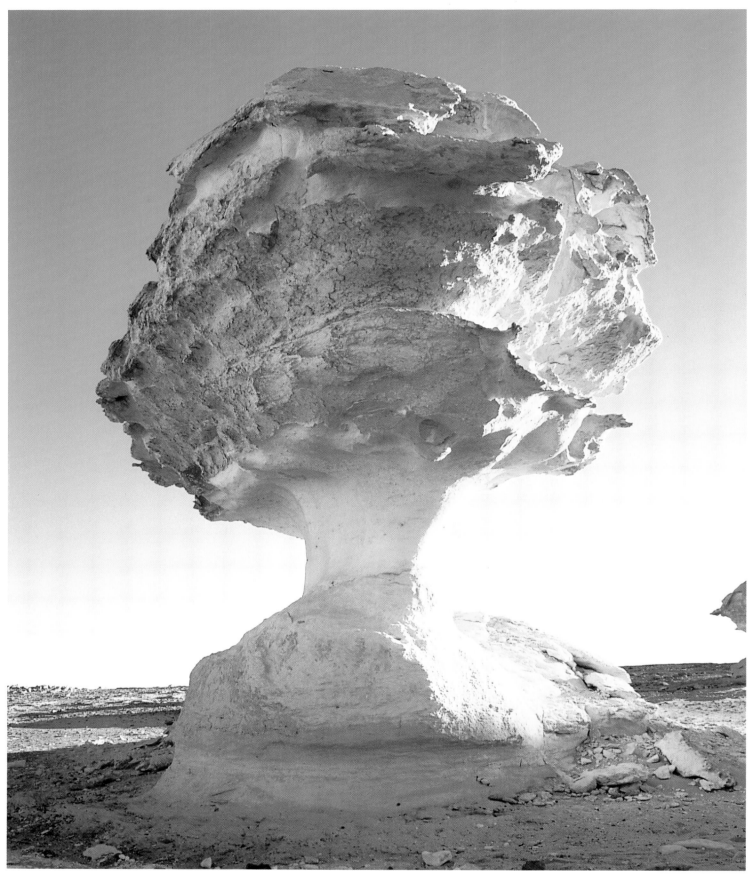

The White Desert and the Sea of Sand
The White Desert with its numerous 'mushroom caps' (*above*) is possibly the most beautiful place in the whole of the Sahara. The forces of wind and sand are responsible for shaping the manifold chalk sculptures. The sandblast effect is strongest near the ground, so the stems of these chalk mushrooms become thinner and thinner until finally the heads collapse. Sand and wind also create these formations in the great sea of sand in the Sahara (*right*).

Following pages:
This surreal image was made possible when an oil company drilled in the White Desert for oil and found water. Unhindered, the precious liquid gushed between the chalk rocks and formed a shallow lake. When the water source was capped, the lake soon evaporated and the plain became carpeted with plants. A year later, however, the desert returned to its former state: a hot, dry wasteland.

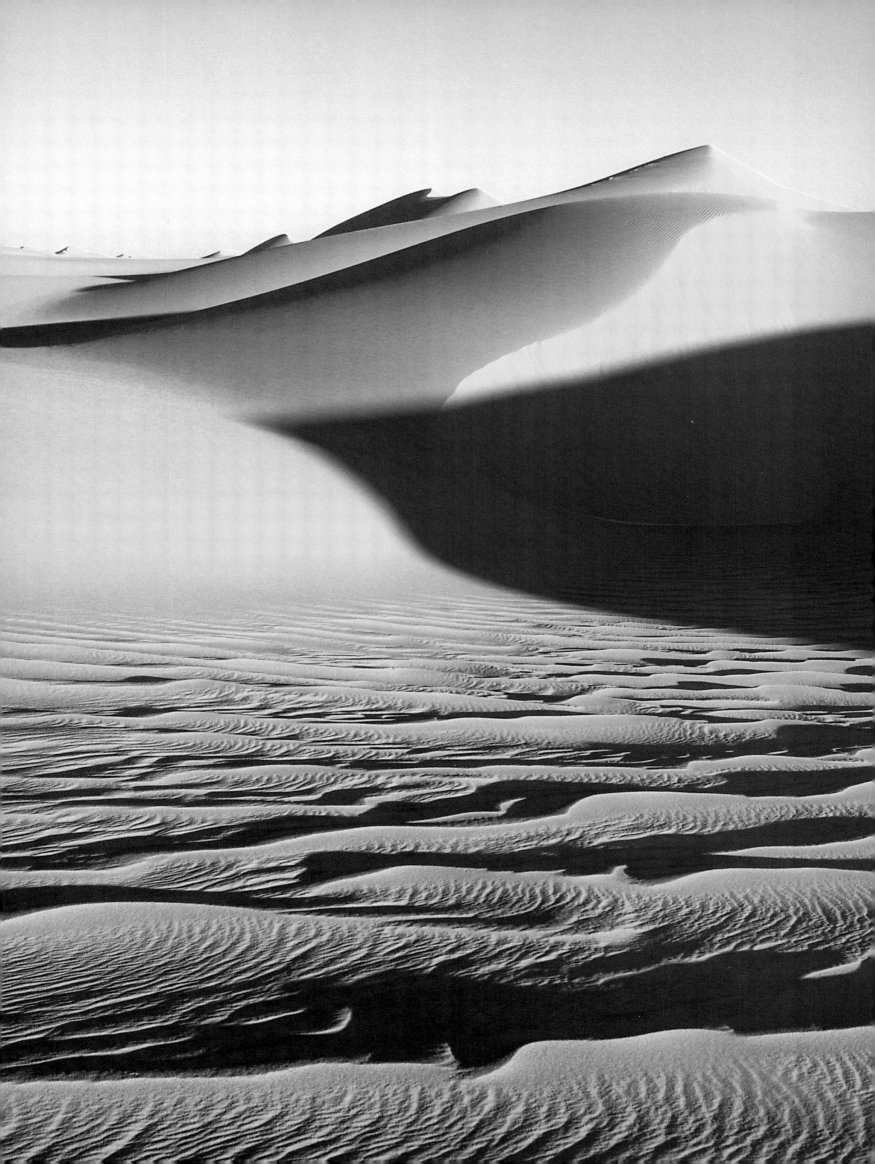

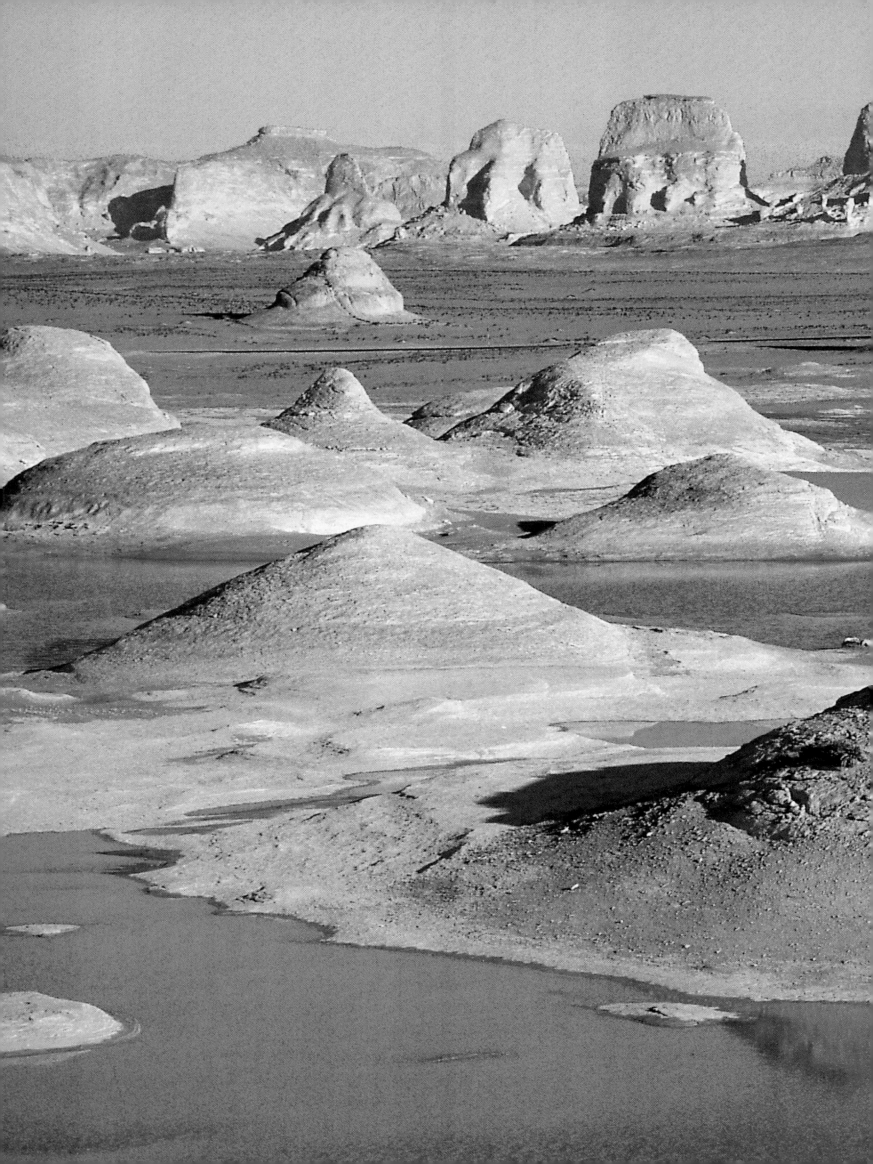

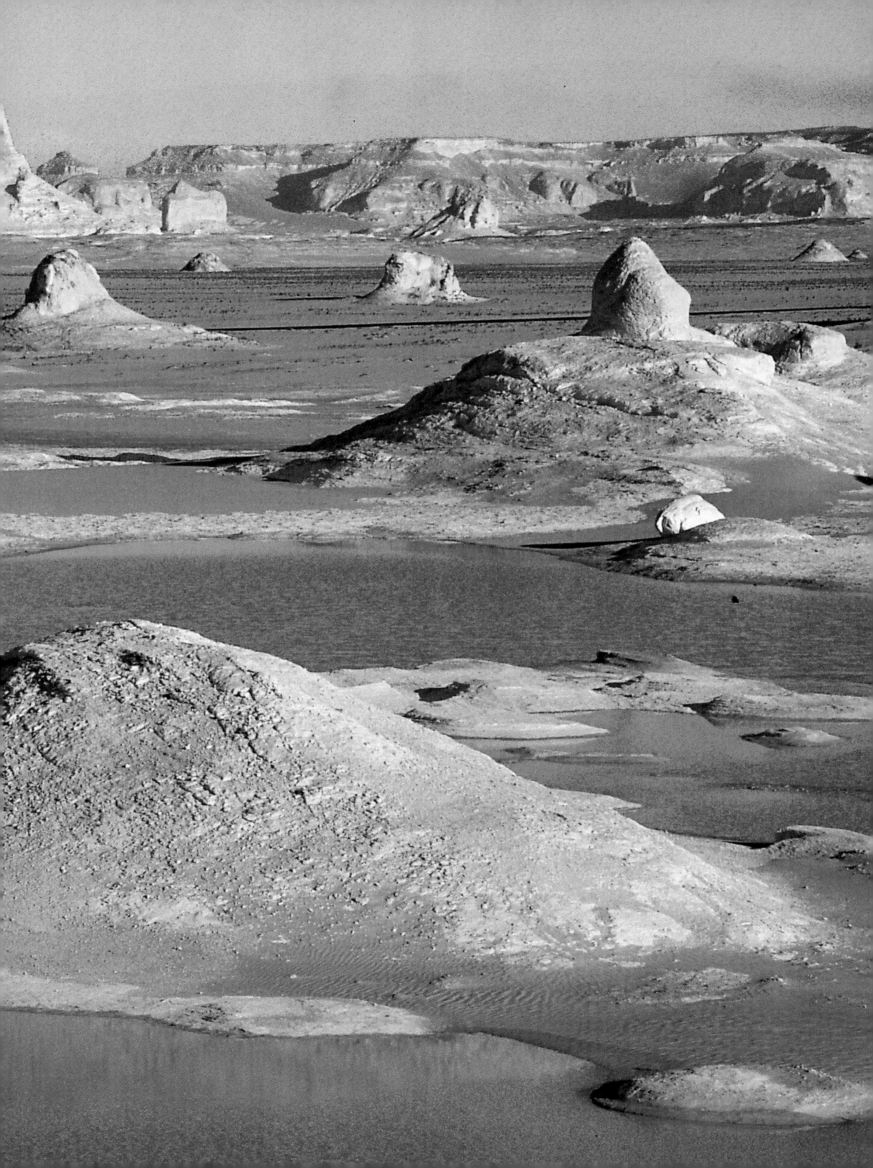

Curiosities of the Desert

The Sahara has many strange children.

The Black Stars of the White Desert developed over eons (*left, below right*). They began their crystalline existence as iron sulfide, which was later dissolved by iron oxide at high temperatures. Today we find crystals of hematite in a form previously unknown to geologists.

Desert roses (*left, bottom left*) are clusters of barite (a sulfate of the heavy metal barium) which sometimes occur in sandstone. The lighter-colored desert roses are formed from gypsum.

The 'melon field' (*above left*), between Kharga Oasis and Asyut, was formed at a time when this area was covered by an ocean. Silicates grew around small crystalline cores millions of years ago. The plump "oak-leaves" (*left, center*) south of Farafra are also common in this landscape.

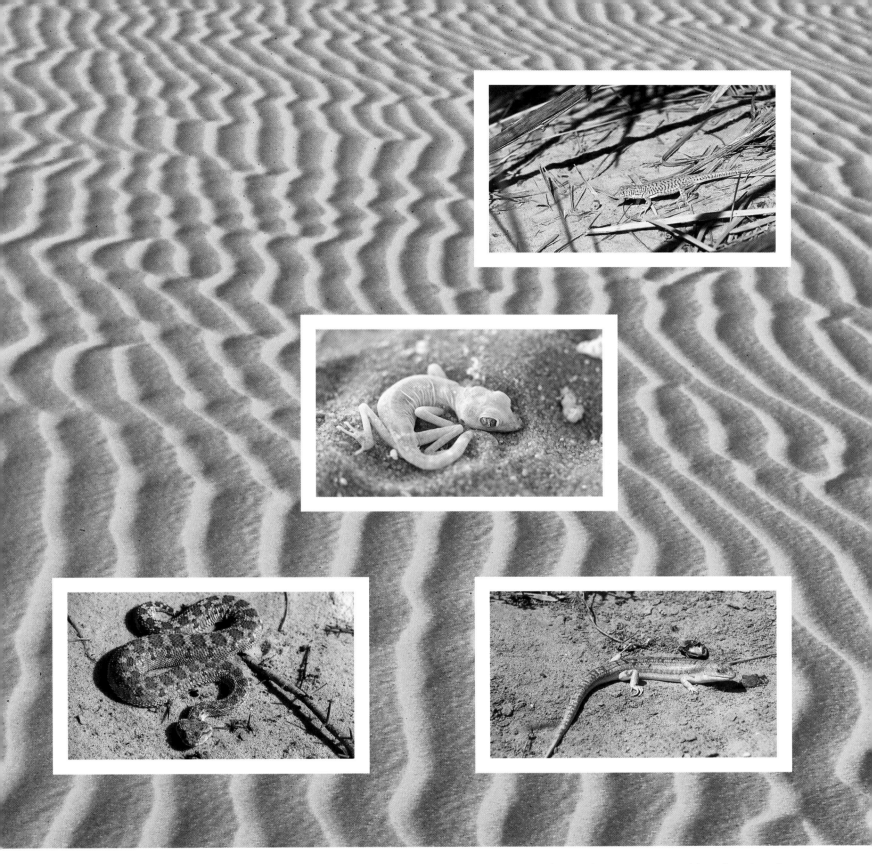

Life in the Desert

Egypt's Western Desert is one of the driest areas of the Sahara. Here, even an experienced desert biologist has difficulty finding traces of life.

Under a stone, this tiny, three-centimeter-long gecko of the genus *Tropiocolotes* (*center*) is hiding from the strong sun. Its light skin reflects the sun, protecting the animal from overheating.

Lizards are one of the commonest desert reptiles. This dotted nidua lizard *Acanthodactylus scutellatus* (*above right*) attacks a small scorpion. In a life-and-death struggle, the lizard repeatedly snaps at the head of the scorpion, always careful to avoid the sting of its enemy. Finally the scorpion lies unconscious on the ground. Carefully the lizard moves over the scorpion, from the head, bites off the tail with its potentially fatal sting and then devours its prey.

This beautifully-colored spotted skink *Eumeces schneiderii* (*bottom right*) is not a true desert dweller. It prefers the edges of oases and cultivated land. To escape a tight corner, this lizard has been known to leap into irrigation canals.

Encounters with snakes, though very rare in the desert, can be dangerous. This flat, S-shaped trace in the sand, repeated at short intervals, ends in small whirl of sand. With the aid of a stick we brought this magnificent example of a horned viper into the daylight from its lair.

Water in the Desert
Water and the desert do not seem to go together. If desert travelers see water they must first suspect a mirage (*center, top*). Close to oases, however, there are sometimes quite extensive lakes, so called *sebkhas*. In depressions like this in the oasis of Siwa (*center,* *bottom*) the salty and mineral-rich water drains from irrigated gardens. When the water of the *sebkhas* evaporates, the salts crystallize (*top and bottom left*). Salty though it may be, such a stretch of water attracts life; even flamingos may be found in Siwa (*top center*).

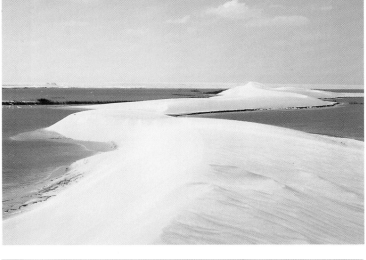

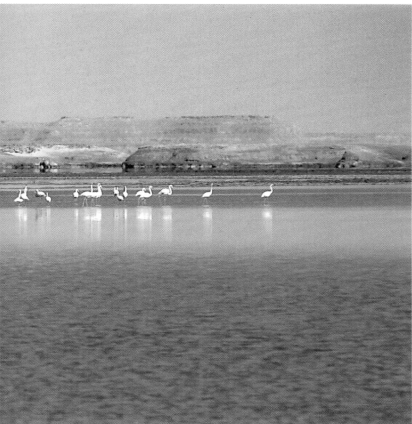

The extensive lake in the sandy desert of Wadi al-Rayyan (*above right*) is artificial. Here, a new irrigation project in the Fayyum has channeled water into a depression which had been dry and hostile to life until recently. In the desert, vegetation flourishes rapidly as soon as a supply of water is available, as the two photographs (*top* and *center right*) illustrate. The photograph in the middle was taken one year after the first at the same spot. The edge is hemmed extensively with reeds. The new Rayyan lakes, which are rich in fish, also offer food and living space for birds.

The tiny oasis of 'Ain al-Wadi (*below right*) was a halt on the old desert route from Farafra to Cairo. It is fed by an artesian well. Ruins and rubble beside the oasis hill may well be Roman. Tools from Neolithic times have also been discovered here.

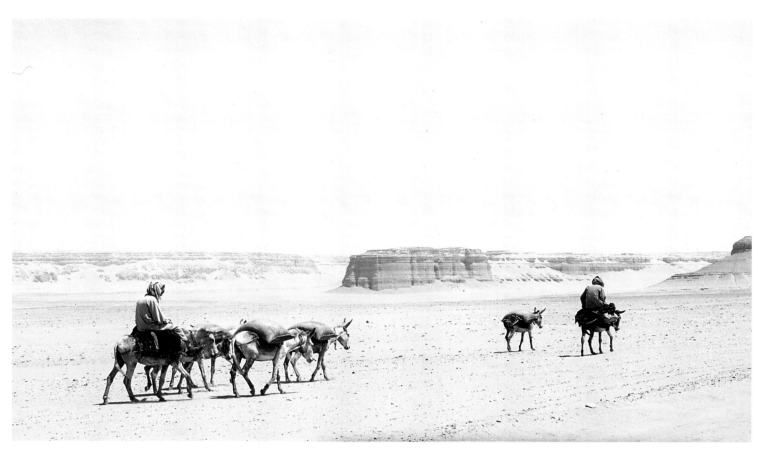

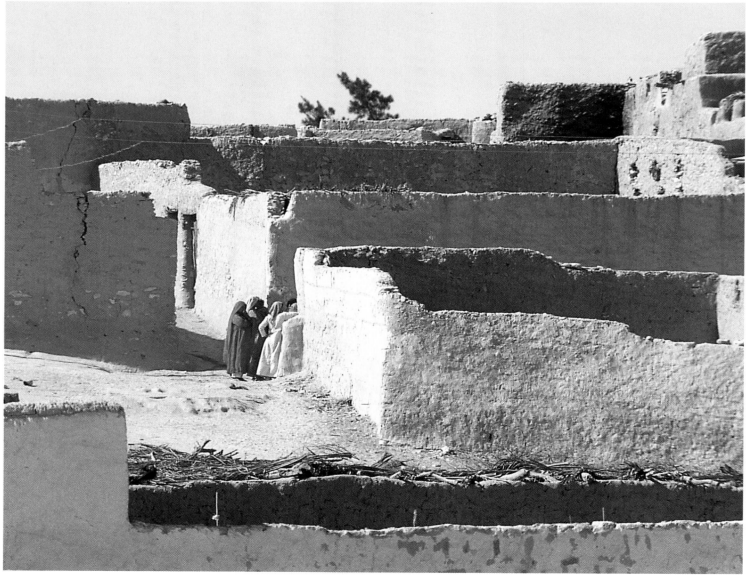

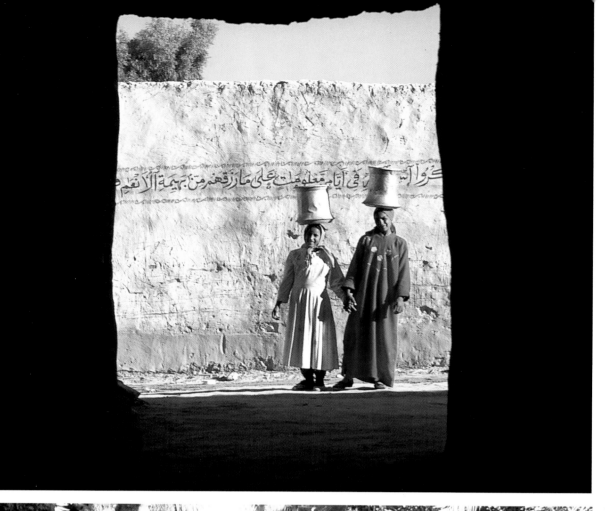

The Oasis – Paradise in the Desert

Our ideas of paradise were formed in the Middle East. It is hardly surprising that people who crossed the hot and drab desert (*opposite page, top*) felt themselves in paradise when the lush green of an oasis appeared before them.

Gardens where rivers run, in which the water does not spoil, and streams of milk which never sours and streams of wine, delicious for those who drink it … And in it they will have fruit of all kinds …
 – A description of paradise from the Qur'an.

In fact, Farafra and the other oases were renowned for their wine cultivation during pharaonic times, but all traces of that have vanished.
Because the scarce soil needs to be used for cultivation, the inhabitants of Farafra have always built their houses in the desert (*opposite, bottom*). The decoration of house walls follows an old custom. As in former times, women take water out of the wells which feed the oasis (*top left*).

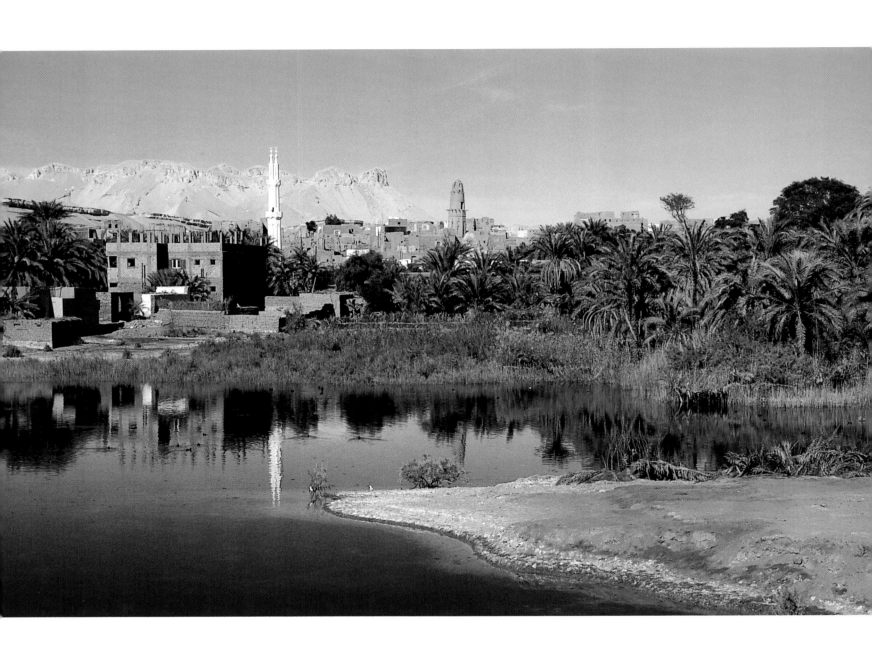

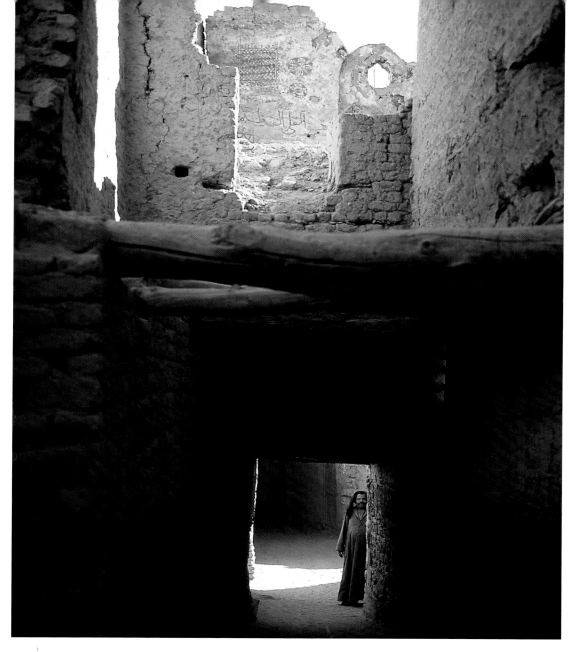

Al-Qasr in the Oasis of Dakhla
Like the other oases of the
Western Desert the village of
Dakhla and its associated
hamlets lies in the shadow of a
steep cliff (*opposite page*) The
settlements nestle together in a
depression formed by a
prehistoric river bed. The
picturesque mud-brick town of
al-Qasr (*opposite page* and *above
right*) originated in the Middle
Ages. It stands on top of the
ruins of a Roman settlement. By
pharaonic times, an oasis city
had developed here of which,
however, there is little evidence
today. A principal feature of the
partially-destroyed medieval
center is the Nasr al-Din mosque
from the Ayyubid period. Its
typical minaret is recognizable to
the right of the white tower. Al-
Qasr is also known for its
beautifully-carved old door
lintels (*bottom right*), which
usually mention the proprietor
and the year the house was built.
Many of these have been
restored over the last few years.
These photographs (*above right*)
capture something of the charm
of the narrow, crooked streets of
al-Qasr.

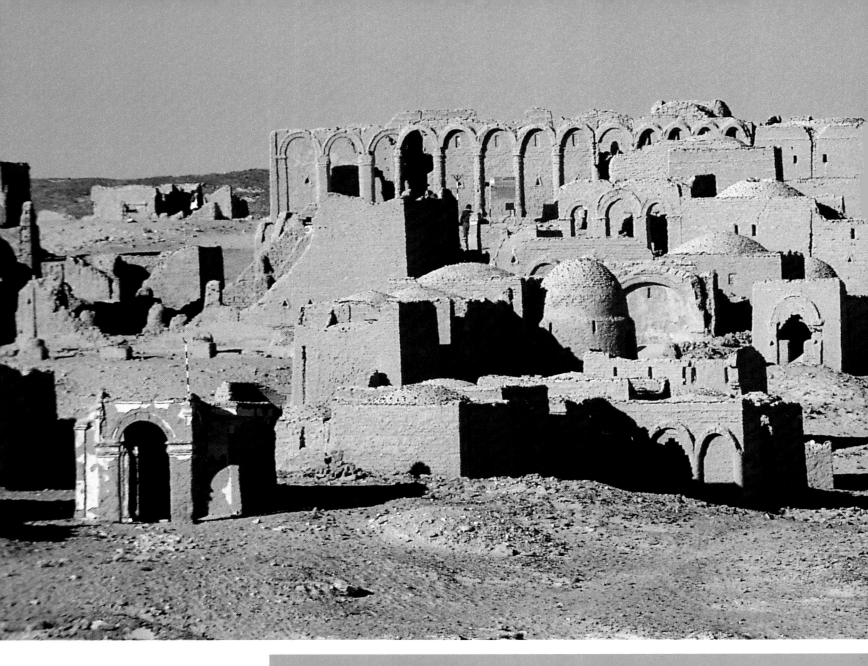

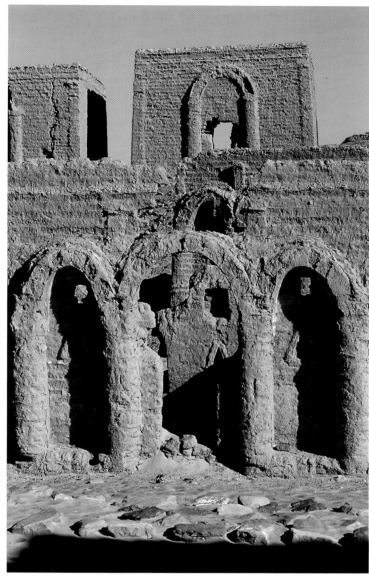

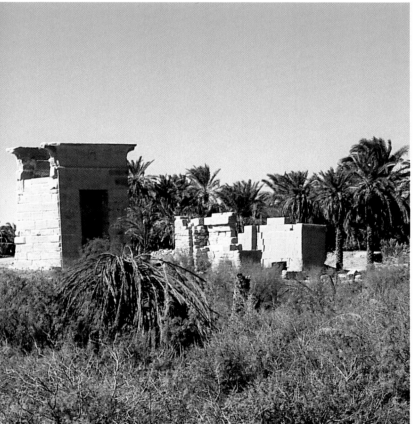

Persians, Romans, and Christians in Kharga

Today, Kharga is the center of the ambitious New Valley agricultural project. But it, too, has a long and eventful history. The oasis was an important trading post at the crossroads of two significant caravan routes: the *darb al-arba'in* from Sudan and the *darb al-ghabari*, which crossed it from east to west. Like the other oases, it has also been, since pharaonic times, a place of banishment for criminals and political or religious undesirables, starting with the practice of banishment of Christians by the rulers of Egypt and neighboring countries. Among those Christians sent into exile were important personalities such as Athanasius of Alexandria and Nestorius, patriarch of Constantinople.

The temple of Hibis (*below left*) is the most important and best-preserved temple structure in the oases. It is dedicated to the god Amun-Re and was built in Persian times. Some other important structures from this period are also preserved.

The necropolis of Bagawat (*above* and *above left*) is one of the first Christian cemeteries. There are numerous funerary chapels, decorated with frescoes, which are surprisingly well-preserved. They are perhaps the most important legacy of the Christian period (from 323–642 CE) in Kharga.

The ruins of the monastery of Mustafa Kashif, about one kilometer north of al-Bagawat, also date from early Christian times.

The Spell of Siwa

On this January day, Siwa was incomparably beautiful. The sun, rising from the desert, was reflected with the palm groves in the shallow waters of the *sebkha*. Soon the warming rays illuminated the mounds of ruins at Aghurmi in the morning mist (*opposite page*). Aghurmi seemed to hover above the crowns of the palm trees. Expectation was in the air. It would hardly have been surprising if Alexander the Great had stepped again through a dark gate into the temple to consult the famed oracle of Amun. The idea of visiting the oracle of Amun in Siwa occurred to Alexander when he founded the harbor city of Alexandria in

332 BCE. At this time, Siwa already boasted one of the most famous oracles in the ancient world. A veil of secrecy lay over this place of worship; anyone wishing to seek advice had to cross the desert in an arduous journey of many days.

Alexander had cogent reasons not to spare himself this hardship. First, his father Philip II had advised him he should perform a sacrifice to the god Amun and honor him above all other gods. Also Perseus and Herakles, whom Alexander regarded as his forefathers and models, had already been to Siwa. Lastly, the curiosity of a man of action spurred him on to undertake this daring journey. Ancient historians, among them Plutarch and Strabo, described the horrifying dangers and the miraculous survival of Alexander and his troops on the way to the oasis. His travails were immediately rewarded. Upon his arrival in Siwa, Alexander was

greeted by the high priest of Amun as a son of Zeus. The priest predicted that Alexander would be invincible and would rule the entire world. Finally, he would become one of the gods. Nobody, however, has ever learned what Alexander asked the oracle and what the answers were. This secret Alexander the Great took with him to his grave when he died three years later.

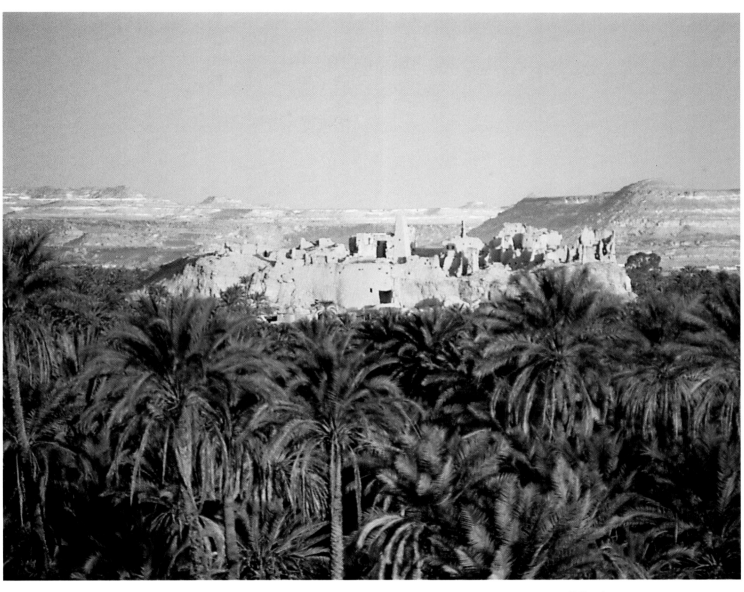

Following pages:
Not a mid-day mirage, but a reflection of desert hills on the calm surface of the lake at Siwa.

Siwa – Land of Palms

The oasis of Siwa probably saw its first inhabitants during the Stone Age. Since the sixth dynasty, the oasis has taken many names. Of these, the pharaonic *se et-am*, meaning 'land of palms,' was perhaps the most appropriate. During Herodotus's and Strabo's time it was called the Oasis of Amun, and in the early Christian period it may have been called Santariah. The name Siwa came with the Arab conquest. The population of Siwa is mainly of Berber origin, but an admixture of black African stock from the times of the slave trade is evident (*bottom opposite page*). Siwa was then situated along one of the most significant slave-trading routes. Later, however, it became almost completely cut off from the rest of the world, an isolation which has left its mark in customs specific to the Siwans.

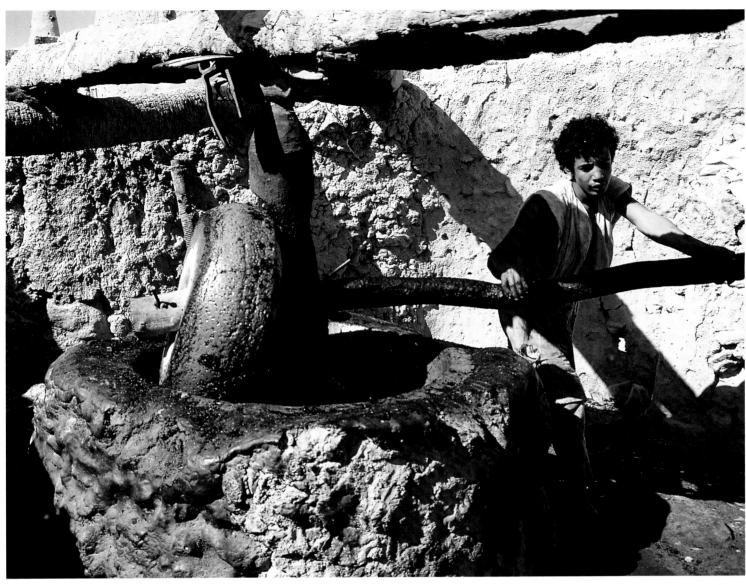

A stranger will rarely meet even a completely-veiled woman on the street in Siwa: they are shielded from the outside world. Unveiled in public, this girl (*above left*) may not enjoy her freedom much longer; already, at the age of ten, a bride-price may have been fixed, and a marriage arranged by her parents.

This olive press (*top right*) is still powered by human hands.

The *salahat* (*bottom left*) is an example of the famous Siwan jewelry. The dangling crescents of this necklace are a decorative feature widespread in North Africa but are not of Egyptian origin.

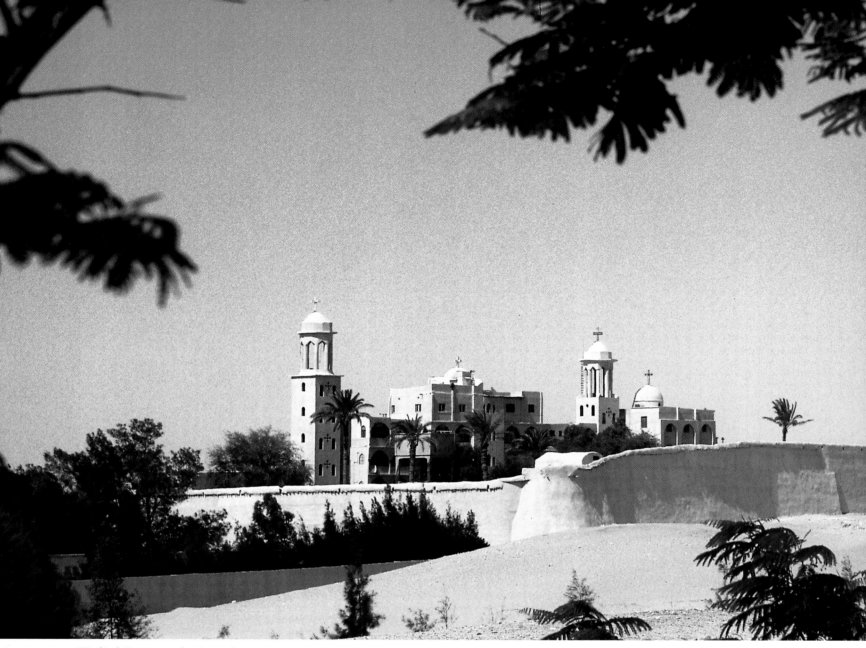

Wadi al-Natrun – the Way of the Monasteries

In the desert depression of Wadi al-Natrun, west of the Alexandria–Cairo desert road, lies a chain of shallow, mineral-rich lakes. From these lakes, the ancient Egyptians extracted natron (hydrated sodium carbonate), which they used to embalm dead bodies. The word 'natron' is of ancient Egyptian origin, as is ammonia, which derives from the god Amun.

In the middle of the fourth century CE, Wadi al-Natrun grew in importance as the call to monasticism spread through Christian Egypt. More and more monks followed St. Antony into the solitude of the desert. At Wadi al-Natrun, their number grew so much that their settlements attracted rapacious Bedouin. When the attacks became insupportable, fortifications were constructed. Monasteries were built for protection around the first defensive towers. The monasteries of Macarius, Baramus, Bishoi, and the Syrian Monastery (*above*) are still there. Despite modern annexes, the monasteries still seem heavily fortified. On feast days, many

Copts from Alexandria and Cairo participate in a mass at Wadi al-Natrun (*above right*). This fresco above the entrance to St. Bishoi's hermitage was discovered in 1991. The remarkably clear picture depicts Mary with the archangel Gabriel, Moses, and the old testament prophets Isaiah, Ezekiel, and Daniel. This fresco, which probably dates from the ninth century, was discovered beneath several layers of overpainting which were painstakingly removed.
In the Syrian Monastery, as in all Coptic monasteries, the number of monks is increasing markedly after centuries of decline and stagnation. The Monastery of St. Bishoi (*below right*) has been

extended several times, as one can see in the old and new church. The Coptic patriarch Shenouda III was exiled here in 1981 by Anwar al-Sadat for some time.

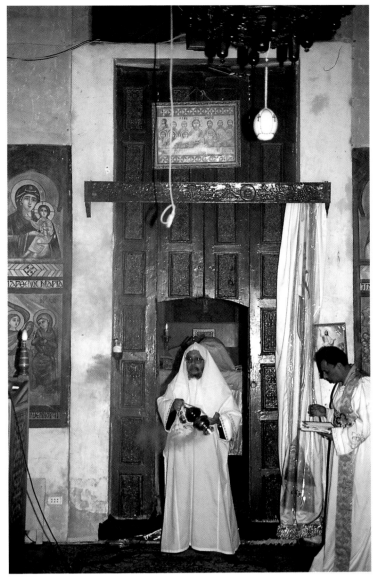

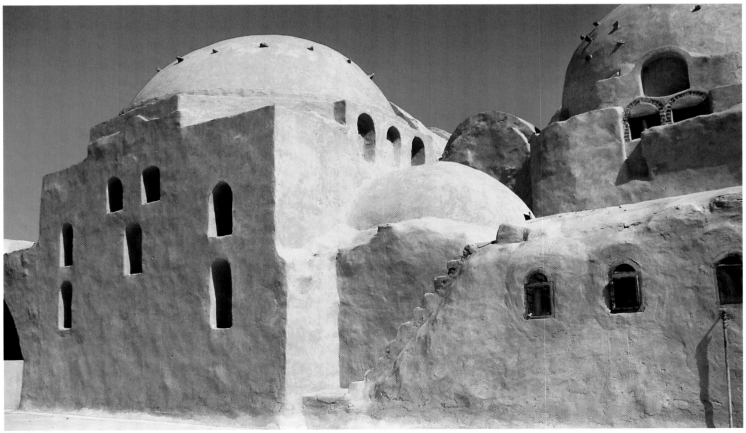

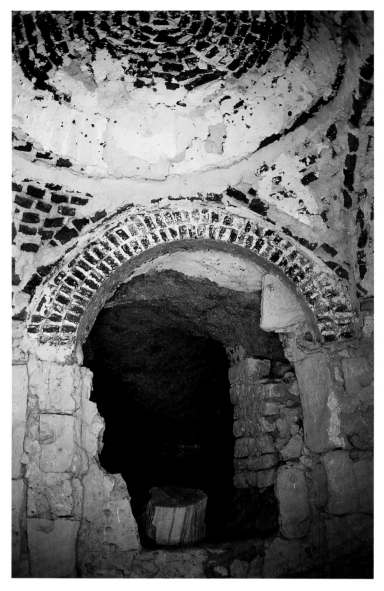

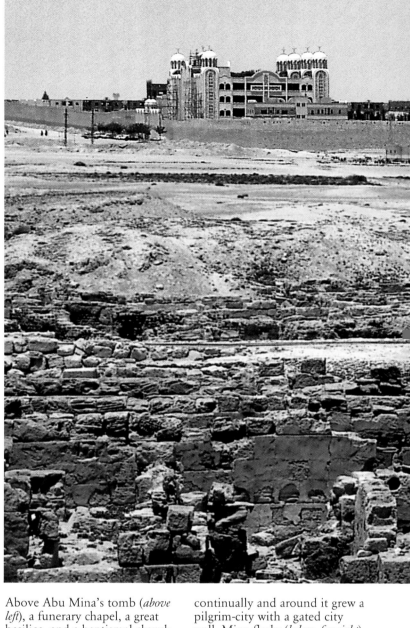

Abu Mina Yesterday and Today
Behind the ruins of the ancient Menas Monastery rises its gigantic concrete twentieth-century descendant (*above right*).

The old monastery incorporated the grave of St. Mina. It became, after the saint's death at the beginning of the fourth century, the most important place of pilgrimage in Egypt until the early Middle Ages. Today, the excavation site is among the five most important places on UNESCO's list of world heritage sites in Egypt, which is certainly not poor in cultural treasures.

Above Abu Mina's tomb (*above left*), a funerary chapel, a great basilica, and a baptismal church were gradually added. The monastery complex expanded continually and around it grew a pilgrim-city with a gated city wall. Mina-flasks (*below, far right*) were popular souvenirs for pilgrims in earlier times. They usually show the praying Abu Mina between two camels. The lion's head at the end of the stone gutter (*below right*) belongs to a wine press.

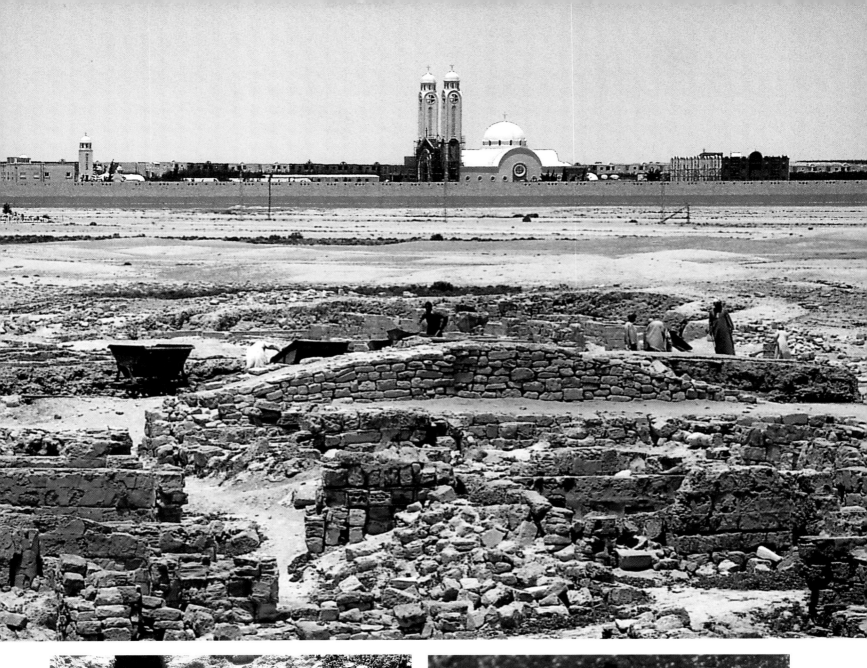

The Eastern Desert

Fireworks over Hurghada? This halt on the Qena trail affords a spectacular view. From atop a granite rock, the fireworks prove to be a powerful monsoon storm far away across the Gulf of Suez off the southern tip of Sinai.

The jagged granite peaks of the Gebel Qataar or the softer outlines of Gebel Abu Dukhan normally reach into an azure sky, undisturbed by the smallest cloud. But the wild, desolate mountain landscape can quickly change its appearance. Suddenly, black clouds appear behind Gebel Abu Dukhan. A little later, in an oppressive, dull light, a gusty wind whips up dust-devils, and in the evening the rugged cliffs are bathed in a deep violet light. The dying rays of the sun fall into a valley like a golden ribbon, while a Bedouin woman passes by with her sheep among caper bushes.

The Qena trail is one of the most beautiful ways of crossing the Eastern Desert from the Red Sea to the Nile valley. Getting stuck in the sand here reminds us of the difficulties of transport on the old Roman road from Myos Hormos to Kaenopolis (Qena). How could the ox carts with their famous royal porphyry from Abu Dukhan possibly have made this journey? But the ruins of wells and castles along the way leave no doubt that, long ago, Roman columns were transported by this route to the Nile.

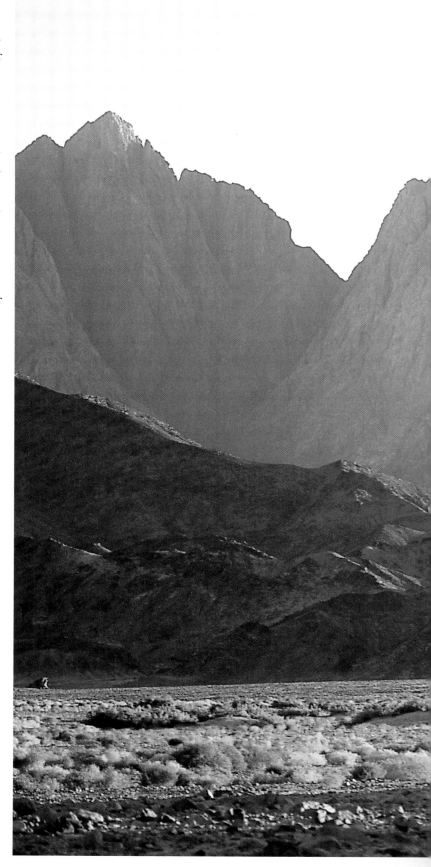

The deeply-cleft granite peaks of the Red Sea mountains are the principal landmark in this difficult rocky desert terrain. They form a dramatic contrast to the endless rubble-plains and dunes of the Western Desert. The totally different character of the Eastern Desert is nowhere more obvious than here at the 2,000-meter Gebel Qataar (*right*), Gebel Abu Dukhan, and Gebel Shayib.

The Red Sea mountain range faces the desert landscape of the southern Sinai peninsula which, on clear days, can be seen across the Gulf of Suez to the East. The Red Sea mountains and the mountains of south Sinai are of common geological origin: they were separated by the East African Rift Valley, of which the Gulf of Suez forms the northern part.

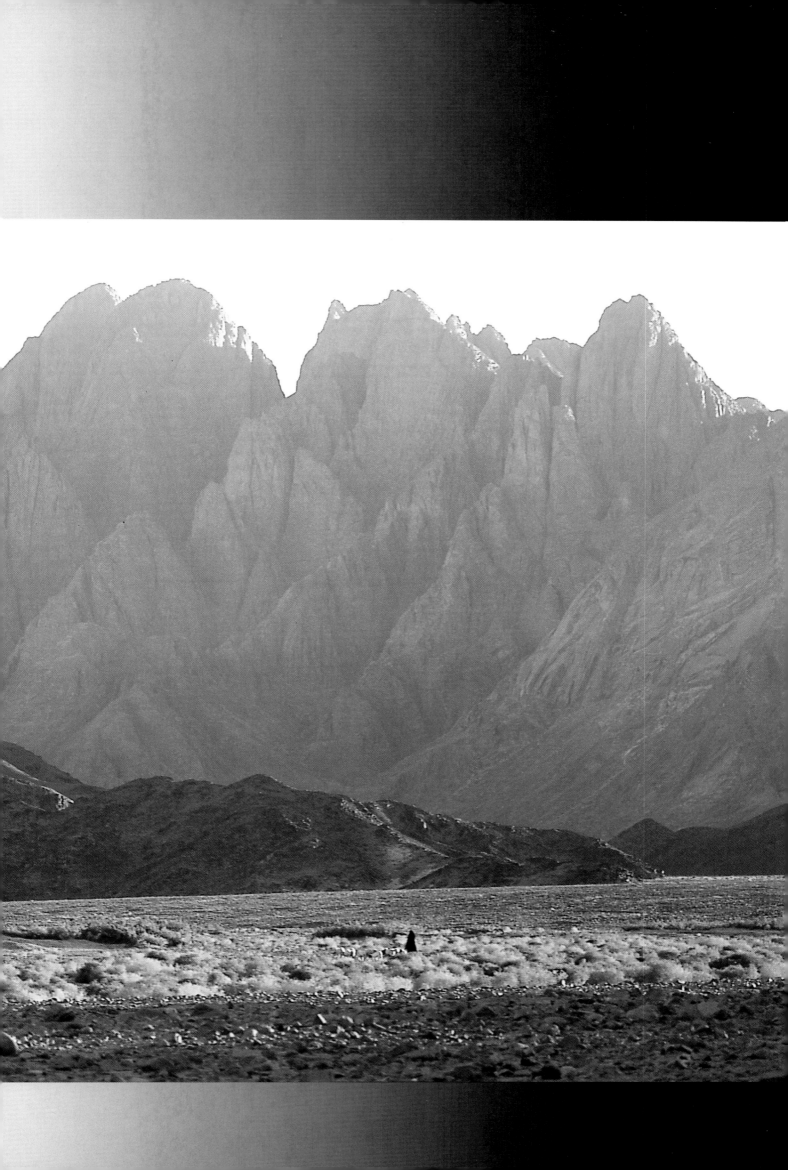

The Columns of Rome from the Egyptian Desert

The Eastern (or Arabian) Desert is a mountainous wasteland and has very different geological features to the Western Desert, giving a totally different impression. Lying between the Nile and the Red Sea, it stretches nine hundred kilometers from north to south and is on average 250 kilometers wide. The heart of the Eastern Desert is a mountain range composed of granite, gneiss, porphyry, diorite, and other crystalline rocks. Up to two thousand meters high in the south, it gradually loses height to the north, finally disappearing under the Eocene limestone plateau of Gebel Galala.

In the northeast, the Gebel Galala plateau falls steeply into the Gulf of Suez. It is crossed from west to east by Wadi Araba, at whose edge lies the monastery of St. Antony and, via a rugged path, the monastery of St. Paul.

In comparison to Sinai, the Eastern Desert is far richer in mineral resources, particularly in the south, a fact which has attracted people from early times. Archeological research has revealed that the pharaohs were not the first to mine here. The earliest signs of mining are associated with copper ores. Some gold can be found in small particles in quartz, invisible to the naked eye, but it seems that deliberate gold mining came only in later pharaonic times. It is possible that the gold used in the famous funerary mask of Tutankhamun originated here.

Other raw materials which the ancient Egyptians were unable to use were left behind: zinc, lead, wolfram, asbestos, phosphate, kaolin, iron, and crude oil, which are present in exploitable quantities. The Eastern Desert is today witnessing a great deal of prospecting.

Another mineral resource which left its mark on Egyptian culture was stone for sacred buildings. The Egyptians spared no effort to mine and transport such stone, although, naturally, they preferred materials that were both beautiful and workable. Perhaps the best-known example of an ancient Egyptian quarry lies in Wadi Hammamat, about halfway along the road to Qift and Quseir, where the highest quality graywacke and granite were worked.

Nowadays tourists mainly seek out Wadi Hammamat, the 'Valley of the Baths,' because of its well-preserved wall carvings and paintings, which date from the Fourth Dynasty up to the time of the third-century Roman emperor Maximus. Slabs and fragments of sarcophagi lie scattered in their original positions.

Many rock carvings which refer to quarrying operations depict the ithyphallic god Min, city god of the ancient Koptos (Qift). He is also called Master of the Eastern Desert and was equated by the Greeks with Pan. Besides hieroglyphs, demotic Egyptian and Greek inscriptions occur.

In Wadi Hammamat, as in many other places in the Eastern Desert, older petroglyphs are clearly visible. They testify to a rich African fauna from a time when the climate was less harsh. Men are shown hunting with dogs for oryx and ibex. Giraffes, elephants, and ostriches are depicted and cattle breeders proudly present their decorated animals. Wadi Sueda at Aswan has particularly well-executed examples of these themes.

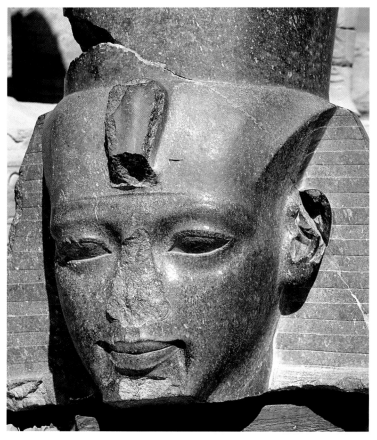

Opposite page:
The head of a statue of Ramses
II in the Ramesseum at Thebes

Above: In the Roman quarry of
Mons Claudianus

Bottom: A lionfish in the Red Sea
coral reef

The Romans left the most remarkable quarries in the Eastern Desert. The workers' camp and the quarries at Mons Claudianus are the best-preserved tourist attraction. The workings give the impression that the Romans left only yesterday: columns in all stages of preparation litter the quarry floor. On the loading ramp in the 'Valley of the Columns,' pieces lie ready for transport.

At Gebel Abu Dukhan, or Mons Porphyrites, are the remains of a no less remarkable quarry. Its red porphyry, the royal stone, was very popular. Strangely enough, the ancient Egyptians, who were always interested in rare stone, did not work here. The extraction began only under Ptolemy II in the heyday of Myos Hormos, a small harbor town on the Red Sea just north of modern Hurghada. Red porphyry from Gebel Dukhan is found at the Palatine Hill in Rome, in Pompeii, and in Herculaneum near Naples.

The desert routes by which the Romans transported their columns can readily be followed, as they are marked by the ruins of small forts and reservoirs along isolated tracks. Some of these forts later became desert monasteries, shown on old maps by the word *deir*. Like its western counterpart, the mountainous Eastern Desert offered numerous remote locations for the first Christian hermits to hide away and meditate. Significant monastic foundations grew from hermitages—particularly the monasteries of St. Antony and St. Paul.

As the rock drawings show, the Eastern Desert was, even in prehistoric times, a favorite hunting area. The gazelles which remain today remind us that ten thousand years ago the whole of the Sahara was much moister, making possible a rich wildlife in savanna-covered North Africa.

While the Bedouin population hunted to eat, hunting was always an amusement for royalty. Many scenes in pharaonic tombs show vivid details of such hunts. The tradition continued into modern times: the hunting lodge of the last Egyptian king, Farouk, may be seen in Wadi Rishrash, not far from Cairo on the Gebel Galala plateau. Ibexes like those in Farouk's trophy collection at Manial palace have now largely disappeared. Nowadays wealthy Egyptians along with hunters from Europe and America follow in the footsteps of the pharaohs. With the introduction of guns and all-terrain vehicles, the last hour for the big game of the desert and its hunter has come.

For most visitors to Egypt, however, the very edge of the Eastern Desert, the Red Sea coast, is its main attraction. Journeys into the desert are day trips at best. This is easily understandable since the Red Sea with its coral gardens offers a fantastic and unique world. The beaches and islands at Hurghada and particularly the coast further to the south are an underwater paradise on a par with the diving areas of Sinai.

Traces of Life in the Desert
The rough mountain landscapes of the Eastern Desert (*above, left*) are often covered in winter by dramatic cloud formations and beleaguered by sandstorms. They show few traces of animal life.

Here, however, a small stilt-legged black beetle of the *tenebrionid* family walks across the rough sand (*opposite, above left*). The long legs are an adaptation to avoid the heat radiated by the sand.

When the occasional plants appear in this desert, they are usually quite dried out and seem dead for most of the year. Yet they bloom readily with a little moisture. Here, the fagonie *Fagonia mollis* (*opposite, below left*) displays surprising and colorful flowers.

The hiker on a drab gravel plain may stumble across the magenta-flowering heron's beak *Erodium hirtum* (*opposite, top right*). Shortly after a rare shower, a barefoot child had left a footprint in the mud (*opposite, below right*). A wind-borne seed came to rest in this little depression. Perhaps slightly more water gathered in the footprint than in the surrounding sand: enough to water a small green desert plant.

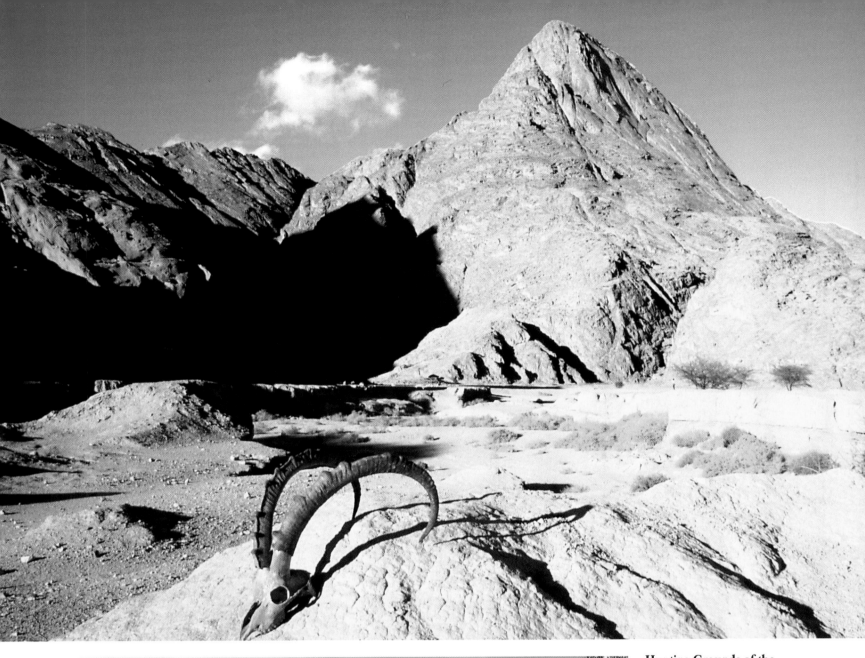

Hunting Grounds of the Rich and Famous

During predynastic times in Egypt, hunting was already the principal amusement of wealthy and prominent people. This remains true today. Egypt's hunting grounds were originally much wetter and therefore much richer in wildlife. Some five thousand years ago, as the Sahara region became ever drier, the mountainous Eastern Desert became the pharaohs' preferred hunting ground. A few ibexes still live in Egypt's mountains and one occasionally finds a skull with its horns (*above*). The hunting lodge of King Farouk in the Wadi Rishrash (*below*) dates from the 1930s when the ibex was still common in the Gebel Galala. Game was hung in the three conical towers: the holes provided ventilation and cooling. Trophies from this period may be found in the Muhammad 'Ali museum in Manial Palace, Cairo.

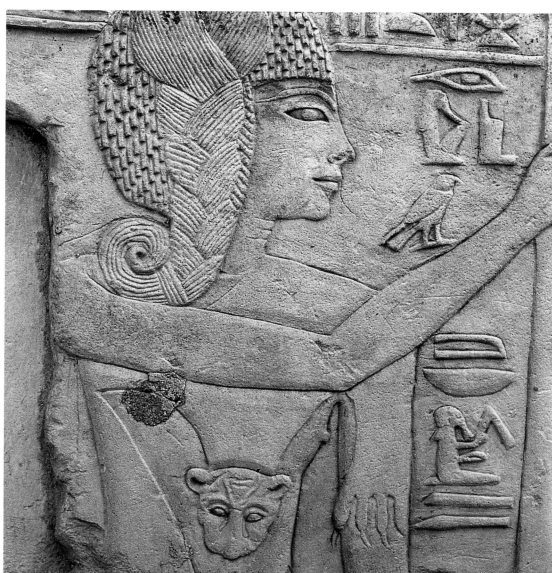

Big Game in the Desert
In the Old Kingdom, antelopes and gazelles were used in temple sacrifice. Today one finds them, stuffed, in the Cairo bazaar, sold as wall-decorations.
Leopards—on one hand feared, on the other hunted for their beautiful coat—are almost extinct. They exist, if at all, only in very remote areas of Egypt. In any case, leopards are very shy and difficult to observe; the magnificent male (*below right*) was photographed in Tanzania. A beautiful representation from the tomb of Horemheb at Saqqara shows a prince with the braided side-lock which indicates his youth. He also wears a leopard-skin as a sign of priestly power (*above right*). This ancient tradition is quite widespread in Africa.

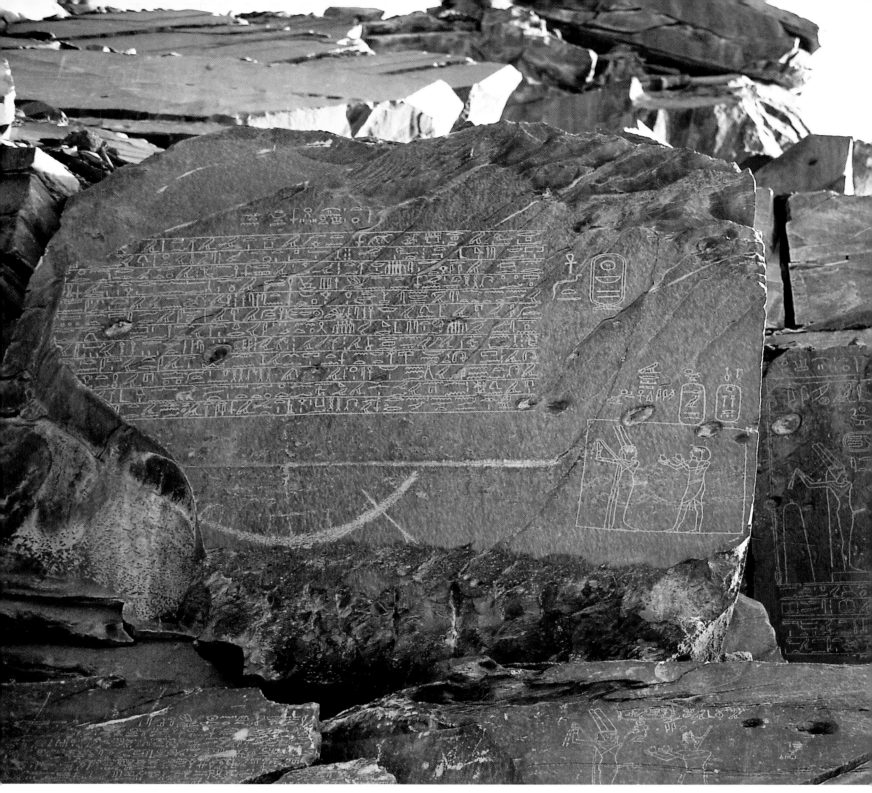

Goldmines and Quarries

In the Eastern Desert one finds not only the hunting grounds of ancient Egyptians but also their gold mines and quarries, which were worked until Roman times.

While the gold mines are hardly worth a visit nowadays, having been exploited completely and spoiled by ugly buildings, some quarries have become significant tourist attractions. The most famous one lies in Wadi Hammamat ('valley of the baths') on the road between Qift in the Nile valley and Quseir on the Red Sea.

If one looks around in the old quarries, it quickly becomes clear how its name came into being. Scattered around one finds 'bathtubs' in various stages of production, which are in fact sarcophagi, carved from the composite stone graywacke, which broke during the work process (*above right*).

The sarcophagi of the Old Kingdom pharaohs Unas, Shepseskaf, and Pepi I are made of Wadi Hammamat graywacke, though the stone is often wrongly called basalt or black granite.

The cliffs at the southern end of Wadi Hammamat are decorated with several well-preserved rock carvings, thousands of years old. The quality of the carvings varies and they display diverse themes and styles. A particularly finely-carved group may be found in the so-called chapel of Pan, or Paneum, under an overhanging rock (*bottom left*) beneath which traces of many older pictures appear.

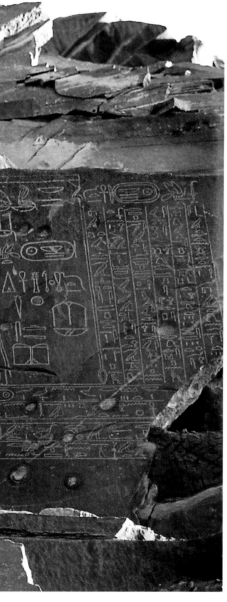

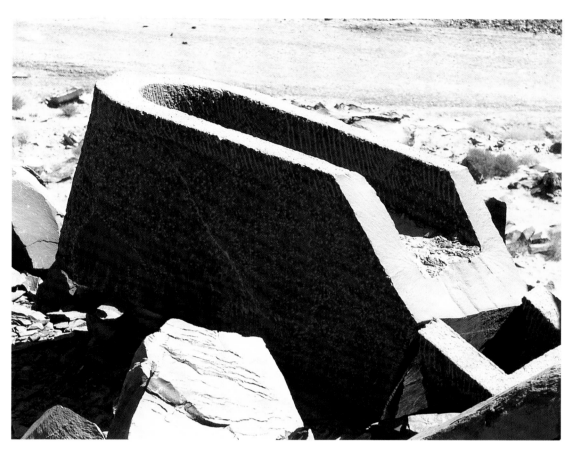

Many carvings record mining expeditions of the pharaohs from the fourth dynasty onward or show the ithyphallic god Min (*below right*), the protective deity of desert travelers and city god of Qift, the antique Koptos. The Greeks equated him with Pan, from which the name Paneum derives.

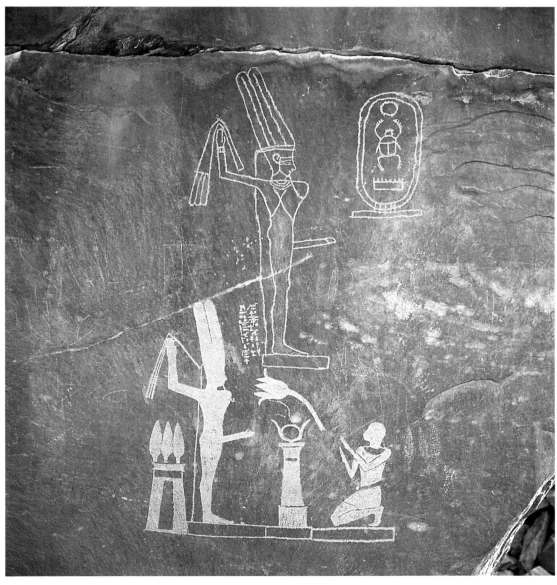

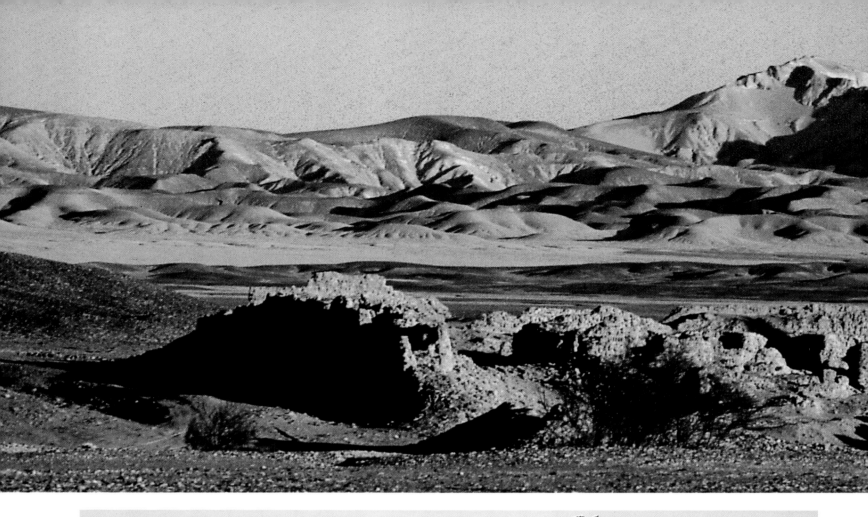

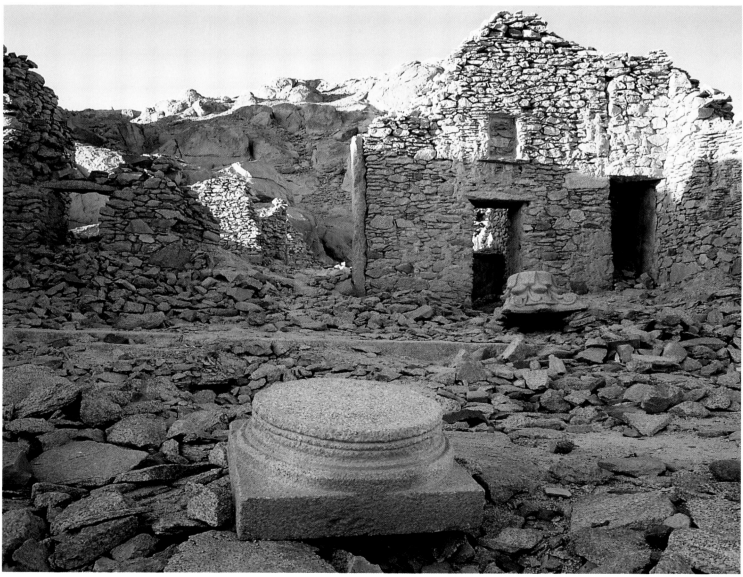

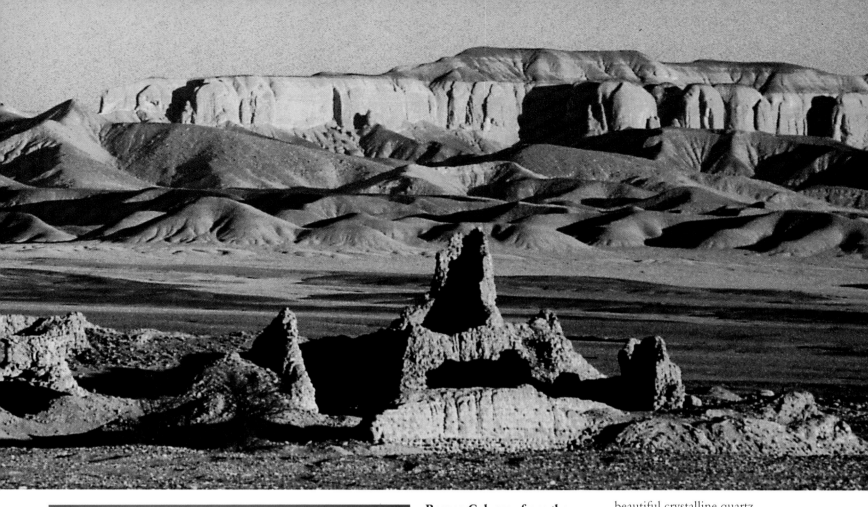

Roman Columns from the Eastern Desert

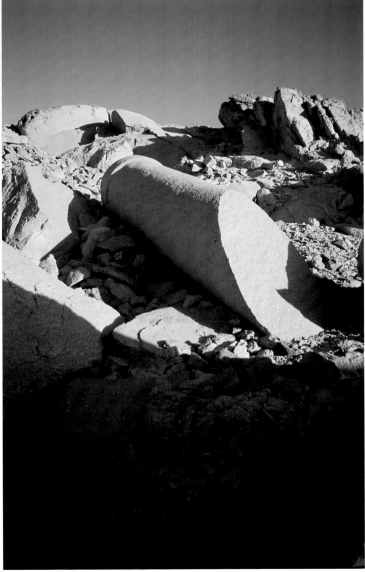

The Romans were connoisseurs of Egyptian stone. Many of the monuments of Rome were made of Egyptian granite or marble. Not only did they take over ancient Egyptian quarries such as Wadi Hammamat but they also established huge new mines. The best known are Mons Claudianus in Wadi Umm Hussein and Mons Porphyrites at the smoky mountain—Gebel Abu Dukhan.

The best preserved camp (*following pages*) on Mons Claudianus was probably established under the emperor Claudius (41–54 CE) and worked under the emperors Trajan and Hadrian. Beside the walled-in workers' camp are the partially-preserved remains of baths, cattle stalls, fodder stores, administrative buildings, and a temple to Serapis (*opposite, bottom*). The transport routes to the Nile are well known, and the ruins of Roman forts, such as al-Heita (*above*) in Wadi Qena mark the way.

A walk through the quarry workings on the slopes of the main and side wadis around the workers' camp is an impressive experience. Here there are examples of all stages of quarry work, from the first notch marking out the stone to be worked to the loading platform where finished column blanks of beautiful crystalline quartz diorite lie ready for transport. How the workers must have cursed when, after weeks of hard work, an almost finished piece broke (*left*).

Walking around Mons Claudianus a visitor gets the impression that the workers put down their hammers and chisels only yesterday and will be back again tomorrow to resume work. Important work it was, for the columns from these quarries grace the Palatine Hill, the Pantheon, and the temples of Trajan and Venus; in these and in many other places one may admire the patina of the Egyptian Eastern Desert on the columns of imperial Rome.

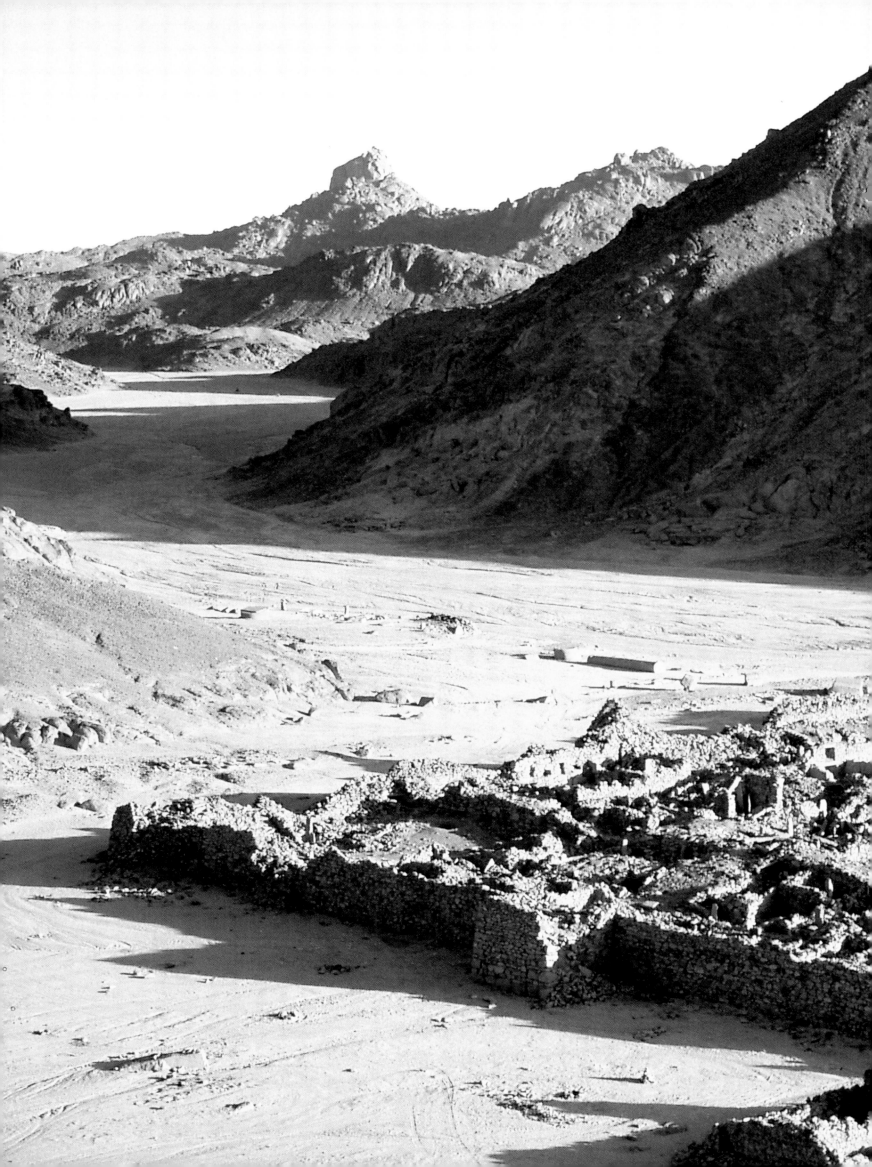

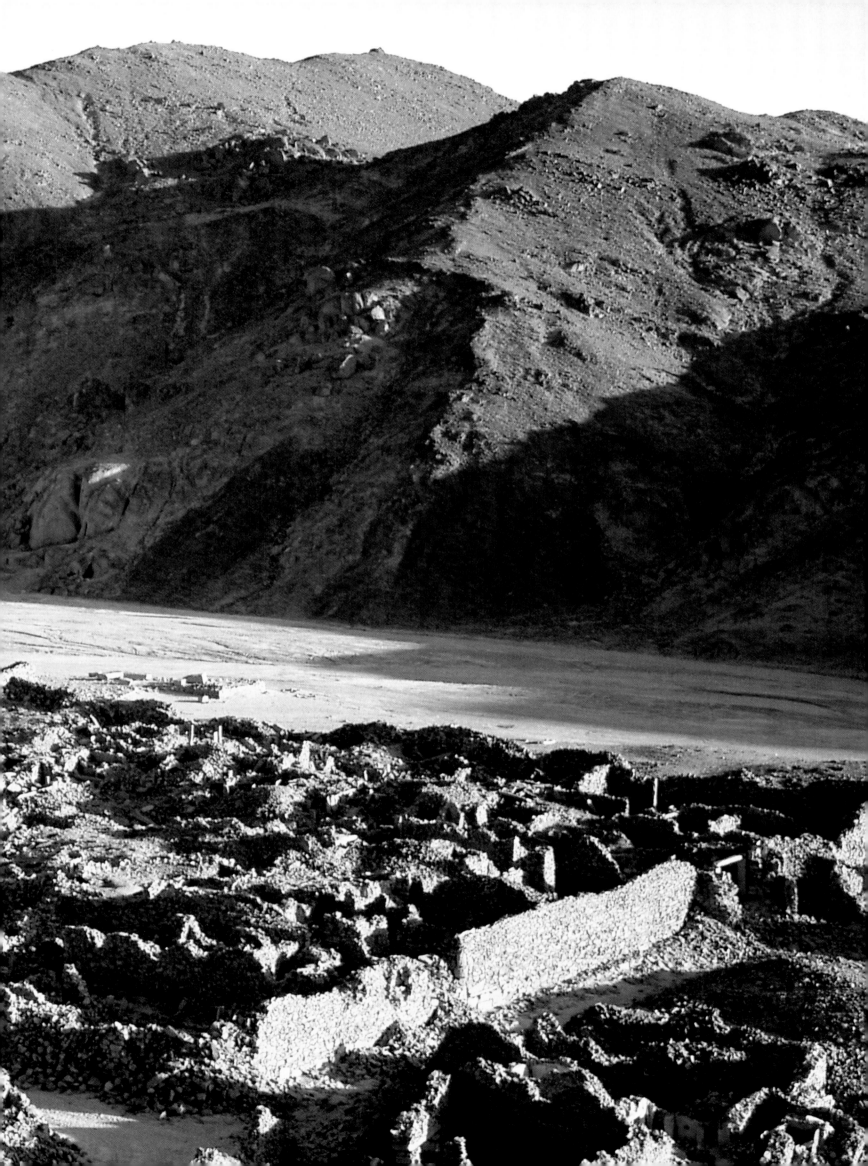

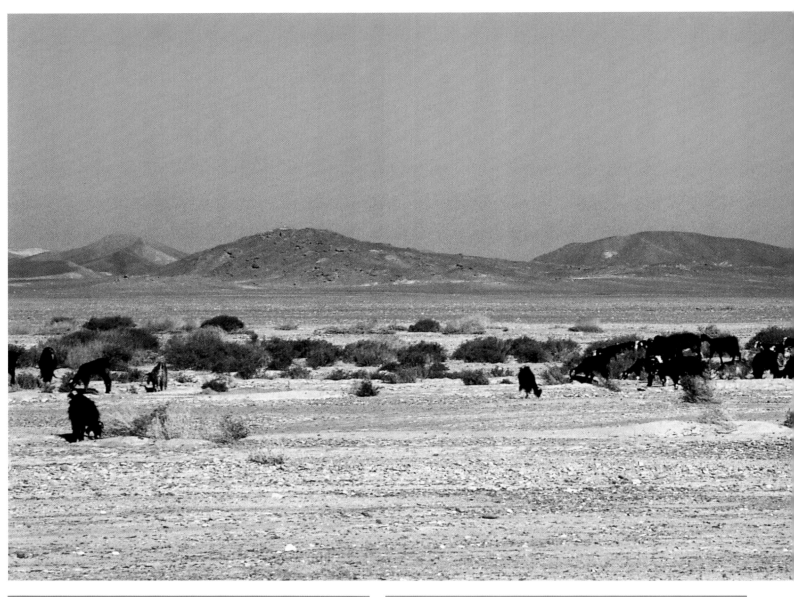

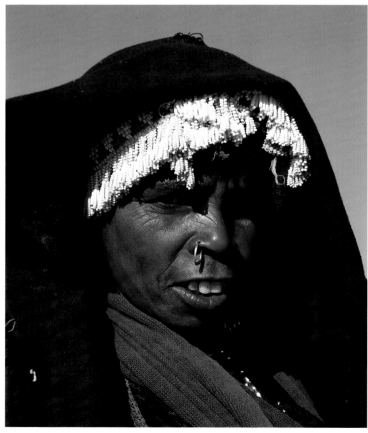

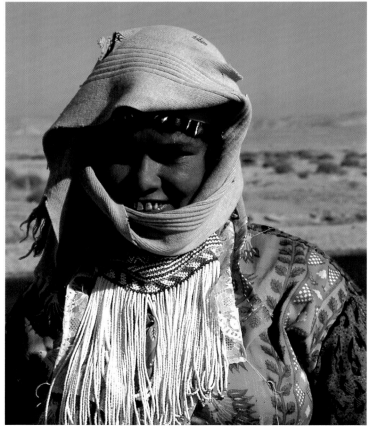

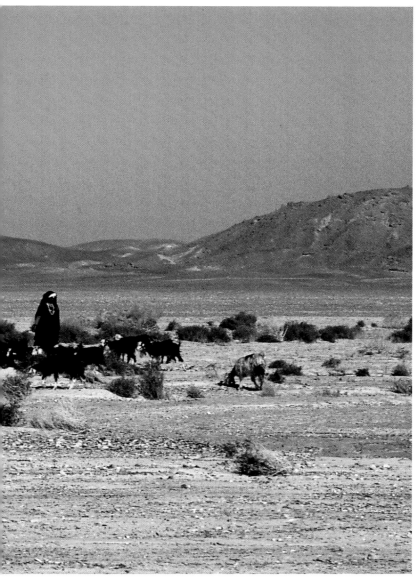
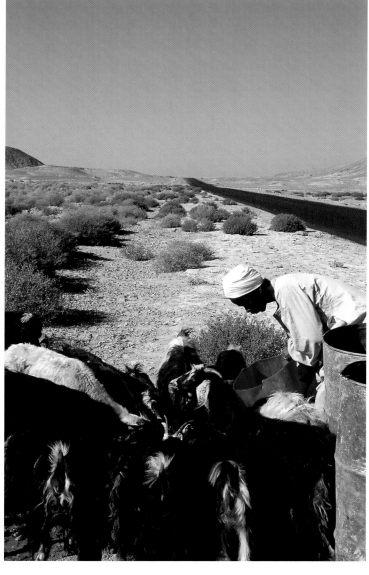

The Bedouin – Original Inhabitants of the Eastern Desert

Quarry workers, gold diggers, civil servants, or traders, they all were and remain temporary desert dwellers. Most of them consider their life here in the wasteland as a punishment; indeed many will have been posted here for disciplinary reasons and wish for nothing more than to return home to the beloved Nile valley.

It is a different matter with the Bedouin, however. These true desert dwellers can hardly imagine living in the overcrowded cities, and have always despised the *fellahin* of the Nile valley. The life of the Egyptian Bedouin is nowadays especially hard: the perpetual drying out of the desert areas–a process which has taken millennia–has gradually reduced the support system for the traditional Bedouin way of life.

The Ababda Bedouin of the Eastern Desert can support very limited herds of small animals (*opposite, top*) and to keep even these few head of goats and sheep, they depend on the largesse of a wealthy sheikh who buys water for his clan and makes it available in barrels (*top*).

During recent decades, the Bedouin have been forced to surrender land for road building, quarries, mines, or settlements and have lost some of their best pasture. Today, these independent and hardy tribes are sinking gradually into poverty, resulting in part from the rush by people from the valley to develop the desert. Nevertheless the women in particular try to keep up appearances in the traditional manner (*opposite*).

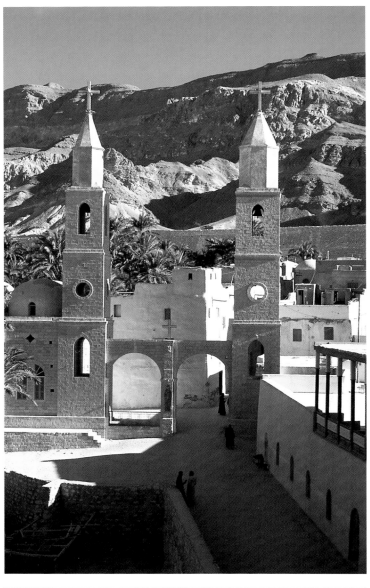

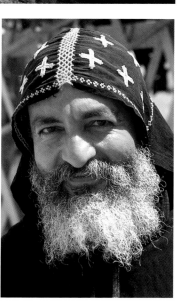

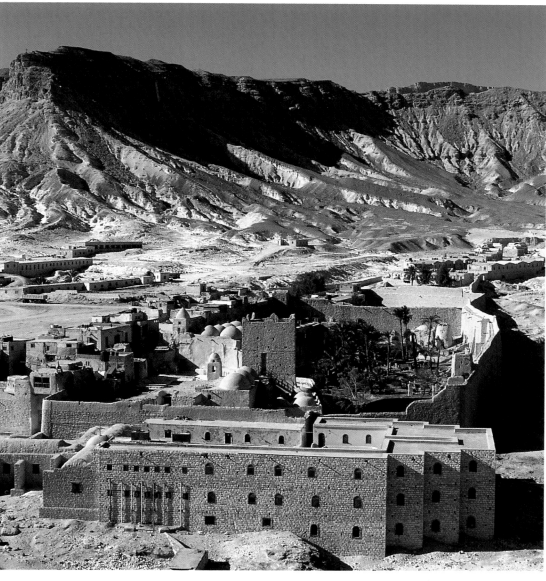

The Cradle of Monasticism

The southern Gebel Galala in the Eastern Desert shelters the monasteries of St. Antony (*above left*) and St. Paul (*above right*), two retreats which mark the origin of Christian monasticism.

While St. Paul, who was an Alexandrian by birth, is considered the first hermit, the significance of Antony lies in his asceticism, which continues to influence the contemplative Christian life. Antony, the son of wealthy parents from the area of Beni Suef, also retreated into the desert for long periods. Athanasius, bishop of Alexandria, and a pupil and friend of St. Antony, describes in his biography of the saint how the devil tempted him in the shape of a seductress and taunted him as horrible demons. It was St. Antony who defined the monastic life as *ora et labora*—prayer and work. His example served as a pattern for the development of monastic practice throughout Christendom. In 356 CE Antony died

and left a small community which founded the monastery at the beginning of the fourth century. Among the oldest parts still standing are the defense tower with a drawbridge which the emperor Justinian had build in 537 CE for protection against attacks by Bedouin. The big cable drum (*below left*) which once lifted a monk-powered elevator in the cloister wall is evidence of dangerous times. At first, St. Antony lived close to the spring, but he later retreated into a cave high above Wadi Araba (*above center*), when he started to feel disturbed in his ascetic practice by more and more admirers. A celebrated story, told many times and frequently illustrated in church paintings, illustrates the piety of these men: St. Antony is said to have visited St. Paul in his hermitage and, as a sign that Antony was a man of god, the desert raven which brought half a loaf of bread each day for Paul now brought a whole loaf. The way to St. Antony's cave

involves an exhausting climb over the high plateau of Gebel Galala, which takes experienced hikers some ten hours.

This monk (*below right*) wears the typical head covering, a dark cap made from pieces of cloth sewn together in a square. The twelve embroidered crosses symbolize the apostles and the thirteenth cross at the back of the head stands for Jesus.

The bread (*below center*) is a significant part of the Coptic liturgy. It is baked for use in the mass to commemorate the self-sacrifice of Christ and is marked with a seal.

113

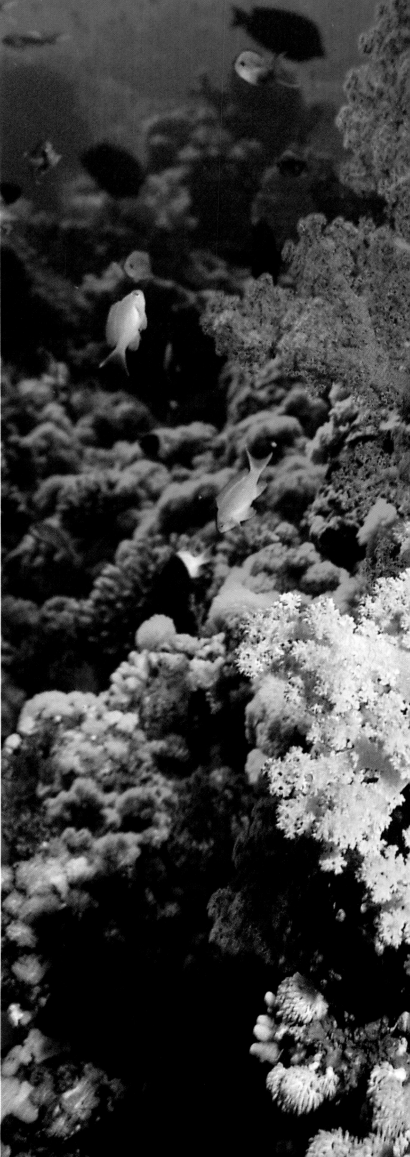

Researching the Red Sea in Antiquity and in the Computer Age

The Red Sea, with its fantastic coral fauna, was the object of scientific examination 3,300 years ago. The amazingly exact depictions of sea animals in the famous terraced temple of Queen Hatshepsut at Deir al-Bahari suggest that experts participated in the famous expedition to Punt. The meticulous results of their study of the fauna of the Red Sea may be still be seen on the temple walls. Compare the wonderful relief of a Red Sea emperor angelfish–*Pomacanthus imperator* (*opposite, center*) with a modern specimen (*opposite, top*).

But for long ages after that, the Red Sea was *aqua incognita* for the scientists. It was only in the eighteenth and nineteenth centuries that European scientists started making a systematic record of the flora and fauna of this former inland sea. Worthy of mention is the German doctor Carl Klunzinger, who stayed for five years at the Red Sea from 1864 and founded an oceanographic center in Hurghada. He also described numerous animals of the coral reef for the first time.

It is not surprising, therefore, that many creatures carry the name of this scientist, such as, for example, the enchanting soft coral *Dendronephthya klunzingeri* (*large photograph, center*).

But also nowadays, in the computer age, scientists still find research opportunities in the Red Sea. The means by which the beautiful sea snail *Conus textile* (*opposite, bottom*) decorates itself was discovered at the Max Planck Institute in Tübingen a few years ago. Curiously enough, sand dunes develop in the same way, and many instances of natural pattern building can be explained with the same principle. Professor Meinhardt from Tübingen fed equations representing the pattern building process into a computer, and discovered that the pattern on each snail comes about through tiny random changes.

Created by the Nile

You created the Nile in the underworld.
You led him up according to your will
to keep people alive …
The Nile from the sky [i.e., rain] is for foreign lands
And for the beasts of the desert.
But for Egypt, the true Nile springs from the underworld.
From the Hymn to the Sun by Pharaoh Akhenaten
(1365–1347 BCE)

Pharaoh Amenhotep IV, who changed his name to Akhenaten, is not the first, but probably the best known Egyptian to consider the Nile to be a miracle. In his hymns to the sun god, Aten, he describes life along the Nile more than three thousand years ago to great effect. We can still experience the green Nile landscape with its people, surrounded by a sea of yellow desert, just as Akhenaten once saw it.

That the Nile should exist at all is quite extraordinary. This river crosses more than three thousand kilometers of desert without drying out. Until the Aswan High Dam was built, the Nile reached its highest water level during the hottest season of each year, bringing with it life-giving black mud. The sources of the Nile were a geographical enigma for many thousands of years. The riddle was solved just over a hundred years ago.

Geologists report extraordinary things of the Nile. About 5 million years ago, it streamed through the area now occupied by Cairo in a deep canyon, far wider and deeper than the Grand Canyon of today in Arizona. Even more extraordinary is the development of the first human high culture along the Nile about five thousand years ago. One has to consider the geographical situation in order to understand this miracle: in the midst of a desert, along a river valley stretching a thousand kilometers in which the strip of arable land is sometimes many kilometers wide, but sometimes as little as ten meters, the ancient Egyptians created their empire.

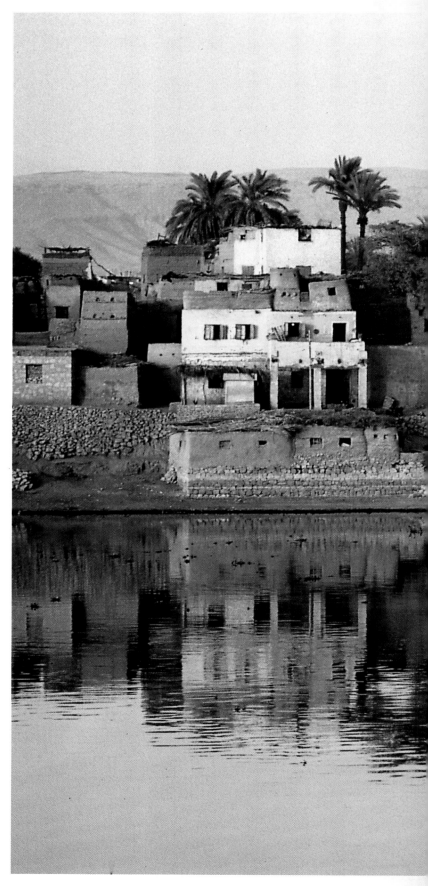

The cities and villages from Cairo to Aswan are strung out along the valley between the deserts and the river, which is bordered by green fertile land stretching sometimes for several kilometers, occasionally narrowing to a strip just a few meters wide. For the Nile traveler who glides calmly along the river on one of the luxurious cruise ships, the traditional and the modern meet in curious contrast. Everywhere, mud-brick settlements dominate the view along the banks, but the occasional building of the modern age breaks the idyll of the past.

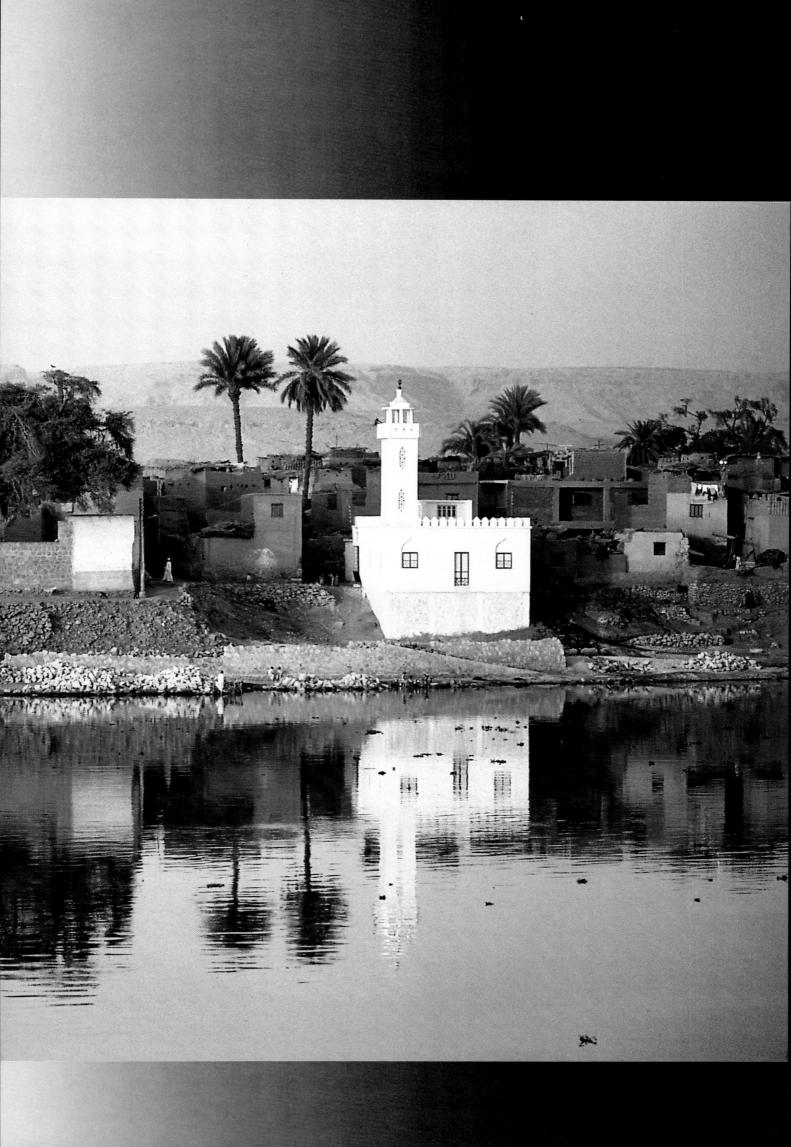

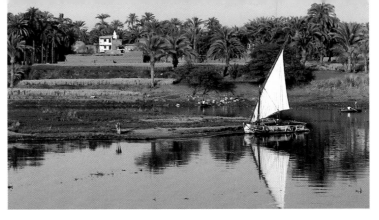

The Nile Valley — the Greatest River Oasis

The Arab geographer al-Mas'udi (whose real name was Abu Hasan 'Ali Ibn al-Husain Ibn 'Ali) settled in Egypt in 941 CE to study the country which fascinated him so.

The narrative of this sage begins: "The Nile is a miracle. Three months of the year, the land at its bank is a shimmering pearl, three months, the land is black musk, three months it shines like a dark green emerald, and three months it has the color of a bar of gold."

Al Mas'udi elaborates:

In the months of July, August, and September, when it is flooded by the river, the land is a silver, shining pearl. The farms and villages on their hills above the restless glittering Nile are like stars. At this time, the villages can be reached only by boat. Black musk is the land in the months of October, November, and December, when the water retreats into the river bed and leaves dark soil in which the fellahin sow their seeds. This soil emits a strong odor of musk. Dark green emerald is Egypt in the months of January, February, and March, when the sprouting plants of the fields and the leaves of the trees everywhere lend it the shine of this precious stone. And Egypt is one great bar of reddish gold in the months of April, May, and June, when the crops ripen, and the grasses, plants, and the leaves on the trees are burnished by the sun. Then the land of the Nile equals gold in its richness and its appearance. The land of the Nile is indeed a miracle.

We search nowadays in vain for much of what al-Mas'udi described so excellently. That silver shining pearl is no more and the land no longer smells of black musk since human beings put the Nile into a strait-jacket with the help of modern technology in 1964. The first dam at Aswan, built in 1900, still allowed the annual inundation through its sluice-gates, and therefore the fertile soil, but this was suddenly interrupted with the building of Nasser's monument, the Aswan High Dam.

Today, as the lake behind the dam has filled to overflowing, the disadvantages of this daring taming of the river are rarely heard. The advantages are clear: not only are three annual harvests now possible in Egypt, but huge amounts of electricity are available for industry. Dry periods of recent years were overcome thanks to the lake and new projects are underway to green the desert. Whereas in 1985 the desert road from Alexandria to Cairo ran through real desert, today the motorist finds new farms, on both sides, in an almost uninterrupted green band. Even the great oasis tour in the Western Desert from Cairo via Bahariyya to Kharga is becoming less of a desert journey. When President Mubarak opened the new Toshka canal from Lake Nasser to the Western oases in the winter of 1996–97, he opened the door to the twenty-first century in which Egypt hopes to expand its agricultural land from under 4 percent of the country to almost 30 percent in one leap.

The ancient religious center of Heliopolis, the former imperial capital, Memphis, and the modern mega-city of Cairo all developed at the apex of the delta, a point which has always separated Upper from Lower Egypt.

Here the Nile has already traveled some six thousand kilometers. Coming from the heart of Africa, the river has passed through jungle, swamp, and savanna. At Khartoum it was joined by the wild waters of the Blue Nile from the highlands of Ethiopia, then plunged into the Eastern Sahara. Here at Cairo, the Nile forks into two main branches, which, some two hundred kilometers downstream, finally arrive at the Mediterranean Sea.

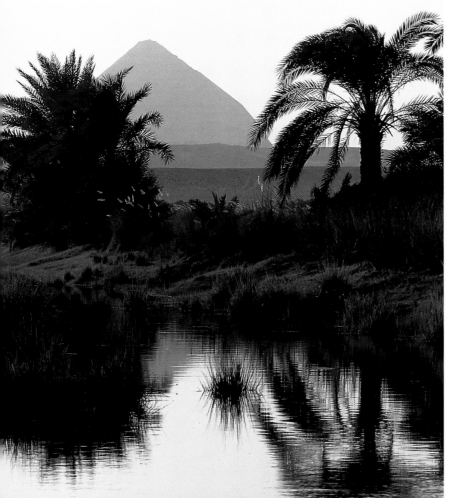

This river valley is the oldest and most important of all routes by which, at the dawn of time, the first human beings to evolve in eastern Africa spread across Sinai to Asia and thence to Europe. This is the same route which storks and other migrating birds take on their journey to Europe each spring.

As soon as a cruise-ship leaves the noisy city, the Pyramids of Giza appear to the West, majestic and calm. Soon afterwards, the necropolis of Abu Sir and then Saqqara with its step pyramid come into view. A little later, the Bent Pyramid and the Red Pyramid of Dahshur are visible and, further south, the Pyramid of Maidum.

Of Memphis, the most significant capital city of the Old Kingdom, nothing is now to be seen from the river. What little remains lies under farmland and palm groves. Only occasionally do archeologists find anything of importance here.

Much more obvious is Helwan on the opposite bank. Once famous as a spa, it is today one of the biggest and ugliest industrial areas in Egypt. It emits enormous amounts of pollution, and, when the wind is from the south, trails of filthy smoke blow north to Cairo.

But soon we leave the industrial area behind. From time to time farms, villages, and cities appear nestling in the green fields and palm groves along the eternal Nile. Many have their roots deep in antiquity.

Beni Suef marks the approach to the Fayyum. Minya, Asyut, and Qena are troubled provinces in which the misery of the *fellahin* has proved fertile ground for Islamic extremism and rebellion. Here is a region with a tradition of violence, where many men go armed and where blood feuds may last for generations. Government neglect of rural Egypt and endemic corruption have led many peasants to see themselves as oppressed by a power which forgets its Islamic duty toward the people. The desperation of some Islamists has led to occasional attacks on both native Christians and tourists. For the most part, however, visitors are made very welcome throughout Egypt, and Muslims and Christians have lived peacefully together for many centuries.

From time to time, the ship passes important pharaonic sites which are not visible from the river: the necropolis of Beni Hassan, Tell al-Amarna (the city of Akhenaten), the temples of Abydos and Dendera.

After the ship rounds a long bend in the Nile, Luxor (ancient Thebes) emerges from the green of the palm trees as the highlight of a Nile journey. The forests of columns, wall carvings and obelisks of the huge temples at Luxor and Karnak, the rock-temple of Deir al-Bahari, the tombs of the pharaohs in the Valley of the Kings have attracted scientists, travelers, and grave-robbers, and inspired poets and artists, historians, novelists, and film directors. In short, they have made the capital city of the New Kingdom world-famous. But at Luxor our Nile journey is far from over.

There follow the temples of Esna from Ptolemaic and Roman times, the almost completely preserved Ptolemaic temple of Edfu and, at a prominent spot where the land juts into the Nile, the mighty double temple of Kom Ombo.

As in former times, every Nile journey ends at Aswan, since the first Nile cataract, the granite threshold which breaks the Nile, bars our journey southward. Overstepping this threshold, one leaves classical Egypt and moves into Lower Nubia, the gateway to Africa.

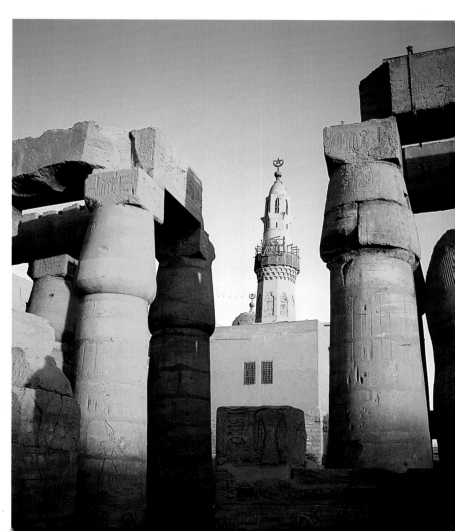

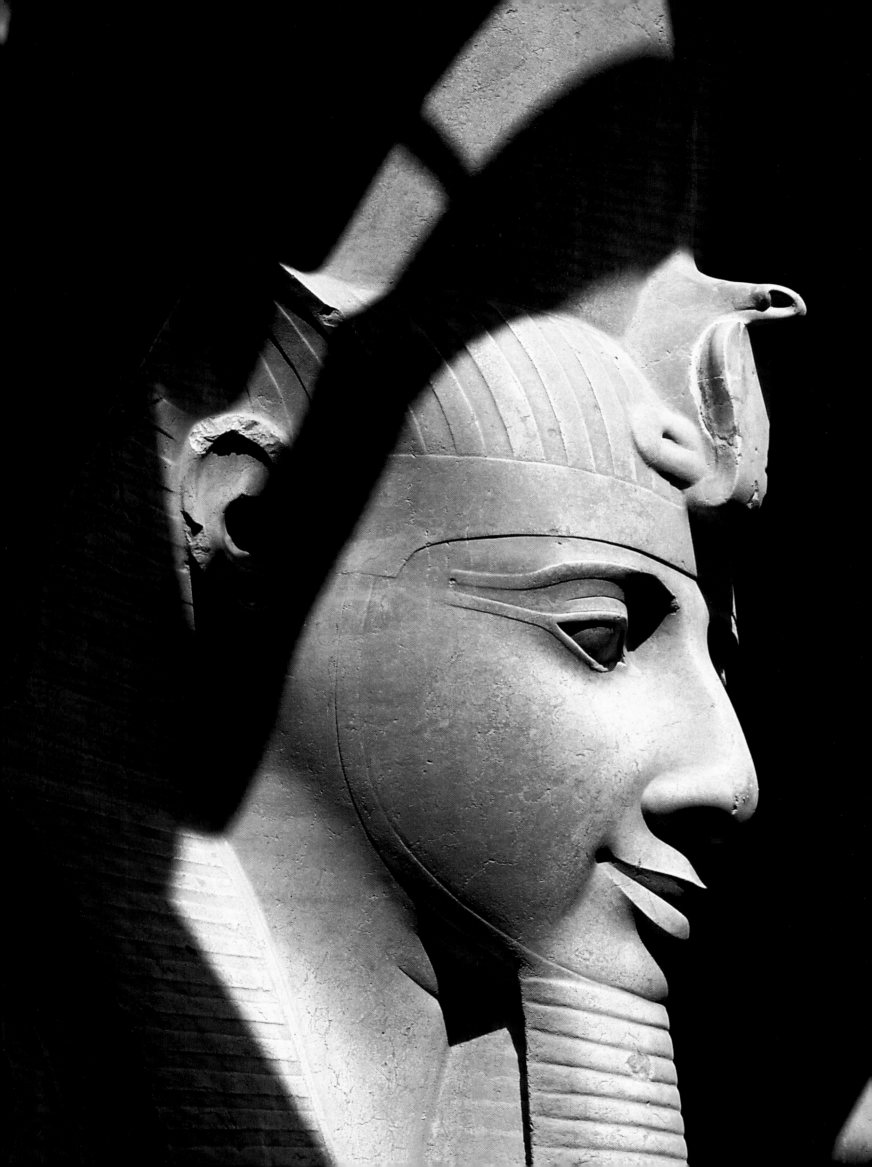

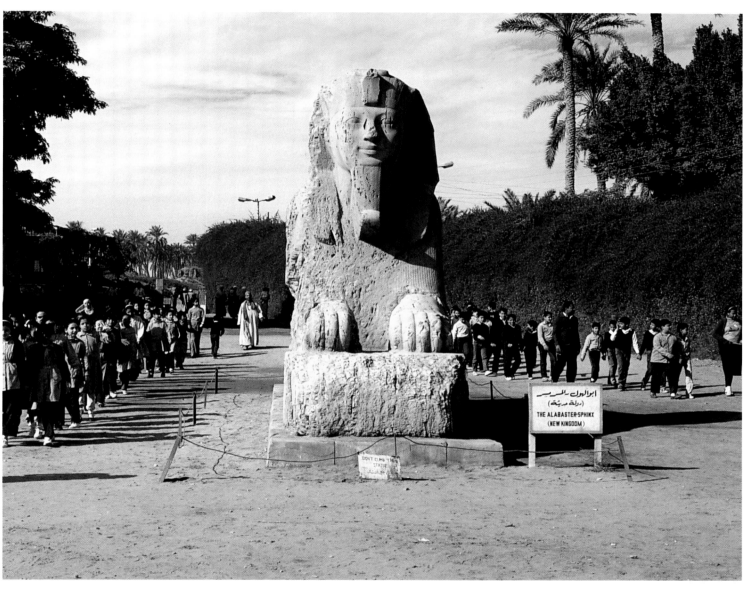

Memphis – Where the Nile Valley Meets the Delta and the Fayyum

Then the Pharaoh Ramses praised the god Ptah of Memphis, saying: "I am your son. You gave me everything that you created ... I have made your house in Memphis magnificent and provided it with priests, prophets, slaves, fields, and herds. I prepared great sacrifices for you. All people, the whole earth, I marked with your name so they belong to you now for eternity."

A medieval Arab writer wrote enthusiastically of Memphis: "The richness of miracles confuses the mind making it impossible to describe, even for the most eloquent."

Although Memphis was the capital of the Old Kingdom, the few remnants which have come down to us are almost all from the New Kingdom.

The extraordinary and well-preserved limestone sculpture of Ramses II (*opposite*) is kept in a small museum at Memphis. Outside in a palm grove, a few mostly fallen colossal figures lie or stand, such as this alabaster sphinx from the times of Amenhotep II. Egyptians such as these school students (*above*) are today rediscovering their history. Those parts of ancient Memphis which escaped plunder by the builders of Cairo now lie buried under Nile mud and palm trees near the village of Mit Rahina.

The few uncovered remnants of the Ptah temple and other monuments are threatened by the high water table and are being eaten away by salt.

Following pages:
Life in the shadow of the pyramids

In many ways, life in the Egyptian countryside goes on much as it did four thousand years ago, when the Bent Pyramid at Dahshur was completed. Seven hundred years later, the black brick pyramid of Amenemhet III (here seen in the background) was erected. Traveling through the countryside, one looks at a land that is vastly ancient and yet still brimming over with life.

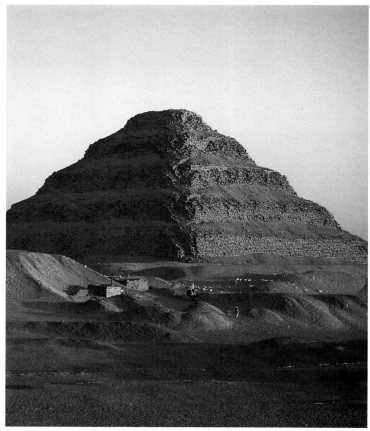

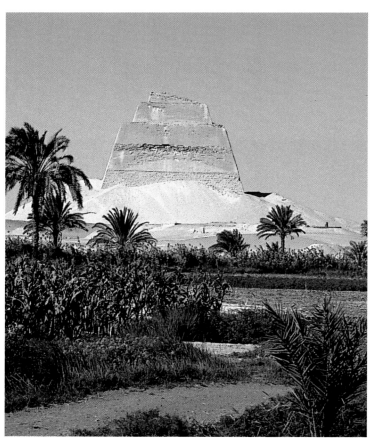

Architectural Development of the pyramids

The history of those most typically Egyptian monuments, the pyramids, began with a pharaoh and an architect of genius. King Djoser, the most significant pharaoh of the third dynasty, gave the order for the building of a tomb monument to symbolize eternity. Imhotep, prince and architect, undertook the work of raising the step pyramid (*opposite, bottom left*), using stone as a building material for the first time. Imhotep was later honored as a sage and elevated to the status of a god. The most enthusiastic pyramid builder of all time was the pharaoh Snofru, "the good king," founder of the fourth dynasty. During his forty-year reign, three pyramids were built, and he is acknowledged as the builder of the first true pyramid. The earlier pyramid of Maidum (*opposite, bottom right*) which some Egyptologists credit to the pharaoh Huni, was started as a step pyramid. Its current shape is due to a complicated building history and, later, a partial collapse.

The Bent Pyramid (*left*) of Dahshur is the first pyramid planned to have four flat, triangular sides, but the ground turned out to be too weak for the massive structure and the steep side-angle had to be flattened when subsidence caused fissures in the walls, giving the pyramid its distinctive shape.

Khufu, Khafre, and Menkaure (often called by their Greek names: Cheops, Chephren, and Mycerinus) were responsible for the pyramids of Giza (*below left*). The Great Pyramid of Khufu was originally 146.59 meters high, its sides slope at an angle of 51° 50' 40", and it has a volume greater than that of the five biggest churches in the Western world, including St. Peter's in Rome. This pyramid was rightly considered one of the seven wonders of the ancient world. With the pyramid of Menkaure, however, the age of the great pyramid builders ended. By then, these huge monuments—symbols of the pharaoh's resurrection in the afterlife—had lost their function as religious cult objects and as reminders of the untrammeled power of a god-king.

The Black Pyramid of Amenemhet III from the Middle Kingdom (*below right*) is an example of the return to the origins of pyramid building, since the earliest mastaba graves of predynastic times were also built of mud bricks.

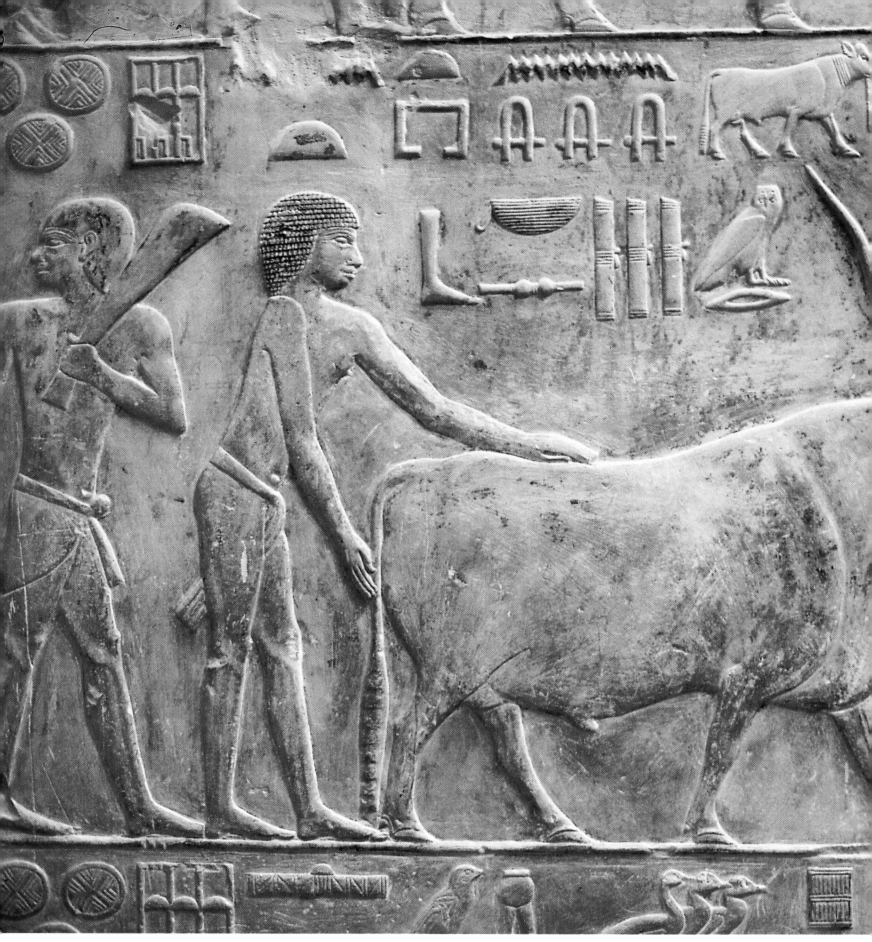

Domestic Animals in Ancient Egypt

Archeological findings show that even in prehistoric times Egyptians kept goats, sheep, pigs, and dogs as domestic animals. Cattle have always been important throughout Egyptian history as draft animals in the fields and as sources of milk and meat. The fattened ox was a vital sacrificial animal. Here (*above*), in the mastaba of Ptah Hotep from the Fifth Dynasty, is a classic depiction of a bull being led to sacrifice for the deceased. Cattle also became the symbol for gods like Hathor, Buchis, Apis, and Mnevis. The food-sacrifice which formed part of the cult of the dead may also have led the ancient Egyptians to experiment in the breeding of domestic animals. Perhaps the diminishing numbers of wild animals in the slowly desiccating desert encouraged the Egyptians to domesticate a number of them to ensure a supply of sacrificial animals. In any case the amazing pictures on the tomb walls of the Old Kingdom show, often in precise detail, how antelopes (*above right*), gazelles, and even hyenas (*center right*) were fattened for the kill so the deceased might be well supplied with meat in the afterlife.

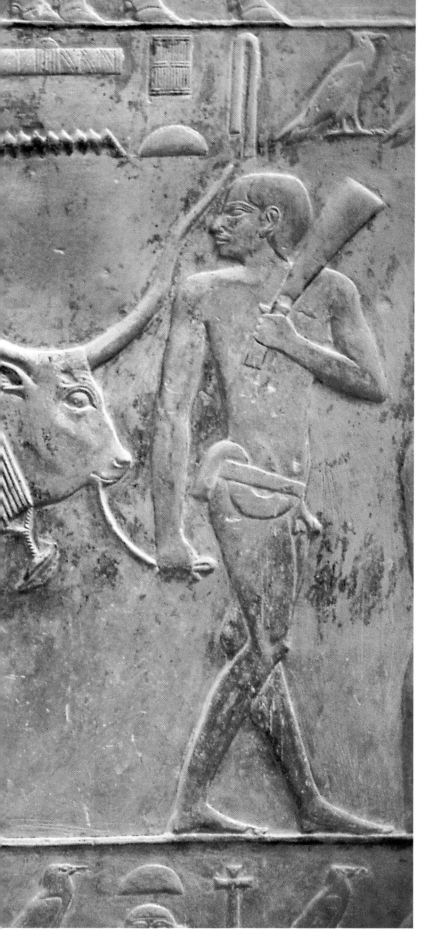

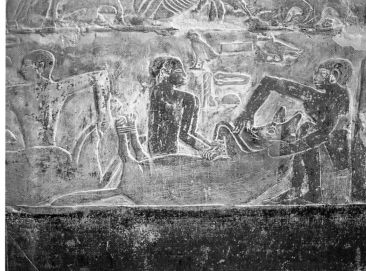

Geese were also used as sacrificial animals, as is shown in this segment (*opposite, bottom*) of a relief in the inner mastaba of Ptah Hotep in Saqqara.

The ancient Egyptians were the first to breed the gray goose (*Anser anser*), the forebear of our modern domestic geese. Migrating wild geese were also hunted.

To learn about the domestic animals of the ancient Egyptians, however, one should not rely on depictions in the tombs, where only animals important to the cult were included. For example, one rarely finds images of pigs and goats.

Camels and horses were introduced into Egypt during the Second Intermediate Period by the Hyksos from the Levant, so it is only in the New Kingdom that they appear on tomb and temple walls.

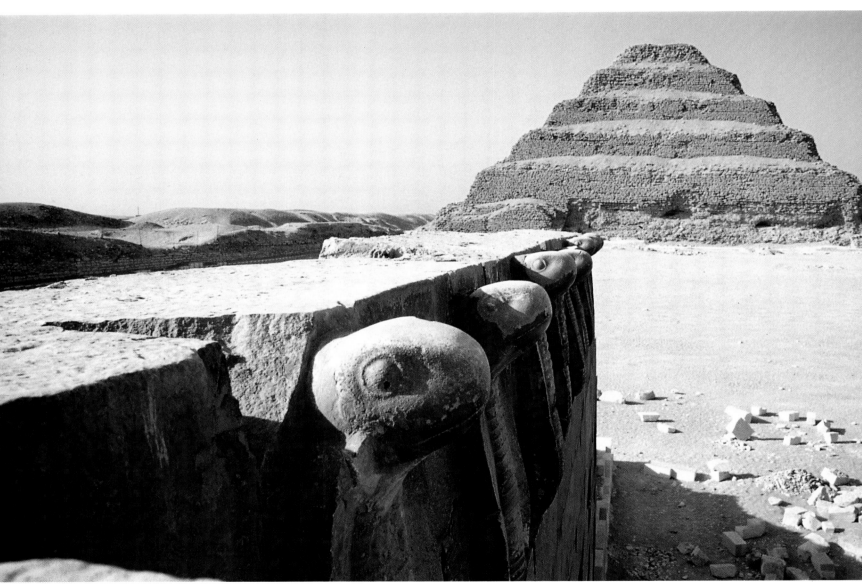

Animals in Myth and Religion

Ancient Egyptians produced a wonderful record of their close relationship with nature. Many hours were spent in agriculture, animal husbandry, hunting, and fishing. There were pets for pleasure and plant and animal products were used in medicine.

Apart from this practical relationship, the ancient Egyptians venerated the natural world for itself, as one can see from the many animal and plant symbols which relate to religion and mythology. Animals used as symbols were not necessarily useful to human beings. The sacred scarab Khepri (*above right*) is, after all, nothing more than a dung beetle.

In Heliopolis, Khepri symbolizes the god of the rising sun, self-creation, and constant renewal. So the scarab became the sign for 'being' and 'becoming' in the throne-name of the great pharaoh Thutmose III: *the becoming of Ra remains*. These three scarabs on the temple wall at Dendera (*above left*) signify 'the world.'

Less surprising is the inclusion of the cobra (*below left*) in the cult of the dead. This dangerous snake was feared for its toxic bite, but honored as a symbol of renewal thanks to its ability to shed its skin. As the uraeus, it protected the pharaoh and his tomb. Here is an example from the tomb of Djoser, builder of the first step pyramid at Saqqara (*below left*). The religious significance of the uraeus has its roots in the mythological ideas of prehistoric times. It is not entirely clear whether the uraeus is *Naja haije,* or the rarer, poison-spitting *Naja nigricollis,* which today occurs only in southern Egypt. From the world of birds, the falcon is frequently represented. The Horus falcon (*below right* in the temple of Edfu) held an important position in the pantheon of gods.

Following pages:
The miracle of the Nile: although the fertile land is often just a few meters wide, it was in this thousand-kilometer-long valley between two deserts that the world's oldest high culture developed. Even this rocky landscape seems idyllic when mirrored in the river.

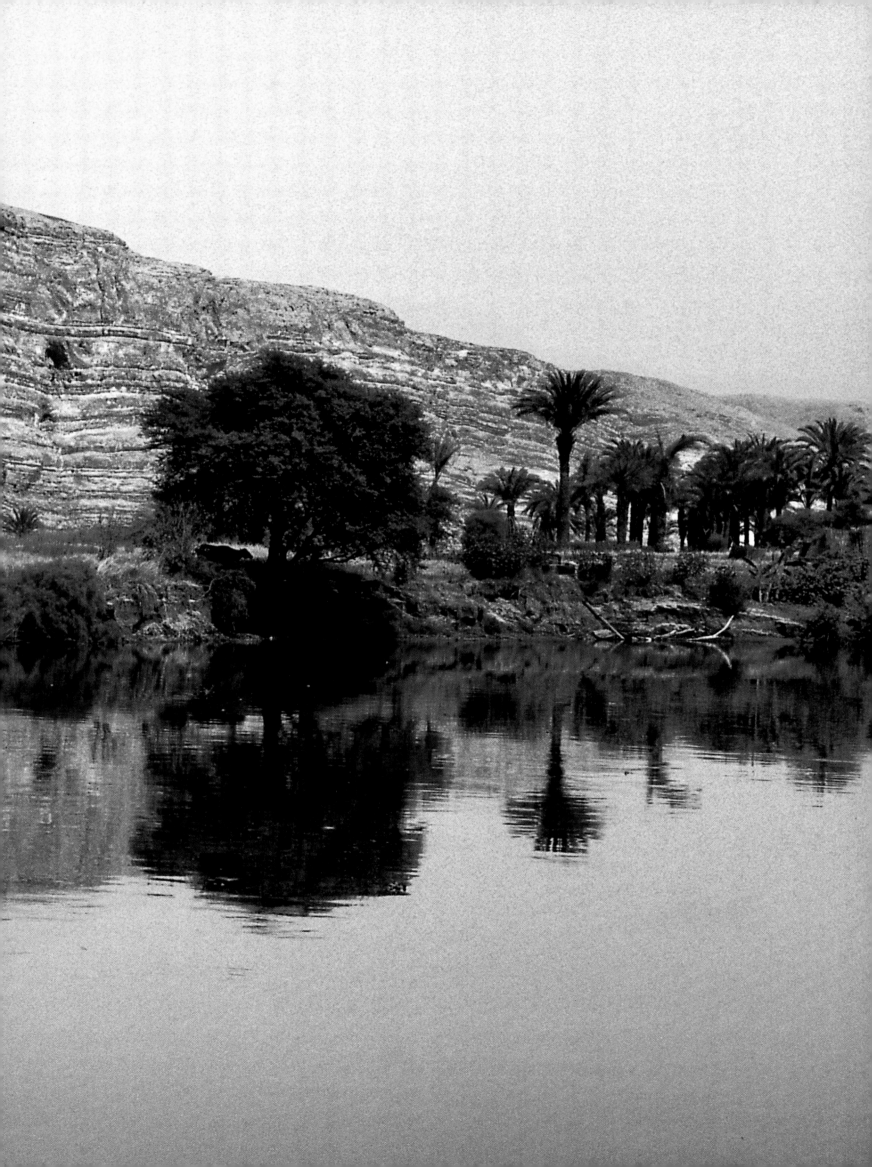

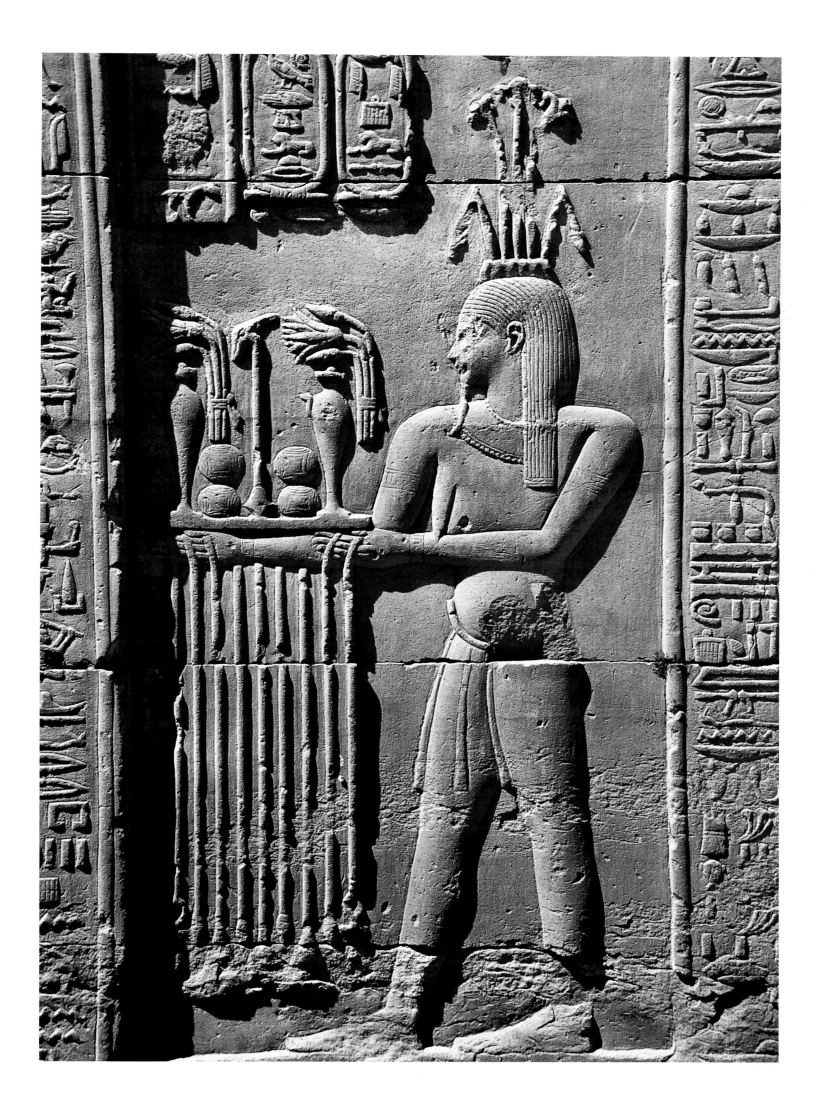

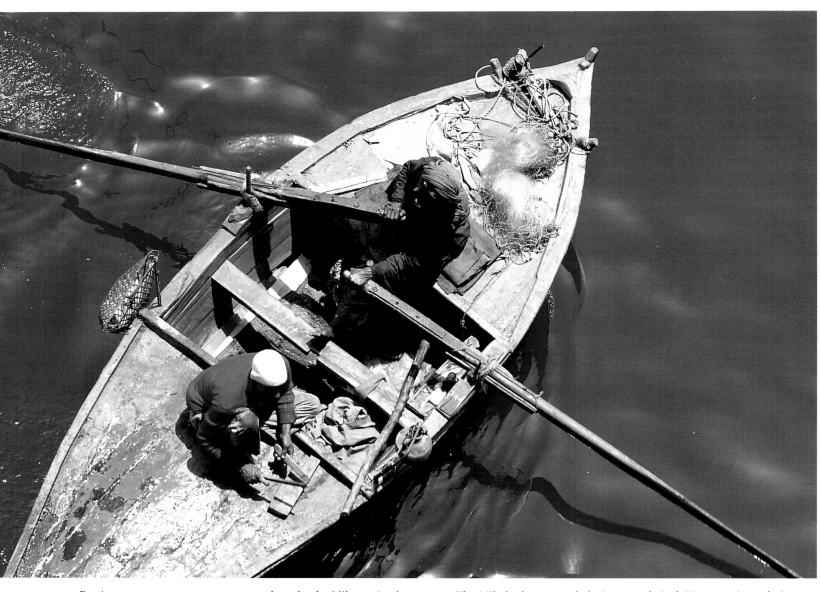

Previous pages:
Egypt – Created by the Nile
It was not until 1862 that the
Nile's southernmost source, at
Lake Victoria, was discovered by
Britons John Speke and James
Grant. Herodotus almost got it
right when he said the waters of
the Nile came from heaven. In
fact, the Nile flood in July or
August each year comes from the
monsoon rains in the Mountains
of the Moon in Ethiopia, which
the locals call appropriately
Ruwenzori, 'the rain giver.'
The Nile is the longest river on
earth. Passing through jungles,
papyrus swamps and steppes, it
then flows through a vast baking
desert to create Egypt. It is
hardly surprising that Herodotus

thought the Nile a miracle,
flooding as it does each year just
at that time when Egypt is
hottest and driest. The ancient
Egyptians probably knew
nothing of the Blue Nile, which
brings the raging torrent each
year from the highlands of
Ethiopia, although it was clear
that the river came from the far
south. In ancient Egypt, it was
common to hold several
apparently contradictory views
about the forces of nature. So
the Nile was at the same time
held to well up from an
underwater cave near Aswan.

The Nile had an overwhelming
importance for the Egyptians: it
was only logical that the river
should be tightly bound up with
their religious beliefs. Hapi, the
Nile god (*opposite*), is at the same
time the flood of Nun, the
firmament which was divided
and pushed to the edge of the
universe in the act of creation.
The annual inundation is the
physical counterpart of the
coming of Hapi. He was also
called master of the rising waters,
father of the gods, source of all
life. Hapi is both ancestral father
and Egypt's nurturing mother:
an old man with beard and belly
and the breasts of a wet-nurse.
Ancient Egyptians would readily
mix and match characteristics in

their deities, to mirror their
responsibilities.
Hapi is not the only Nile god.
As is usual in Egyptian religious
thought, this deity is interwoven
with other gods. Hapi is
sometimes identified with the
potter god, Khnum, creator of
life and shaper of men. It is
significant that the ram-headed
Khnum is the guardian of the
supposed source of the river at
Elephantine and married to
Satet, the sovereign of the
nearby first cataract. At Satet's
side stands the goddess Anuket
of the island of Sehel, which
breaks the Nile's flood. The
three form the holy triad of the
First Cataract (*center left*).

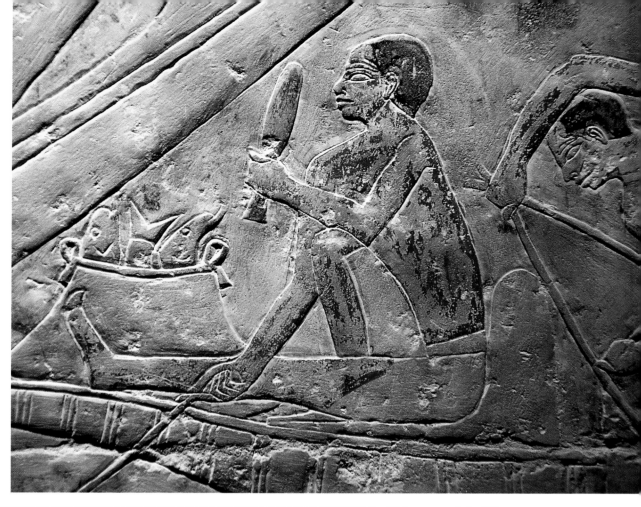

Fishermen of the Nile

The fertility of the Nile is attested by the diversity of fish it supports. From the very earliest times, people would fish for food. Here, too, the methods have hardly changed in five thousand years. Fortunately, the ancient Egyptians documented all life's significant events quite precisely on tomb walls, as an eternal record. This enables us to determine even the kinds of fish they caught. In the middle of Cairo, in the late twentieth century, we can hear Nile fishermen knock on their boats with a short piece of wood (*opposite*), so luring fish to the hook (*left*). This technique is depicted at Saqqara on the walls of the tomb of princess Idut, built some 4,200 years ago (*above*).

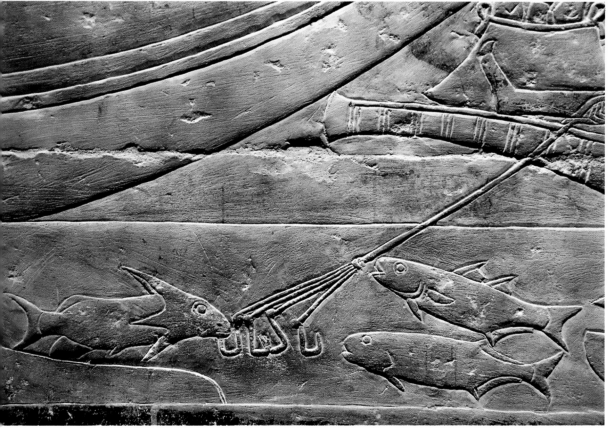

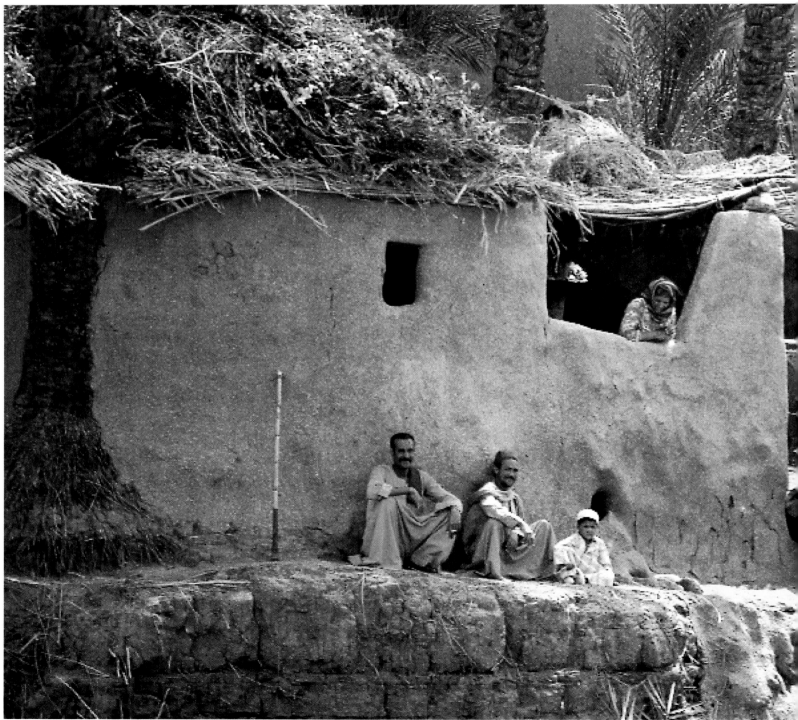

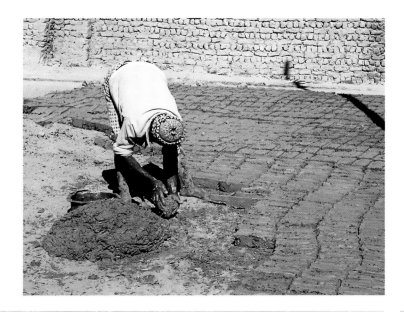

Nile Mud: Both Soil and Building Material

In contrast to the stone-built tomb constructions of the ancient Egyptians, very little is left of the cities of the pharaohs. This is because, although Nile mud makes an excellent building material, unless it is carefully protected and maintained, it disintegrates. Papyrus matting, also a common building material, met the same fate. Flooding and earthquakes must have destroyed countless mud-built settlements in the valley and the delta.

On higher, rocky ground to the west of the river, several Middle Kingdom pyramids were built of brick. This represents a deliberate reversion to much earlier, traditional, mastaba-building techniques. These pyramids were soundly built, and well protected. Nevertheless, they were largely destroyed by later generations of peasants who used the mud bricks to fertilize their fields.

Then, as today, the rural population built their houses from easy-to-manufacture air-dried bricks (*above right and below right*). The walls are finished with a layer of Nile mud (*below left*). Flat rounds of bread are baked in ovens (*above left*) also built of mud after an ancient technique.

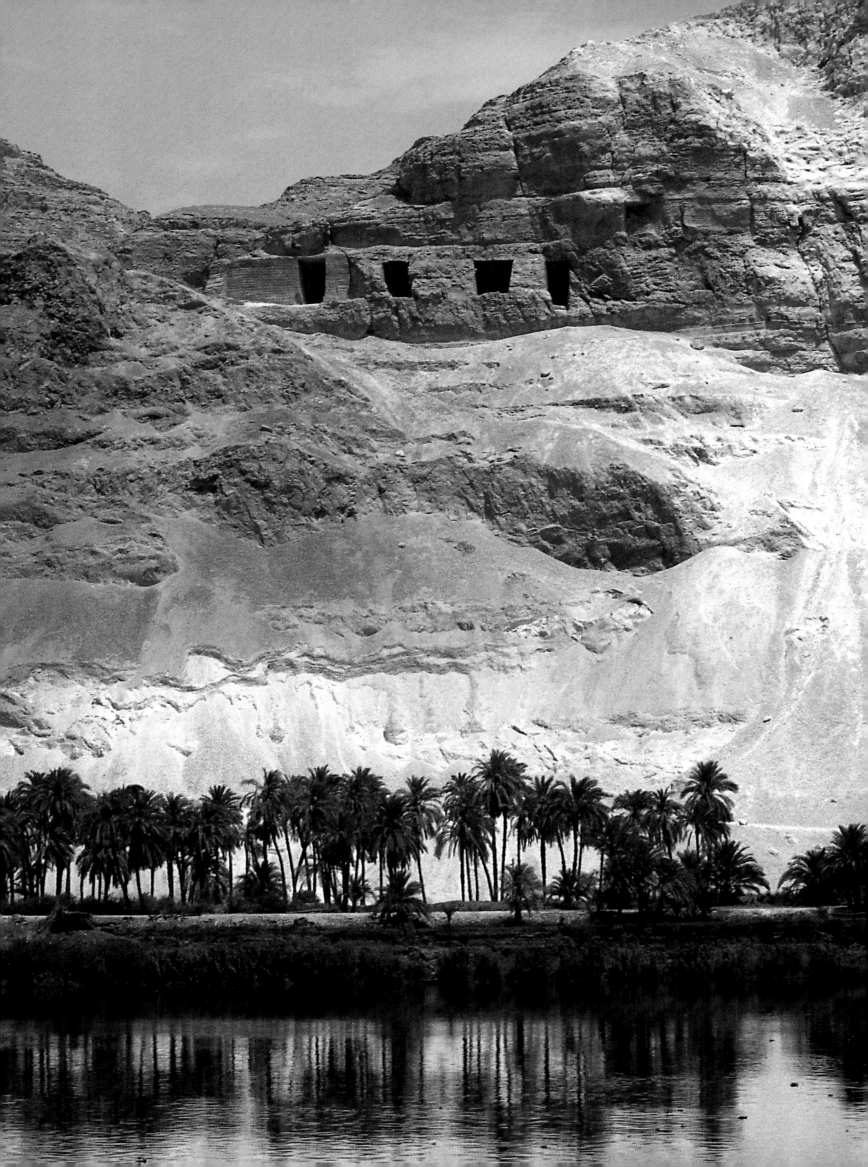

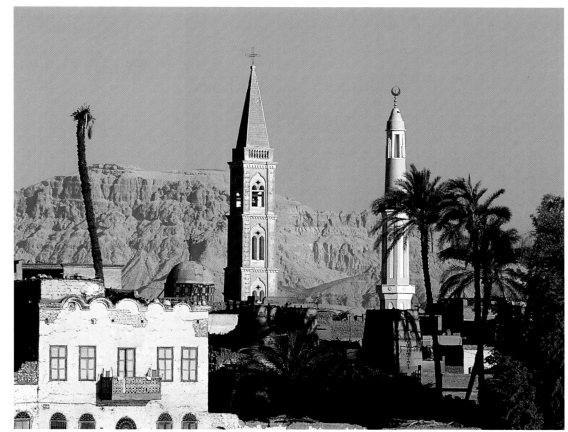

Tombs and Monasteries, Churches and Mosques

The Nile has seen many religions come and go—perhaps the longest river in the world also has the longest history of religion. Our knowledge of prehistoric Egypt is sketchy. It is known that the Nile valley has been inhabited since the Old Stone Age and that the Egyptian people were a mixture of Libyans and other north Africans together with Semitic immigrants from Asia. Each group surely came with its own cults and religious customs. This is evident from study of prehistoric tombs of the Nile valley. With the pharaohs began three millennia of high culture which in its development, consistency and longevity, leaves all other cultures of antiquity far behind. At the beginning of the Old Kingdom, religion and philosophy reached a refinement and maturity which remained unrivaled for centuries. Most records of this development come from tombs in which the ancient Egyptians recorded many of their beliefs about life in the hereafter. The most important cemeteries and cult places of ancient Egypt are at Saqqara, Abydos, and Thebes, but not unexpectedly they may be found throughout the Nile valley, as for example here at the rock graves at Sohag (*left*).

It is not always remembered that Egypt was also the first Christian country in the world, and one of the monasteries by the Nile (*below right*) stands as a symbol that monasticism is an Egyptian invention. Nowadays the Coptic cross stands side-by-side with the Islamic crescent (*above right*). For many centuries, for the most part, these religions have coexisted peacefully in Egypt.

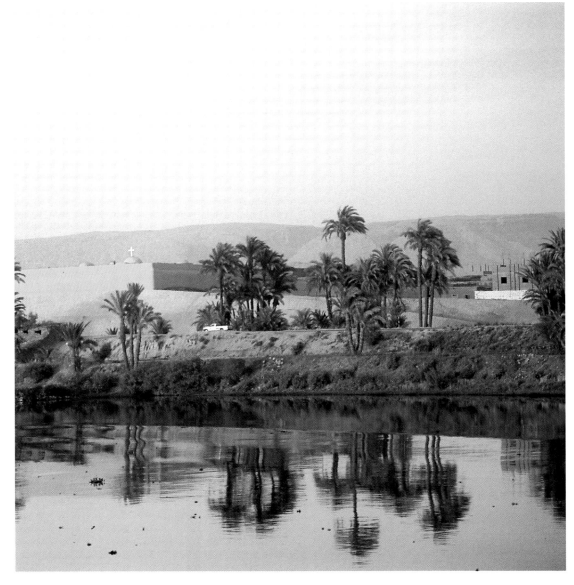

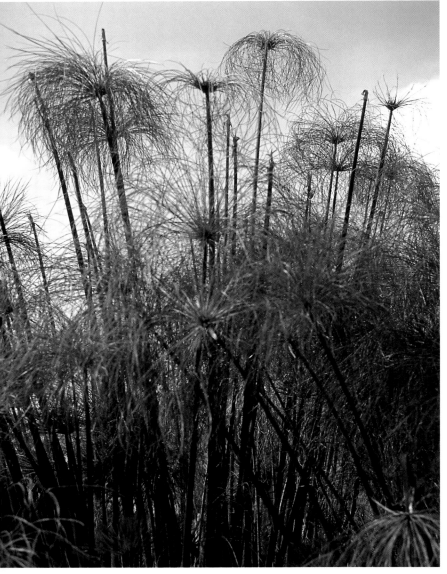

Papyrus and Lotus

No plants have become such symbols of Egypt as *Cyperus papyrus* (*left*) and *Nymphaea lotus*, or *cerulea* (*above right*). Papyrus, the heraldic plant of Lower Egypt, probably once covered the swamps of the entire Nile valley and delta. In the last few centuries, however, it had virtually disappeared and was held to be extinct in Egypt. But in the middle of this century, papyrus was rediscovered as a wild plant in a lake in Wadi al-Natrun. The plant is now farmed commercially as the raw material for papyrus sheets which are decorated for the tourist trade. It has recently begun to spread into the wild at Saqqara.

For the ancient Egyptians, this umbellifer was both a holy plant and a vital raw material. The paper which bears its name is made from sections of stalk beaten thin, soaked, woven loosely together, and dried in the sun. This papyrus-paper was the medium which enabled the massive expansion of bureaucracy in the Old Kingdom. Egyptian papyrus was famous throughout the ancient world and constituted a significant export commodity. Our word 'paper' derives, through Latin and Greek, from the word 'papyrus.'

The plant was also an important building material for boats (*opposite, below,* tomb of Ptah Hotep) and house walls. It was the raw material for sails, ropes, and sandals. Mats and baskets were made of papyrus and even the lower parts of the harvested plant became fodder for domestic animals. The sacred plant was the model for the huge papyrus-bundle columns, typical of Egyptian temples. Here (*below right*) they carry the huge architraves of the temple at Luxor.

The papyrus and lotus motif was a popular wall decoration as here, on a temple wall at Dendera (*opposite, above right*). The two were planted together in flower gardens and were among the most important grave goods. The lotus flower was practically the rose of the ancient Egyptians. They knew the white *Nymphaea lotus* as well as the blue *Nymphaea cerulea* (*above right*), appreciated for its fragrance. Because the flowers open in the morning and close in the evening the lotus flower became a symbol of rebirth. The "lily of the south" on the heraldic pillar of Karnak is probably not a lotus flower (*opposite, below right*), but is yet to be identified.

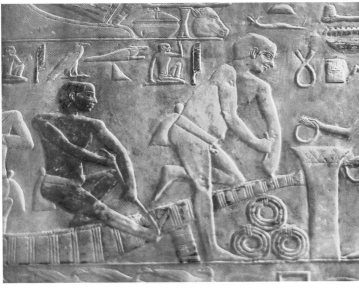

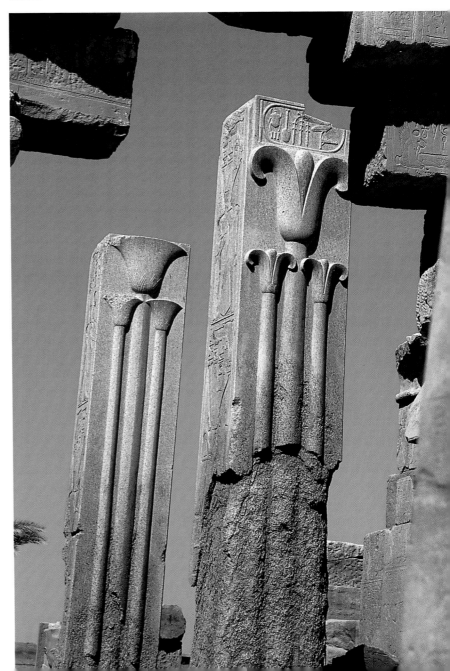

Columns

Columns are both literally and symbolically the supporting elements in the temples of the ancient Egyptians. Their design and decoration, both taken from nature, were heavy with mystical significance. The temple represents the original land as it first emerged from the primeval ocean. The columns are icons for the first plants to spring from this magical soil.

Lotus-bundle columns are common and palm trees (*left*) were models for another type of column. In the late period, the different motifs were combined to form composite columns as here, in the temple of Esna (*right*).

There stands a flower cup-column, alone, one survivor.
One cannot embrace it, so it stands, longer than life.
Only together with the night, one understands somehow,
takes it as a whole with the stars.
From their perspective, it is just another, fleeting human experience.
(Rainer Maria Rilke).

142

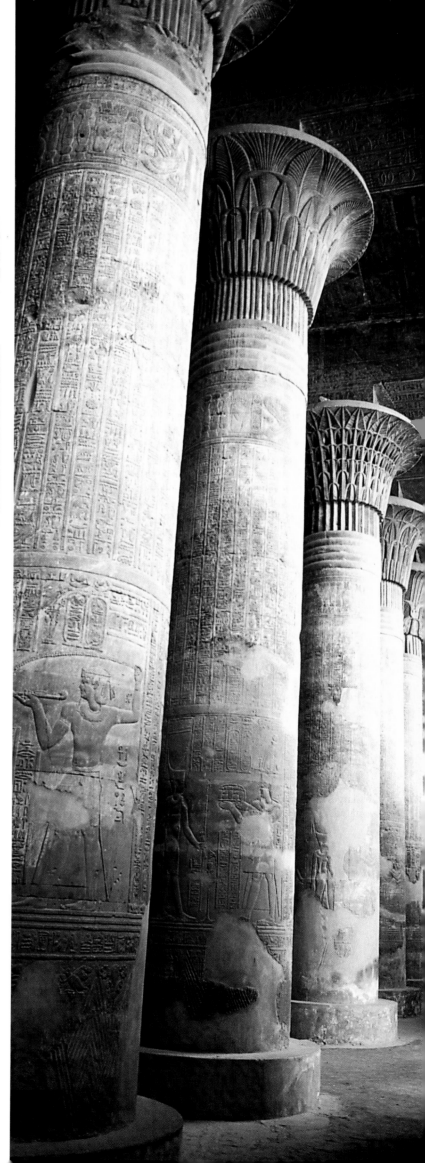

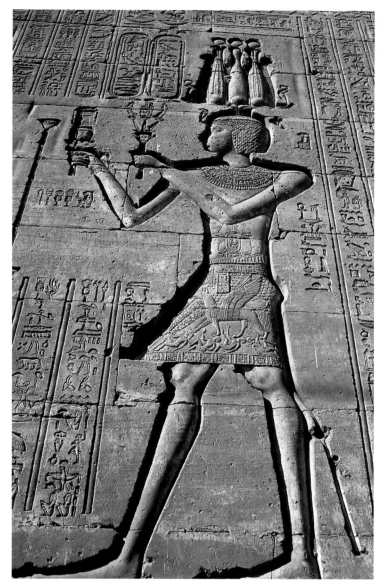

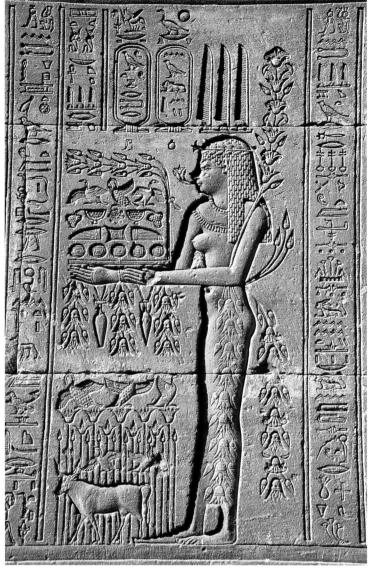

Egyptians, Romans, and Copts in Dendera

Dendera is an ancient cult center of Hathor, goddess of love, inebriation, ecstasy, and death, mother of the sun god, whom she rejuvenates, ruler of heaven, Upper and Lower Egypt, and all foreign lands. Sources point to a temple, which Khufu, builder of the largest pyramid, may have donated, and there are hints of a prehistoric cult here.

The temple which stands at Dendera today is a late Ptolemaic and Roman construction, the blocks of which were quarried from previous temple buildings. By this time, Hathor had become identified with Aphrodite, and the pharaohs depicted on the walls are the Roman emperors Augustus, Tiberius, Caligula, Claudius, and Nero (*above left*). The *mammisi* or 'birth house' (*below*), is also a Roman structure. On the walls unfolds the story of the birth of the god-child and his feeding by wet-nurses.

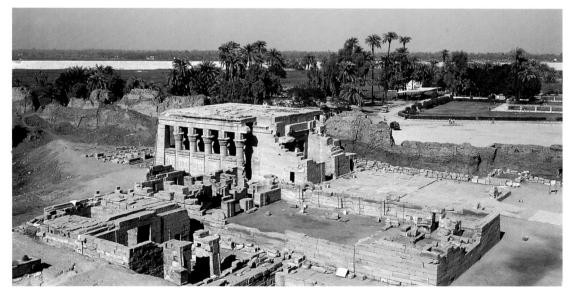

The priestesses (*above right*), beautifully dressed and richly garlanded with lotus flowers, lead sacrifices at the famous celebration of Hathor of Dendera. During this festival each year, she spent fifteen days with her husband, Horus, in his temple upstream at Edfu. This celebra

tion was the occasion for extended feasting by the whole population, a custom which ended only in the fourth or fifth century CE when the Christians took over Dendera. As in many other places, the antique temples were turned into churches or closed and a church built close by.

The ruins of this late fifth-century Coptic church at Dendera (*below*; in front of the mammisi) show how ancient Egyptian decoration was consciously avoided: Greek and Roman architectural elements were used instead.

143

The Stone of the Monuments

In Memphis, capital of the Old Kingdom, major monuments were built of local limestone, while in the south Nubian sandstone was preferred. This is not simply because the architects used local materials. Both were available in many parts of the country and distance was no object if a particular stone was required.

Until about the twelfth dynasty, however, monumental building was done exclusively in limestone. But once masons discovered that the more easily-worked sandstone was in fact more durable, it was naturally adopted as the main building material. Most monuments at Luxor date from the New Kingdom and are built in sandstone. Even so, in special circumstances, limestone was occasionally used, as here in the temple of Hatshepsut (*opposite, top*). This temple was cut into the mighty limestone cliff which guards the Valley of the Kings. Here and there, scattered on the ground, lie fossilized mussels, indicating the presence of chalk layers (*opposite, bottom*).

For special objects, particularly beautiful and valuable kinds of stones were used from earliest times, and no trouble was spared to obtain the rare material.

The beautiful rose granite for the obelisks (*right*, here of Thutmose I) and for the royal statues (*opposite, below right*) was brought on barges from Aswan, while graywacke for sarcophagi came from Wadi Hammamat in the Eastern Desert.

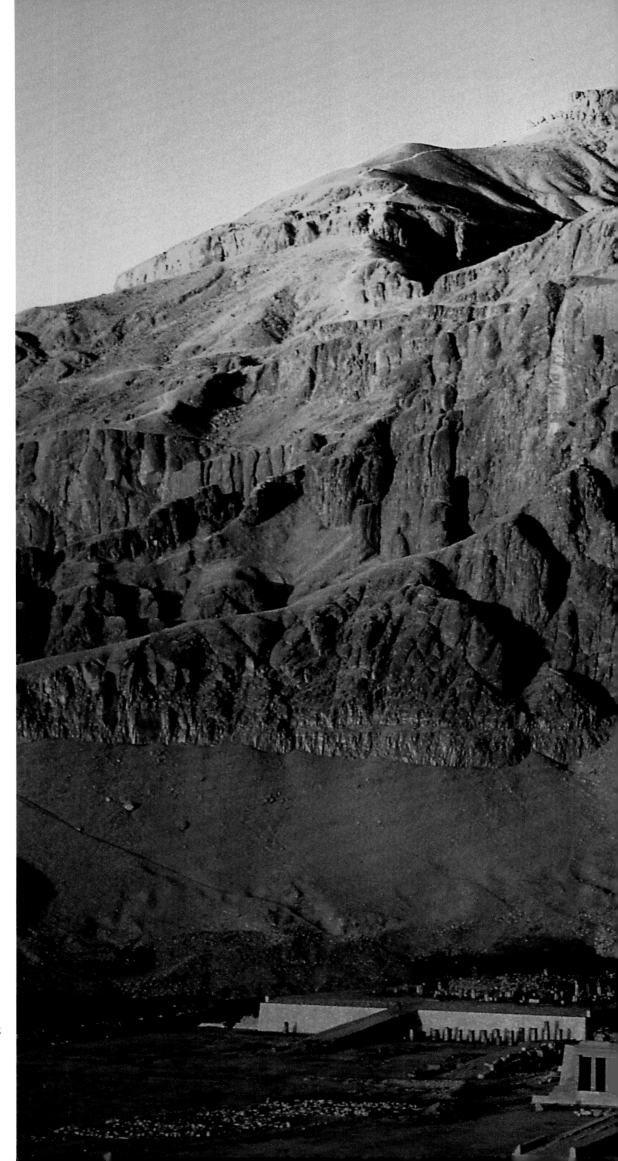

The Temple of Hatshepsut
Suddenly the pyramid-shaped mountain summit above Deir al-Bahari glows red against a blue sky. The reddish shine spreads over the steep cliff and, only a few minutes later, the rays of the rising sun touch the mortuary temple of Hatshepsut, the great empress of the Eighteenth Dynasty. This astounding monument, built for one of the most famous women of ancient Egypt, glows majestically in the morning light over the Nile valley. Even the reconstructed temple makes a magnificent impression. How much more astounding the original building would have been. From the valley temple (now destroyed), a 37-meter-wide ramp, flanked by colossal sphinxes, led to the terrace temple. Before the first ramp, basins containing papyrus plants decorated the temple garden. Myrrh trees, part of the booty of the expedition to Punt, grew in the terrace. Along the walls of the colonnades, historically important wall-reliefs describe that famous voyage of discovery. The royal tomb chamber was carved from the rock behind the temple. The architect of this unique monument was supposedly Hatshepsut's high steward, Senenmut. Much has been written about his private relations with her, all of it speculation. Despite extensive destruction and restoration, the structure remained in use as a temple until Ptolemaic times. It was later adopted by Christians and became the Epiphanias monastery. Just to the south lie the ruins of the mortuary-temple of the Middle Kingdom pharaoh Mentuhotep, whose construction probably served as a model for Hatshepsut's temple; unfortunately this interesting monument is now heavily damaged.

146

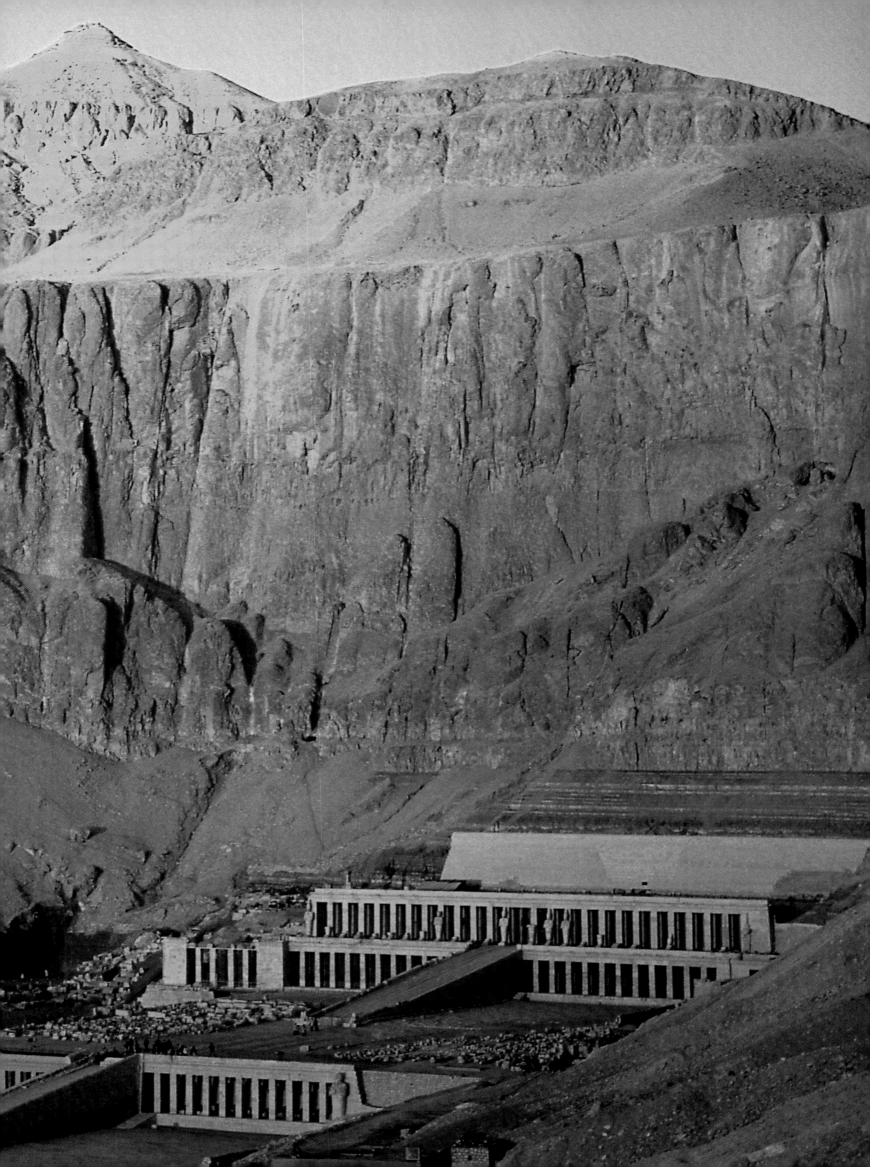

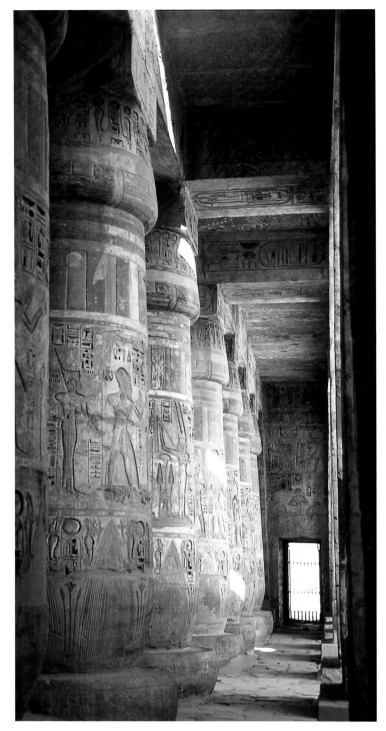

Hundred-gated Thebes, City of Religious Festivals

The once hundred-gated Thebes has today split into three districts. On the east bank, the former residential areas and temple precinct have become Luxor and Karnak. On the west bank lies the ancient city of the dead, although even in antiquity, priests, priestesses, stone masons, construction workers, artisans and artists lived there with their families.

Thebes was the city of the god Amun. The focal point of religious celebrations was the Amun temple of Karnak (*above*), one of the largest temple complexes in the world. The white chapel of Senusert I of the Middle Kingdom (*below left*), covered with meticulously-carved reliefs, counts as one of the oldest preserved parts of the Karnak temple.

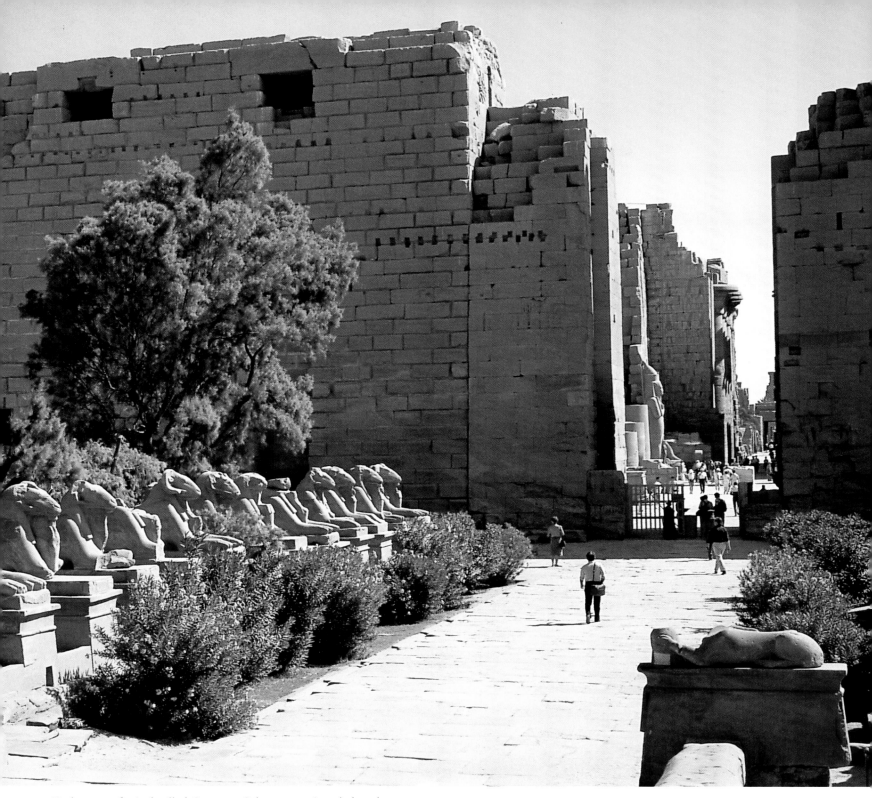

Each year, a festival called Opet took place in celebration of the marriage of Amun to his consort Mut. A procession started at the Amun temple and slowly moved in great splendor on a Nile barge towards the temple of Luxor. In another festival, held every ten days, the god Amun crossed the Nile to Medinat Habu (*above left*), the mortuary temple of Ramses III. The procession, called the "beautiful feast of the Nile valley" ended at the terrace temple of Queen Hatshepsut (*previous pages*).

Other processions led to the Ramesseum (*below right*), the mortuary temple of Ramses II, and to the very extensive mortuary temple of Amenhotep III, of which today only the famous Colossi of Memnon still stand.

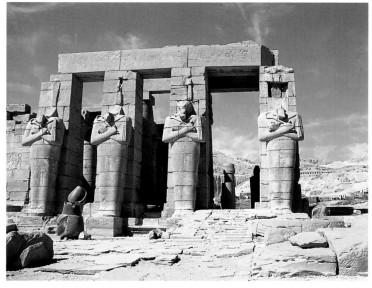

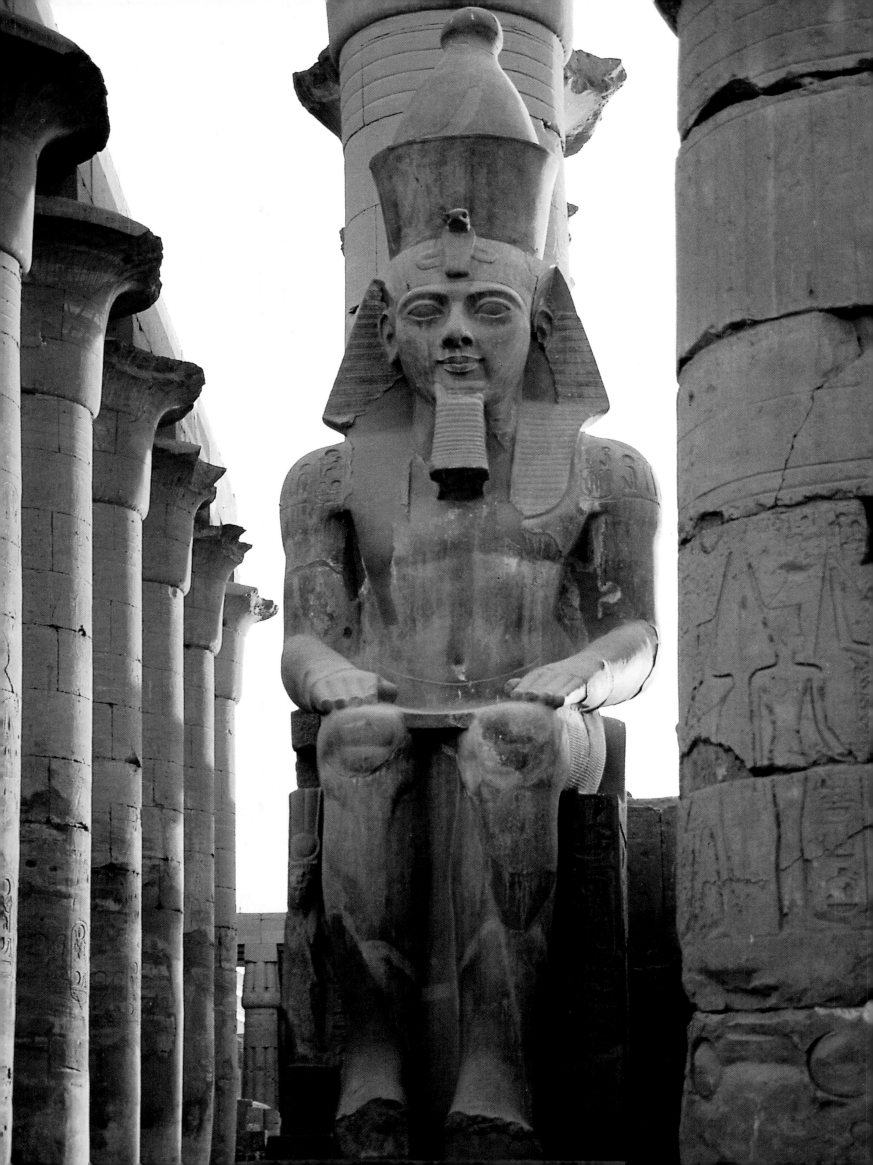

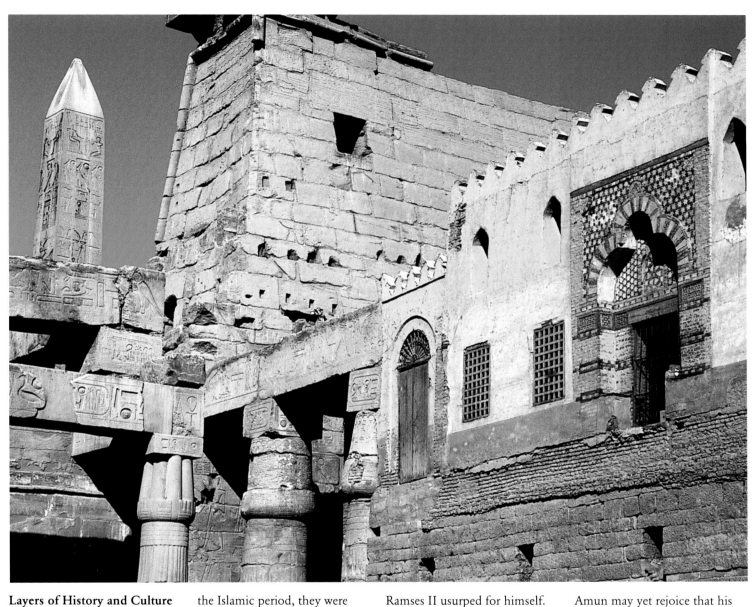

Layers of History and Culture in the Temple of Luxor

With the conquest of Egypt by the Persian king Cambyses in 525 BCE, the history of independent ancient Egypt came to an end. Foreign rulers made use of the Egyptian cults and temples for their own glory, extended existing constructions, and even built new temples such as those at Esna and Edfu. Later, Egyptian temples became churches, fortifications, and warehouses. After 640 CE, during the Islamic period, they were forgotten if not used as quarries. The sand and mud of centuries gathered in the huge buildings, and perhaps also covered the seven-meter-high seated statue of Amenhotep III (*left*), which Ramses II usurped for himself. The new rulers of Luxor built the mosque of Abu al-Haggag into the old temple (*above*). Only recently, since the temple has been uncovered, has it become clear that the foundations of the mosque begin at the height of the column capitals and probably rest on the remains of a Christian church.

Amun may yet rejoice that his festival is remembered: as an annual procession for a local Islamic saint, the *moulid* of Abu al-Haggag, the ancient pharaonic Opet celebration continues.

The Way to the Afterworld

Death cults, perhaps the oldest rituals of humankind, may well have been the direct ancestors of later, full-blown religious systems. The ancient Egyptians paid greater attention to the afterworld than any other cultured people in antiquity. Expenditure on the death cult was so huge that the attitude of the Egyptians toward life has been often misinterpreted as fatalistic and uncaring. In fact, the afterlife was important to them precisely because they knew how to appreciate and enjoy life on earth. Extensive preparations were made to allow life to continue in the style to which the deceased was accustomed. Rich grave goods and regular sacrifices by the living were thus of great importance. Not that this attentive funerary activity was occasioned by fear of the dead. In fact the welfare of the dead was thought to be dependent on the regular performance of grave-rites by the living. Life in the hereafter was considered as real

as this life and equally threatened by disaster. Nothing was more feared by an Egyptian than the second death which would be final.

Furthermore, the kings' tombs—particularly the pyramids of the Old Kingdom—fulfilled a symbolic function: they embodied the central monarchy and the resurrection of pharaoh as god. Their grave chambers inside the huge geometrical stone buildings were originally without decoration, but monumental, as in the case of the Red Pyramid of Dahshur (*right*).

The first pyramid with significant interior decoration is the pyramid of Unas (Wenis) from the end of the Fifth Dynasty. The walls of the tomb chamber are covered with exquisitely-carved spells and incantations to ensure the king's

successful journey to the stars. It was during the Old Kingdom that the elaborate depiction of scenes of sacrifice and daily life began, a tradition which would continue for over two thousand years. During the Old Kingdom, only the pharaoh and his immediate relatives looked forward to immortality among the stars. Later, however, as central authority weakened during the First Intermediate Period, license for passage into an afterlife was extended to nobles, priests and, eventually, to ordinary people. By the New Kingdom, even peasants would be buried with a papyrus roll bearing vital verses from the Book of the Dead.

Several burial customs of ancient times are preserved in modern Egypt, such as the practice of hiring wailing women—professional mourners (shown here in the tomb of Ramose, *left*).

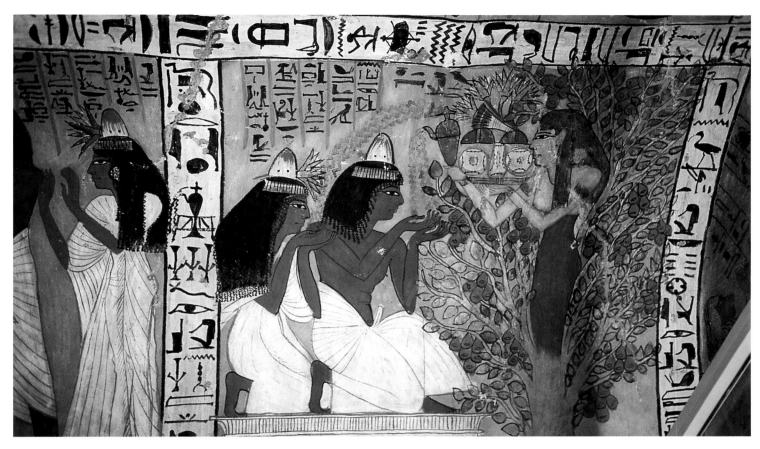

Artisans for Tombs of the Mighty

Deir al-Medina, the village of the necropolis workers in western Thebes, has proven an invaluable resource for Egyptology. In this guarded and secluded settlement not far from the Valley of the Queens lived the workers, artisans, and artists who for their entire lives were engaged in fashioning the tombs of the kings, queens, and dignitaries of the empire.

In the ruins of Deir al-Medina, researchers have found many pictorial and written accounts of the daily life of ordinary people which have taught us a great deal about ancient Egypt. The inhabitants of the workers' city constructed their own necropolis above the settlement with small but often elaborately-decorated tombs for themselves and their families.

Sennedjem, 'Servant at the Place of the Truth' and craftsman, constructed a small tomb opposite his house remarkable for its well-preserved wall paintings. The ceiling of the

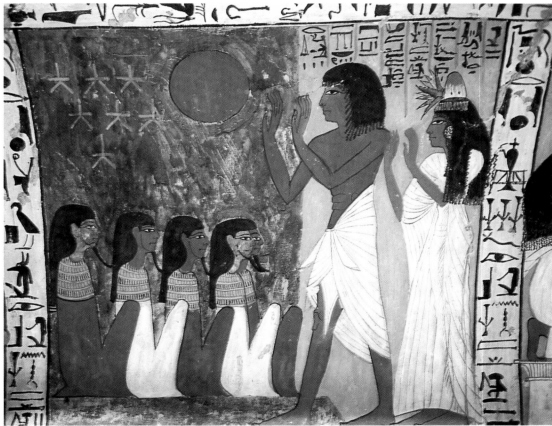

tomb chamber (*above* and *below*) depicts a sycamore-tree spirit, offering food and water to a couple on their ultimate journey (*above*). A papyrus, kept in Turin, contains a love song from the Twentieth Dynasty which says: "The small sycamore, which she has planted with her hand, moves her mouth to speak. The rustle [of her leaves is like] the scent of honey. She is beautiful. Her fine branches are green."

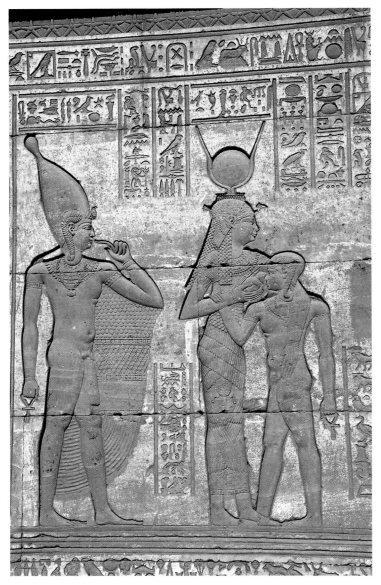

Women in Ancient Egyptian Society

If we interpret the historical evidence correctly, women played a role in ancient Egyptian society which, thousands of years later, might serve as a model for their modern descendants. Whereas the emancipation of women is often understood today as a struggle between the sexes and the striving for material equality, and against the economic dependency of women, relations between the sexes in ancient Egypt were marked by something best expressed as natural completion.

In the pantheon of the ancient Egyptians, goddesses were as significant as male gods. Goddesses reared the royal deities, as here Hathor suckles Horus in the mammisi at Dendera (*above left*); a goddess might crown the pharaoh, as illustrated vividly in the temples of Edfu (*above right*) or Abu Simbel (*below left*).

Women enjoyed the highest honors as 'royal wives,' and could even ascend to the throne, as did the female pharaoh, Hatshepsut.

At the lower levels of society, women were equal to men in the material sphere, had their own property, could inherit and bequeath, and could earn their living at court as servants, civil servants, scribes, and priestesses, sometimes in quite exalted positions.

The vulture was associated with Mut, the great mother-goddess: many depictions of goddesses show them wearing a vulture-cap, as in the photographs above left and right.

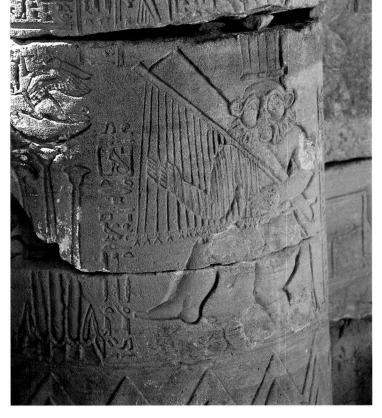

As Long as the Celebration of Life Continues

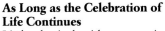

Little physical evidence remains of daily life in ancient Egypt, since secular buildings and household utensils were made of materials which have not survived.

But it is clear from tomb paintings that the ancient Egyptians took great joy in life. Perhaps the most beautiful depiction of a feast (celebrated by both men and women) is to be found in the tomb of the vizier Ramose, who served under the pharaohs Amenhotep III and Akhenaten. Four splendidly

decorated couples with elaborate coiffures (*above*) visit Ramose and his wife.
Ihy, son of Hathor of Dendera and young god of music (*below left*), pleases the gods and the ladies at the banquet with the sound of the rattling *sistrum* and the jingling *menit*, with its big pearl ribbons which avert evil

spirits. The harp, here played by the satyr-like demiurge Bes in the temple of Philae (*below right*) counts as one of the oldest musical instruments of the Egyptians.

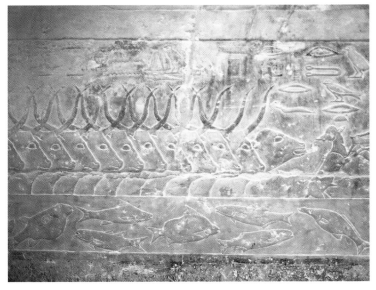

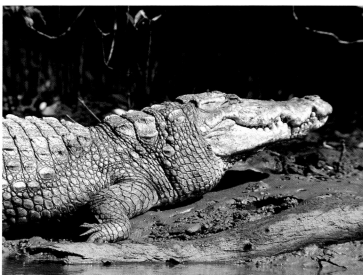

The Nile Crocodile

No animal has a stronger connection with the Nile than the crocodile (*below left*). It had long been extinct in Egypt, and it was only with the creation of Lake Nasser that crocodiles from Sudan were able to recolonize the Nile in the far south. Meanwhile they have multiplied to such an extent that wealthy Arabs are again allowed to hunt without limit.

The crocodile was feared as a marauder and killer (*above left*, Mereruka): the shepherds charmed it with a song when they had to drive their herds through the river, as can be seen in a wall painting in the tomb of Idut at Saqqara (*above right*). At Dendera, however, it was said that men had no fear of crocodiles, as this love song suggests:
The love of my lover is mine. A crocodile lies on a sand bank. But when I've gone into the water I step on the flood and I find the crocodile as harmless as a mouse, because of my love which makes me so strong; it makes the water magical for me.
According the historian Herodotus, the crocodile was eaten at Aswan, because it was not considered sacred there. Stuffed crocodile mummies are still found in many parts of Egypt as a charm to ward off the evil eye (*below right*).
But for the most part, the crocodile was sacred, being associated with the god Sobek. Several temples were dedicated to Sobek from the delta to Kom Ombo (*opposite page*). There was also a temple in the Fayyum at Lake Qarun, which must have been teeming with crocodiles. Many crocodile fossils have been found here. At Crocodilopolis, Sobek was honored as the chief of gods.

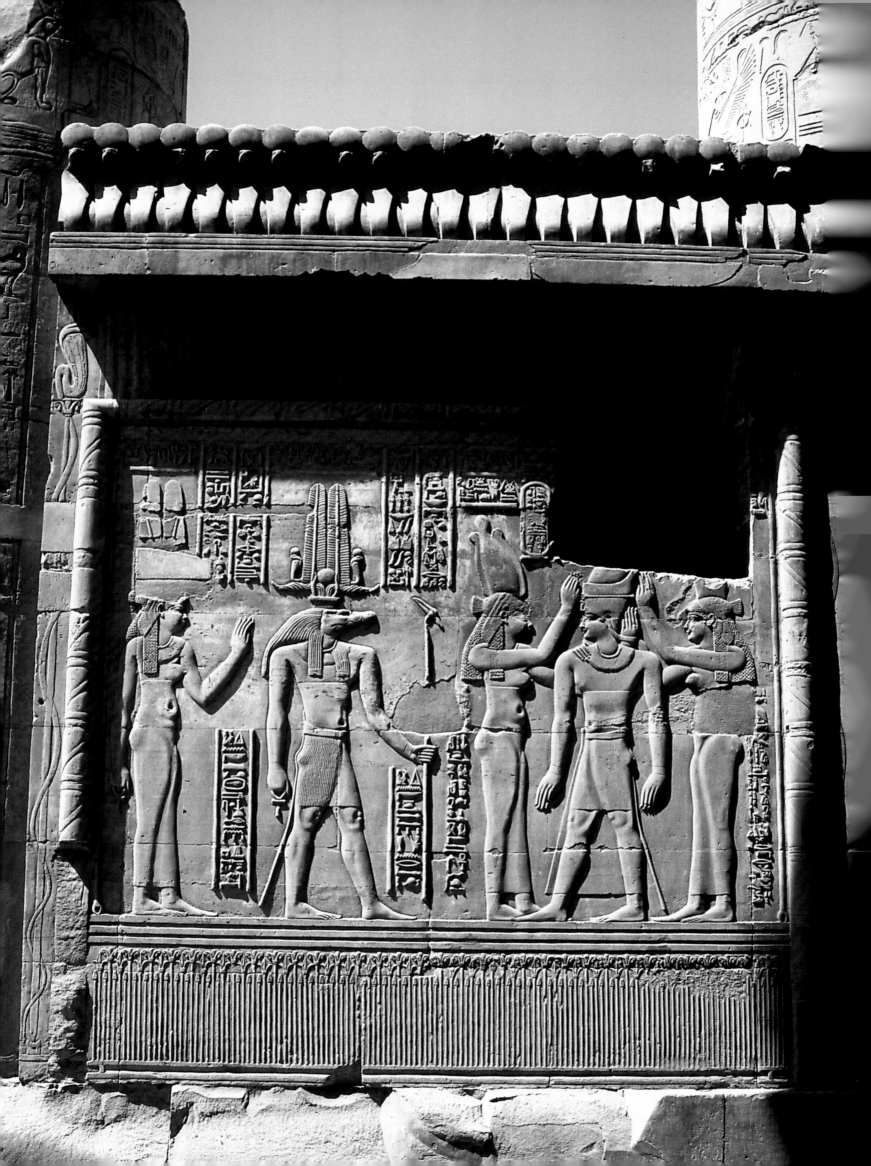

Nubia – Gateway to Tropical Africa

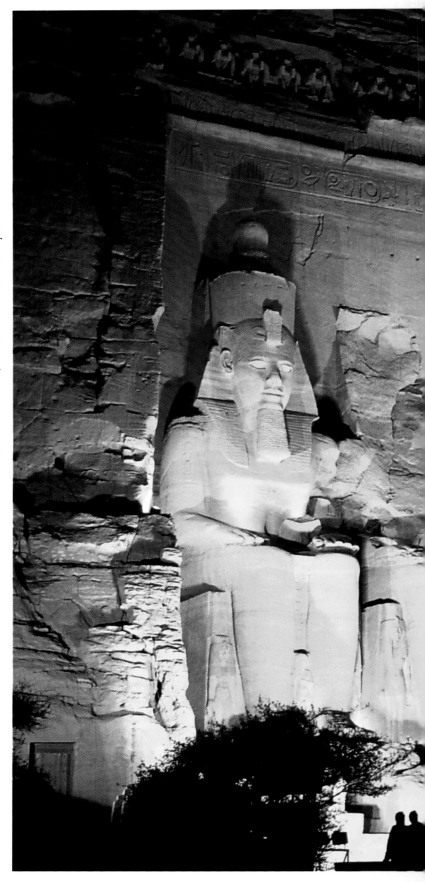

Abu Simbel, showpiece of imperial Egyptian power, has become the most prominent symbol of Nubia, almost all of which is now submerged beneath Lake Nasser. Mahmoud 'Abdel Aziz, a Nubian living in Cairo and a good friend for many years, fired our imaginations with his stories and opened up an unsuspected Nubia for us. Mahmoud's father was a respected Sheikh in Old Aniba. He told this story to his sons:

A wise old man was about to die and called his four sons. He told them each to go and get two small pieces of wood and then return. The father took from each son in turn one piece of wood and broke it in front of them. Then he took the second piece from all of them, bound them together and tried to break them as well. But he could not break them. "Look, my sons" said the father, "if you hold together in life like these four pieces of wood, you will be strong and nobody will be able to harm you."

A strong family bond and a deeply rooted love of the homeland is characteristic of most Nubians. Mahmoud also said: "Every time I go back to Cairo and say good-bye, my mother follows me for seven steps. At each step, she scoops a little sand and keeps it until I return."

Abu Simbel – Symbol of Power
No other pharaoh demonstrated his claim to power over Egypt and the world with such grandiosity as Ramses II, whose gigantic monuments are spread all over the empire. One of the most impressive of these is the famous rock temple of Abu Simbel (*right*). The temple is uniquely positioned, high above the Nile in Lower Nubia. With this monument, the Egyptian claim in the south, at the gate to sub-Saharan Africa, is clearly marked. The huge temple was originally cut into the cliff, and the decoration is especially fine. Four colossal statues of the king line the entrance which is positioned so that, twice a year, the rays of the rising sun illuminate the sanctuary in the depths of the temple. This sanctuary contains the seated statue of Ramses between the gods Ptah, Amun, and Ra-Horakhty. Ramses presents himself here outside the Egyptian heartland not only as the offspring of a god, but as a god himself.

Abu Simbel gained world renown when the temple was cut out of the rock and relocated—an impressive engineering feat—to save it from the floods of Lake Nasser.

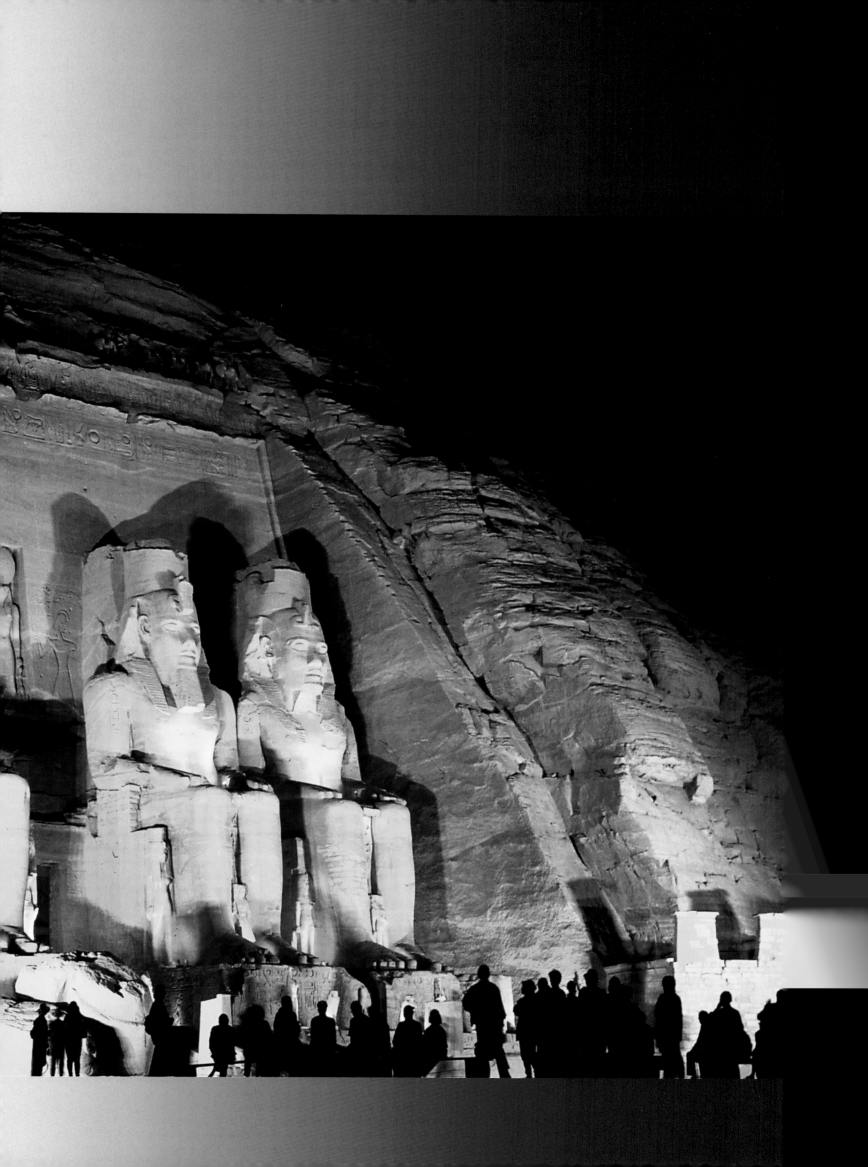

Nubia – Water and Desert

For five thousand years, Egypt has been the fate of Nubia. It started with the plundering of Kush, "the land of gold," in the time of the earliest pharaohs. They appreciated not only this precious metal but also gemstones, valuable hardwoods, the sturdy cattle of the Nubians, and not least their sons as soldiers.

Lower Nubia, stretching from Gebel Silsila (just north of Kom Ombo) to the Second Cataract (south of Wadi Halfa) became an Egyptian province during the Middle Kingdom—perhaps even earlier. Even so, the area was largely ignored except as a source of raw materials and a trade route to the African heartland.

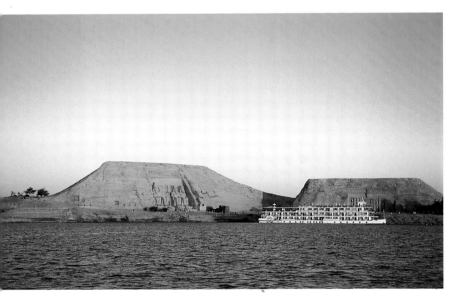

Despite a long joint history, the Nubians have always maintained an identity separate from the Egyptians. Egyptian civil servants were sometimes posted to Nubia for disciplinary reasons. They feared the hot dry climate, the frugal life, and the dark-skinned people whose language and traditions they could not understand.

When Nasser dammed the Nile in 1964 with the Aswan High Dam he sealed the fate of this old land for ever. It is a part of Nubia's tragedy that the whole of this lost land should be represented by the rescued temples—power symbols of the pharaohs—from Kalabsha to Gebel Barkal in Sudan. The High Dam, which marks Egypt's proud break with the colonial past, is for Nubians a monument to the sacrifice of

their world. The waters of the Nile, source of their material and spiritual life for thousands of years, became the grave of their homeland. One hundred and twenty thousand people were obliged to give up their villages and land so Egypt might feed its growing masses. But Egypt absorbed the uprooted people, gave them new land, built villages for them, and provided a basic infrastructure, and so afforded the Nubians a new start.

Nubia has, by all accounts, always been a frugal land. Arable land is scarce and always threatened by an uncompromising, mountainous desert. Every patch of fertile land and every tree was cared for. The life-giving Nile received prayers at its banks. The villages were generously built, however, since there was plenty of space. Public spaces were kept clean and the walls and inner yards of the houses were painted colorfully with magical signs and decorative ornaments. Here and there in the hills, domes of sheikhs' tombs could be seen. One of the worst losses for the expelled Nubians was that they had to leave the land where their ancestors are buried.

Only from the water can one now experience what is left of Nubia. The pharaohs' temples were relocated in an international rescue operation. Some of the most important are New Kalabsha, New Wadi al-Sebua, New Amada, Qasr Ibrim, and, of course, Abu Simbel.

Nowhere more than at Lake Nasser do water and desert clash so starkly. In the midst of the sandy waste is a watery desert. Mountain peaks have become

curious islands, blue water penetrates surreally into sandy inlets and now, since the lake is so full following the high flood of 1996, the scanty vegetation which had grown up on its margins over the last few years has disappeared. Sometimes one can see the tips of some flooded tamarisks. The only signs of former habitation are the occasional cemeteries, set high above the Nile valley.

In a mellower light, birds flock over the lake. For several years now, tropical and subtropical birds have made Lake Nasser their home. They are joined by migrating birds in spring and autumn. Fisherfolk enliven the water with their boats, accompanied by seagulls. Their efforts are rewarded by a fine catch.

The drastic and widespread effects of the lake on the ecology of the area are clear. There is often a haze in the air, and clouds form over a region which rarely saw them before. Disastrous winter storms have descended on Aswan and Upper Egypt during the last few years and their number seems to be increasing. Not only does fertile mud bank up, unused, behind the High Dam but also huge amounts of water are lost through evaporation, and one wonders for how long the Nile can continue to provide enough water for all the large irrigation projects in the desert.

Old Nubia is today water and desert. But what has become of the new Nubia, that stretch of desert land, far from the Nile, which was given to the Nubians as their new home? At the edge of the arable land, in a strip fed through canals, the Egyptians built new villages. In order to not disrupt family and tribal bonds completely, they were built in the same sequence as in old Nubia. In the first years after 1964, this desolate area with its undecorated villages must have traumatized the uprooted Nubians. But a short journey through the flat but nowadays very green landscape shows they have made a remarkable effort to adapt to their new circumstances. A visit to these villages for a few days confirms the impression. Full of pride, the Nubians point out the many new agrarian projects, workshops, and shops.

The guest is invited into a clean, tasteful, and practically-furnished house and, conforming to tradition, the table bends under the weight of delicious food. Nile landscapes of old Nubia hang on the walls.

One senses the bonds of a community which continues to encompass the Nubian diaspora in Cairo and Alexandria or abroad. Many of the originally sad house façades are, like the inner rooms, painted colorfully again; here and there, traditional symbols and decorations appear. It is a mistake to think Nubia is dead; the Nubian people live and plan for their future.

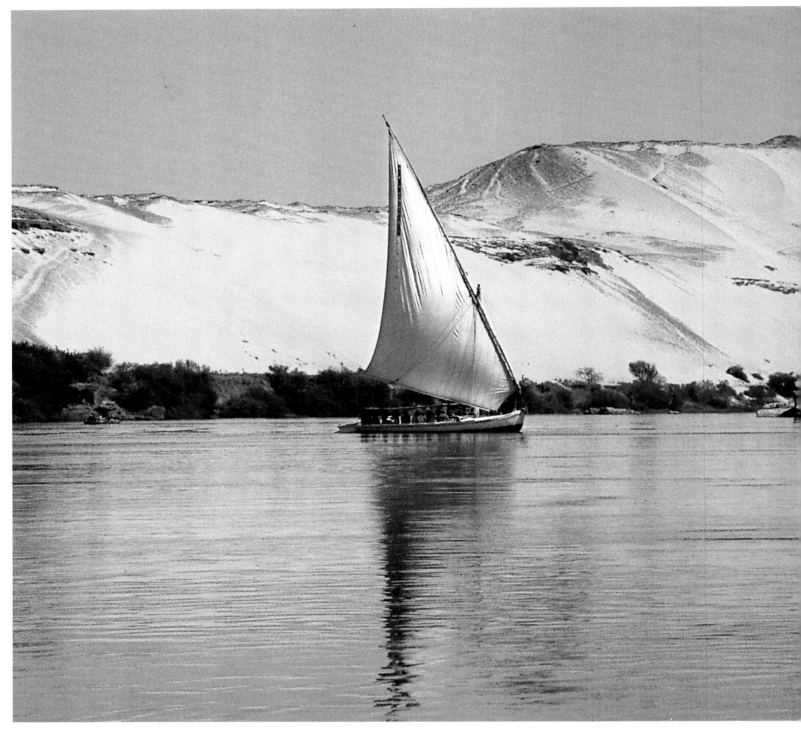

Aswan at the First Cataract
Huge granite blocks in the river bed mark Egypt's natural southern border at Aswan. But the Nile plunges through this chaos of rocks, which the countless floods have rendered round like the backs of elephants.
If one strolls in winter on the corniche along the Nile, one experiences an open, friendly, sun-pampered winter resort with a mild climate in a blessed location. The view extends over the blue river, decorated with white felucca sails and green islands, to the reddish-yellow slope of the Western Desert (*above*). In these rocks, the local dignitaries of ancient Egypt cut their graves. Aswan is held in high esteem for winter holidays and many of the rich and famous have come here for rest and recreation. The Aga Khan, head of the Shiite Ismailis, not only had his villa at Aswan but had his mausoleum built on the edge of the desert here. Not far beyond it one finds the ruins of St. Simeon's Monastery. This seventh- or eighth-century Coptic foundation was deserted in the thirteenth century because of Bedouin attacks and lack of water. Some parts of the building, such as the vaulted dormitory corridor (*opposite, left*), were so well preserved that it was thought appropriate to support them with modern iron pillars. In one of the tombs beside the largely destroyed church are remnants of wall and ceiling paintings, among them a pomegranate (*opposite, right*).

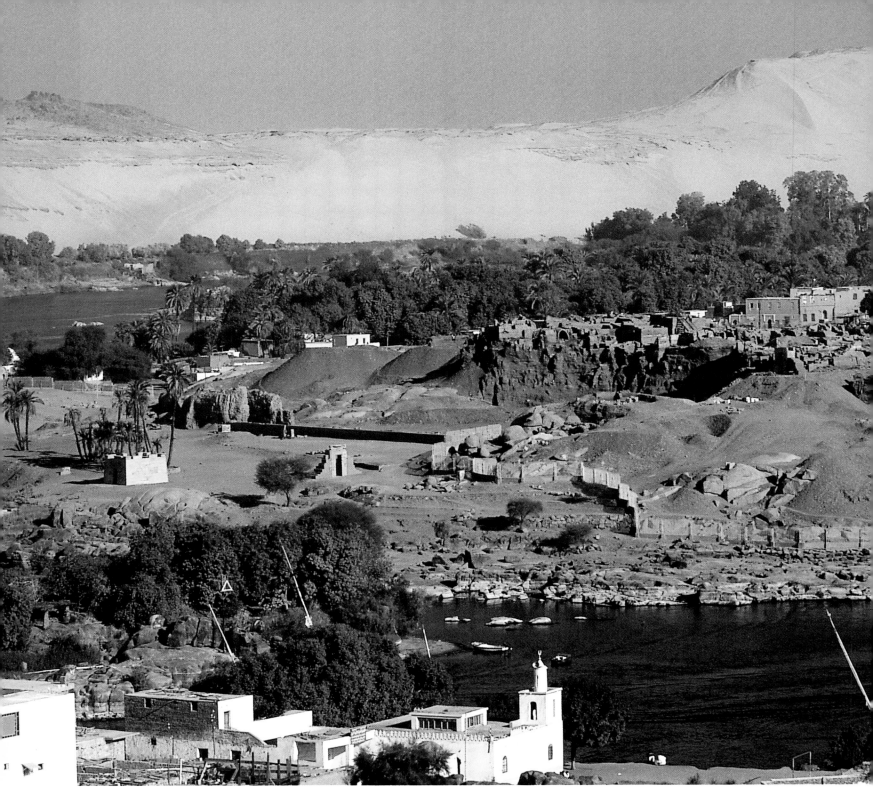

Elephantine – Five Thousand Years at a Glance

The true heart of Aswan lies on the cataract island of Elephantine (*above*), known in ancient times as Abu, the Egyptian word for elephant. Old rock paintings around Aswan seem to show that elephants and other African wildlife were still found in this region during the time of the first pharaohs. In any case Elephantine was an important station for the ivory trade with Punt.

Traces of very ancient settlements have been found on Elephantine. In exhaustive work, members of the German Archeological Institute and the Swiss Institute have uncovered five thousand years of history on one site, right next to a Nubian village.

The lord of the cataract, the ram-headed god Khnum, is seen here together with the goddesses Anuket and Satet of the island of Sehel. Together they form the holy triad of Elephantine.

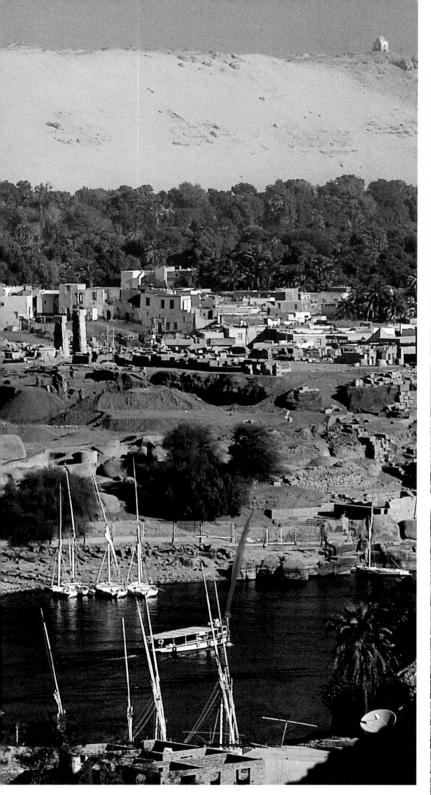

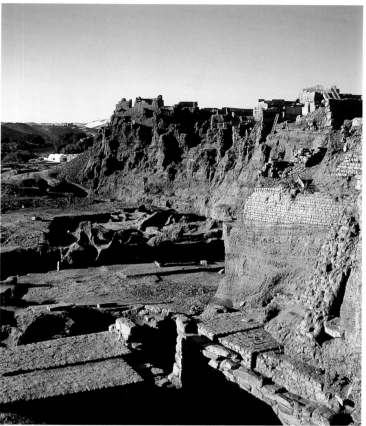

Here at Elephantine, the ancient Egyptians believed, was a cave from which Satet, the "bringer of water" sent forth the annual Nile floods when the dog star Sirius showed itself again in the heavens. This was the time of the Egyptian New Year and the occasion for a great feast.

Elephantine is the site of one of the most important Nilometers. On the walls the highest, mean, and lowest water levels were recorded. Formerly, Nile floods left their marks on the rocks of the cataract just as the pharaohs left their cartouches (*below right*).

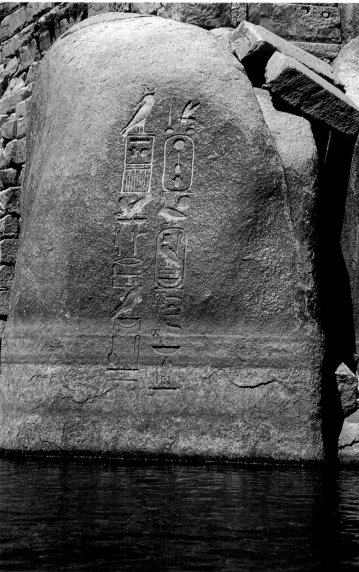

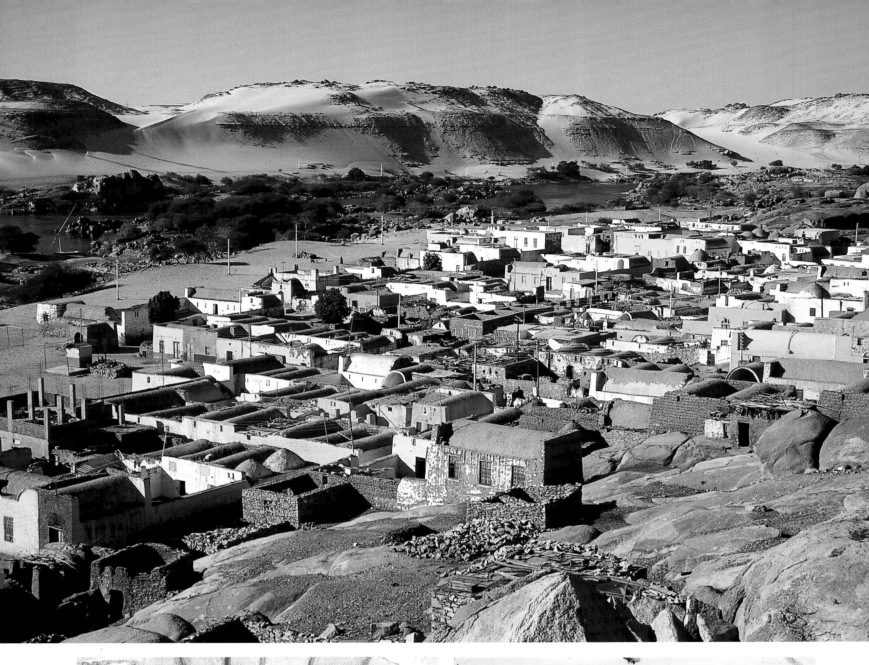

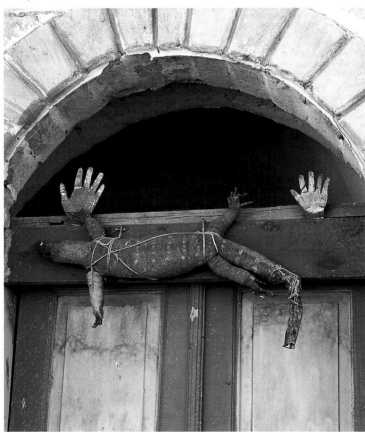

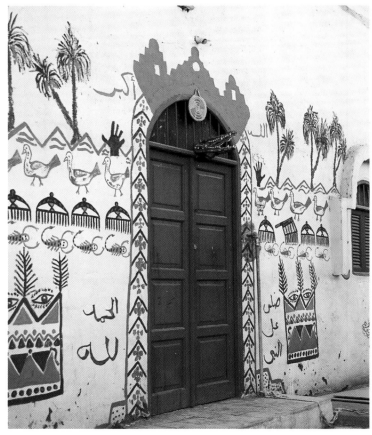

The Last Villages of Old Nubia
When the British started building the first Aswan dam in 1898, they started a process which would end in the destruction of over five thousand years of settlement in Lower Nubia. In the first few years of this century, as the waters began to rise, the Nubians founded new villages higher on the desert plateau. But with the raising of the High Dam, Lower Nubia drowned in the waters of the tamed Nile. Thus the scarce remnants of original Nubia are all the more interesting. The Nubian villages on the islands of Elephantine and Sehel (*opposite, above*) a little further south are a popular attraction for visitors on felucca trips from Aswan. Here we find the traditional domestic architecture of the Nubians: a courtyard surrounded with rooms roofed with barrel vaults made of mud-brick. The walled yards huddle closely together, maintaining an intimate privacy. The entrances require special protection, which is secured not only through thick door planks and heavy bolts: the open hand symbol (*opposite, below left*), which was known in early Christian times as 'Mary's hand,' and later in the Islamic period as 'Fatima's hand,' traces its roots back to the Paleolithic era and is a very old symbol to fend off evil forces. The crocodile, or the stuffed monitor lizard (*opposite, below left*) are supposed to protect against the evil eye. Doors often carry other magical signs, as here in Elephantine (*opposite, below right*). Nubia was always a poor land: often, built in the narrow, steep-sided, sun-scorched river valley, villages had to make do with scarce patches of soil to grow their meager crops. This little garden (*above right*) on Sehel demonstrates the careful use of every last patch of earth. The strong bond of Lower Nubia with Egypt is recognizable everywhere, as in these granite rocks (*below right*), which were decorated thousands of years ago with pharaonic inscriptions.

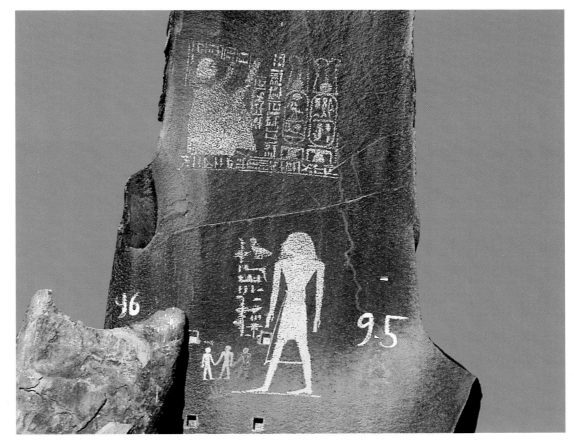

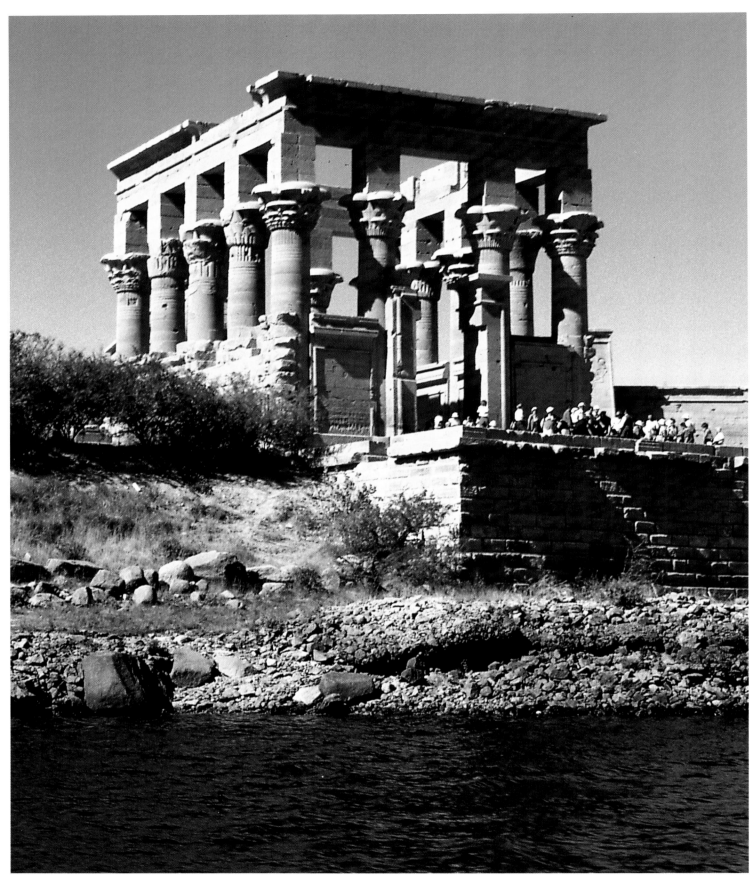

Philae, Pearl of Egypt

The approach by water is quite the most beautiful. Seen from the level of a small boat, the island, with its palms, its colonnades, its pylons, seems to rise out of the river like a mirage. Piled rocks frame it in on either side, and purple mountains close up the distance. As the boat glides nearer between glistening *boulders, those sculptured towers rise higher and ever higher against the sky. They show no sign of ruin or of age. All looks solid, stately, perfect. One forgets for the moment that anything is changed. If a sound of antique chanting were to be borne along the quiet air—if a procession of white-robed priests bearing aloft the veiled ark of the God, were to come* *sweeping round between the palms and the pylons—we should not think it strange.*

This is how the author Amelia Edwards described her arrival at the island of Philae in 1874 to visit the famous temple of Isis (*above right*). Today, the pearl of Egypt is no longer on the island of Philae. The first Aswan dam flooded the island for nine months of the year, allowing only the temple roofs to show above the Nile. With the raising of the High Dam, these exquisite monuments would have perished for good, so they were moved to the higher ground of the neighboring island, Agilka.

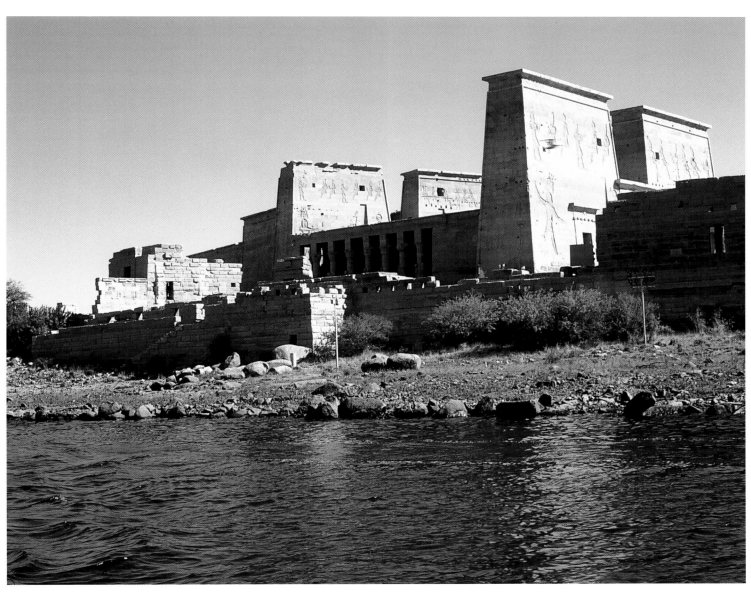

Agilka was partially reshaped to resemble Philae and the dismantled temple of Isis was painstakingly reconstructed here (*above left and below right*) together with the wonderful kiosk of Augustus Caesar (mistakenly attributed to Trajan) and other buildings. Most monuments here date from Ptolemaic times, although there are some remnants from the reign of Nectanebo I. The resurrected 'Philae' is today a major tourist attraction and boasts a sound and light performance at night. The temple of Isis became a focal point of an international cult of Isis which blossomed in the Mediterranean countries in the early part of the first millennium CE. Philae was probably the last temple in which the ancient Egyptian cult was practiced when the country had become Christianized. Likewise, in this deeply-conservative land, Christianity persisted in Upper Egypt long after Egypt had adopted Islam as its official creed.

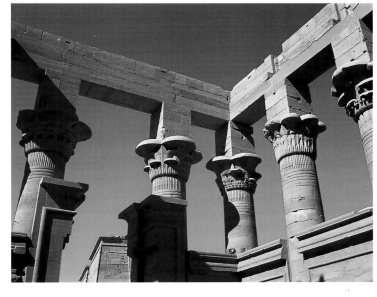

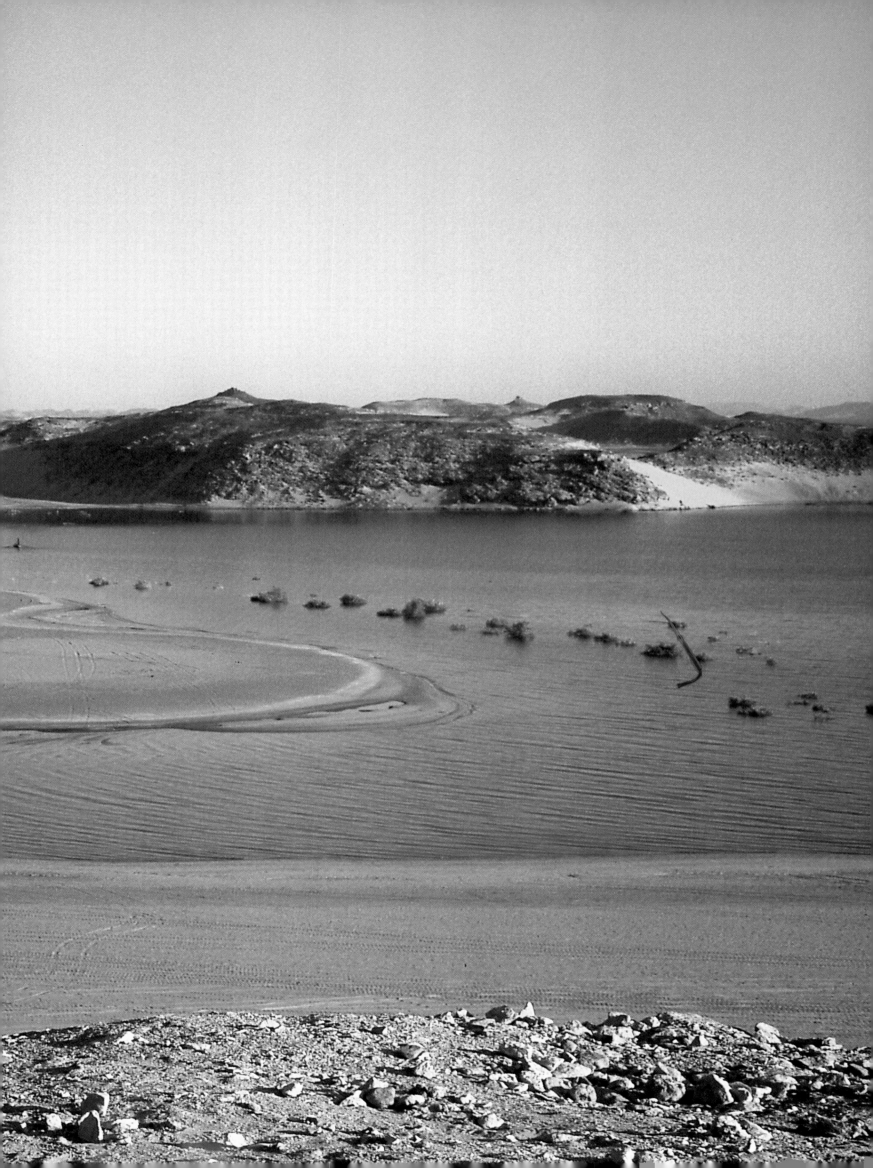

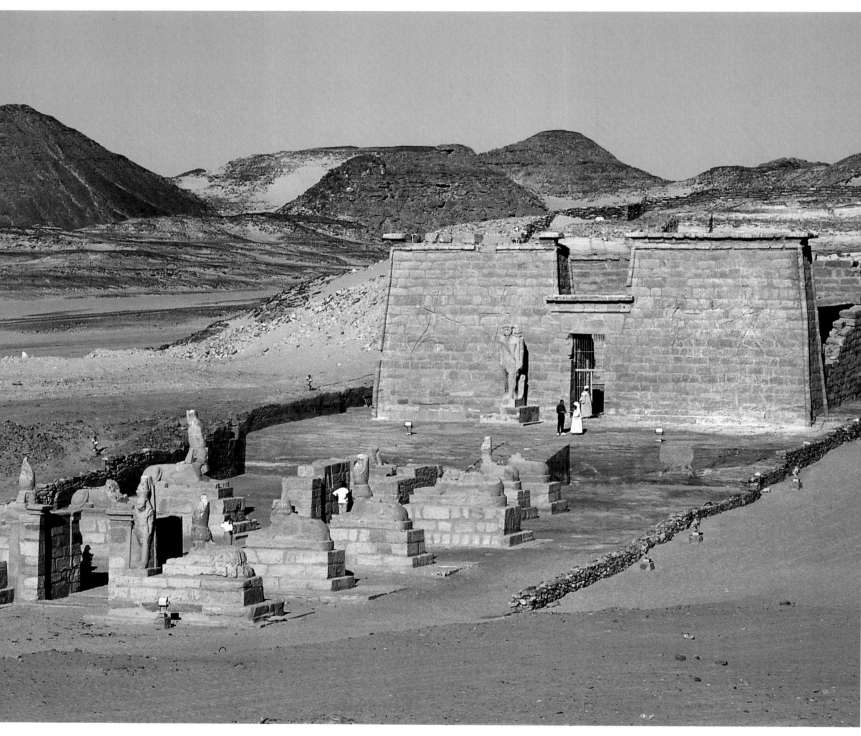

Previous pages:
Nasser's Monument
Lake Nasser is an engineering feat in the superlative: it holds up to 157 billion cubic meters of water, reaches a maximum surface area of five thousand square kilometers, and is 550 kilometers long, reaching 200 kilometers into Sudan. This gigantic mass of water has a unique economic, strategic, and ecological significance for Egypt. For Lower Nubia, however, it became a watery grave. The photograph shows the unnatural shores in the desert in the area of New Sebua. These days, the water level is so high that what little vegetation there is has been flooded—here only the tips of the tamarisks are visible.

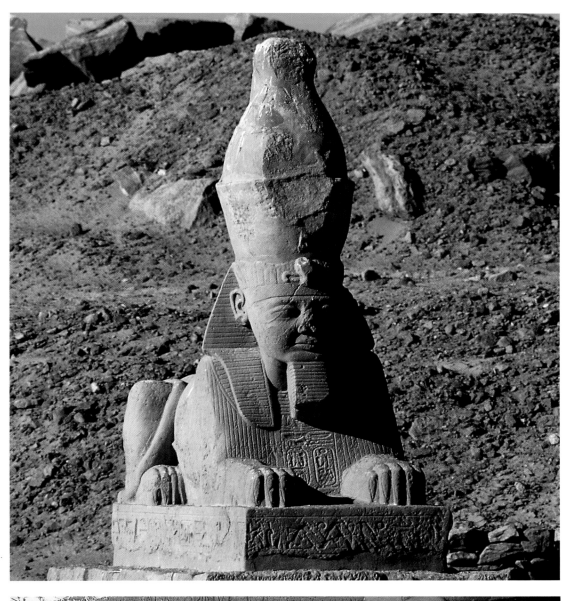

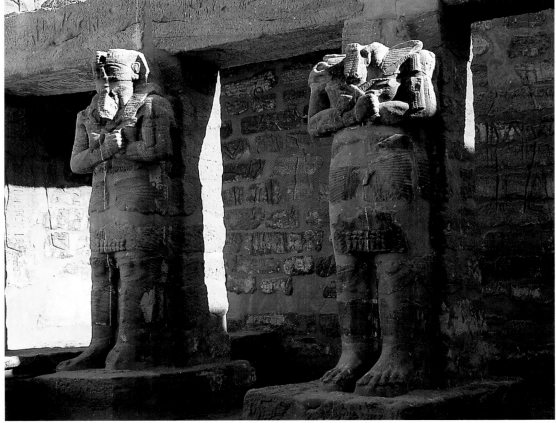

The Lion Temple of al-Sebua
The temple at Wadi al-Sebua (*opposite*) today lies four kilometers west of its original location, which was drowned in the new lake. It was dedicated to the gods Amun and Ra-Horakhty by Ramses II. Only the inner sanctum of the 109-meter-long temple was cut into the sandstone. The power of the pharaoh is emphasized symbolically through an avenue of finely-carved lion-sphinxes (*above left*) and colossal statues in front of the pillars (*below left*). In Christian times the temple was transformed into a church and the walls were plastered over and rendered. Some of the plaster has since been removed, so that in the cult niche Ramses the Great now offers flowers to the apostle Peter.

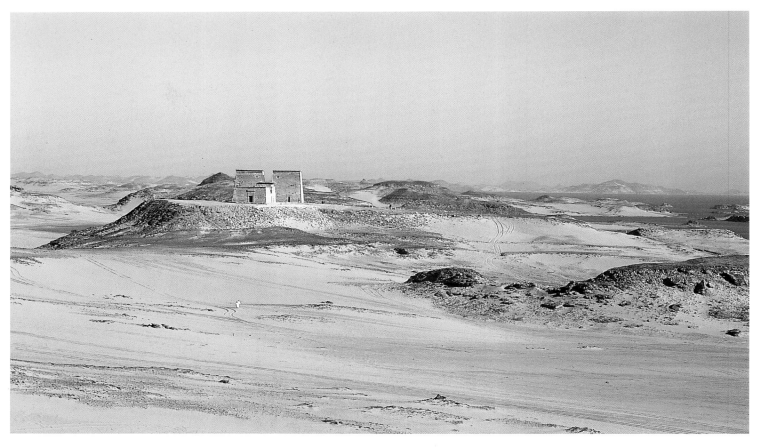

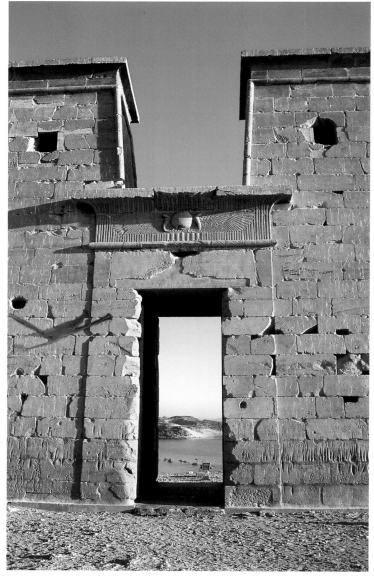

The Temples of al-Dakka and Amada
Between 1961 and 1965, many Egyptian temples in Nubia were relocated to higher ground during a huge international rescue operation. Egyptologists, architects, and engineers made an effort to choose or adapt appropriate new destinations. Apart from such famous monuments as Kalabsha or Abu Simbel, other temples, less known, but no less interesting, were preserved and have become attractive ports of call for cruise boats on Lake Nasser. Sometimes several temples were grouped together, as here (*above left*), where the small, well-preserved temple of al-Dakka stands with the temples of Sebua and al-Maharraka at New Sebua.

Jointly founded by the Ethiopian king Arkamani and Ptolemy VIII, it was extended considerably by the Romans under Augustus Caesar and Tiberius, who added the impressive pylon (*below left*). The temple of Amada (*above right*) is considerably older and was dedicated to the gods Amun-Ra and Ra-Horakhty by Thutmose III and his successor Amenhotep II. The pillared hall (*below right*) dates from the reign of Thutmose IV. On the rear wall of the sanctuary, Amenhotep II describes a campaign to Syria during which he took seven princes prisoner and had them strung upside-down. Because the temple of Amada held well-preserved reliefs and inscriptions, it was not cut into pieces when relocated but, with the help of hydraulic equipment, moved as one piece two and a half kilometers north and 65 meters higher.

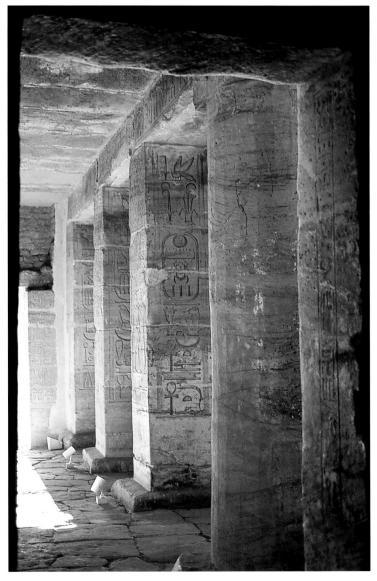

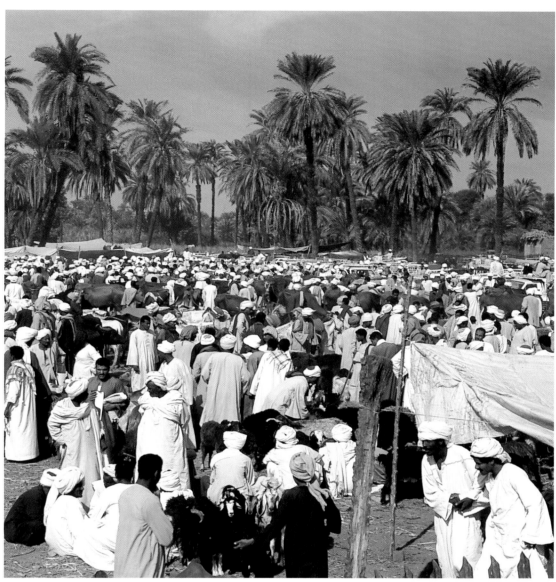

Nubian Society
The camel trading town of Daraw (*above left*) has become a significant social meeting point for the relocated Nubians. Here, the Nubian languages and their various dialects are widely spoken and Arabic is not always well understood. Traditionally tight social relations are still maintained. Marriage to non-Nubians is still frowned upon. At the daily gathering of relatives and friends on the mastaba in front of the house there is much laughter. Great hospitality is shown—even to foreigners who know no Nubian. Children are the pride of a Nubian family and are reared lovingly.

The light, semi-transparent black cloth and golden necklace of this Nubian woman (*opposite*) are a typical costume here. Music and dance play an important part in Nubian life. The most important instrument is the tambourine-like *riqq*, which gives the rhythm for the lute. These accompany dances and love songs at big weddings, during which guests dance for days, many ending up in a trance.

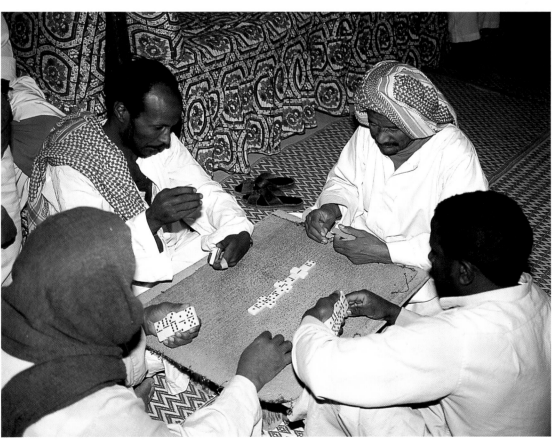

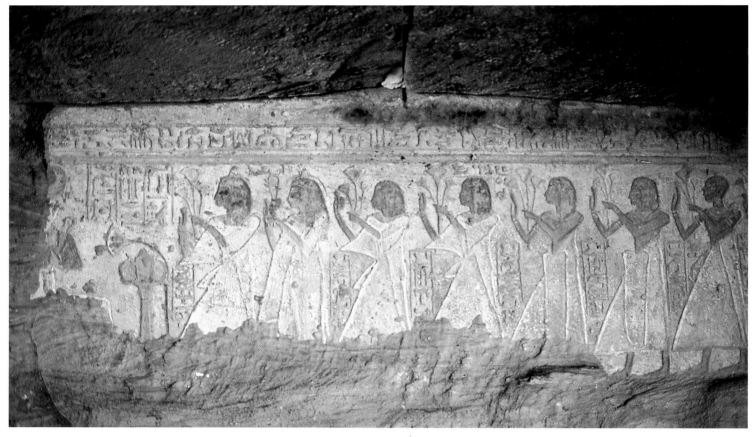

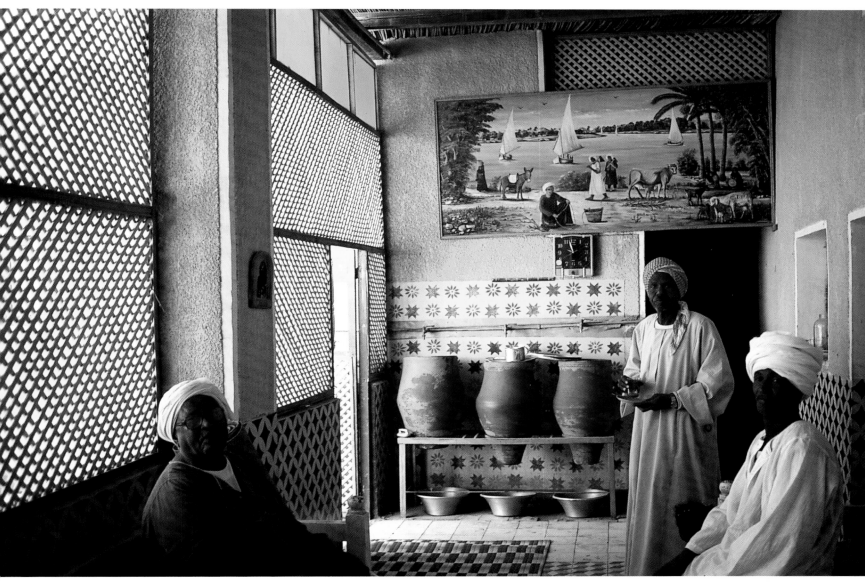

Old and New Aniba

The importance of Lower Nubia in the New Kingdom is underlined by the considerable number of monuments found from that period. One is this rock tomb of the civil servant Pennut (*opposite, above*) who served under Ramses VI. The wall paintings show Pennut with his wife and six sons praying before Ra-Horakhty.

Today Aniba has been re-established far to the north at Kom Ombo along with many other Nubian villages. While the people who had experienced the expulsion from old Nubia have not come to terms with the loss of their homeland, the second and third generation have begun to make the houses and villages more comfortable with modern conveniences.On the other hand, they try to restore old traditions as far as possible. Prefabricated concrete houses, hot in the summer and alienating in appearance, were provided by the government at the time of relocation. Now, however, house façades are being painted, benches put in front of

them, courtyards are being added and decorated. And in almost every reception room or yard hangs a reminder of the past in the form of a large painting of life along the Nile in old Nubia (*above*). There are always three *zir*-pots for drinking-water.

There are many rescued objects in the houses, and old doors (*opposite, below right*) are often found. Wealthy or talented Nubians are creating a new lifestyle with simple and natural means. A successful example is the so-called Nubian house (*opposite, below left*) in the town of Daraw. Walls and ceilings here are newly designed, with curtains made from palm stalks and decorated with the fruits of the doum palm.

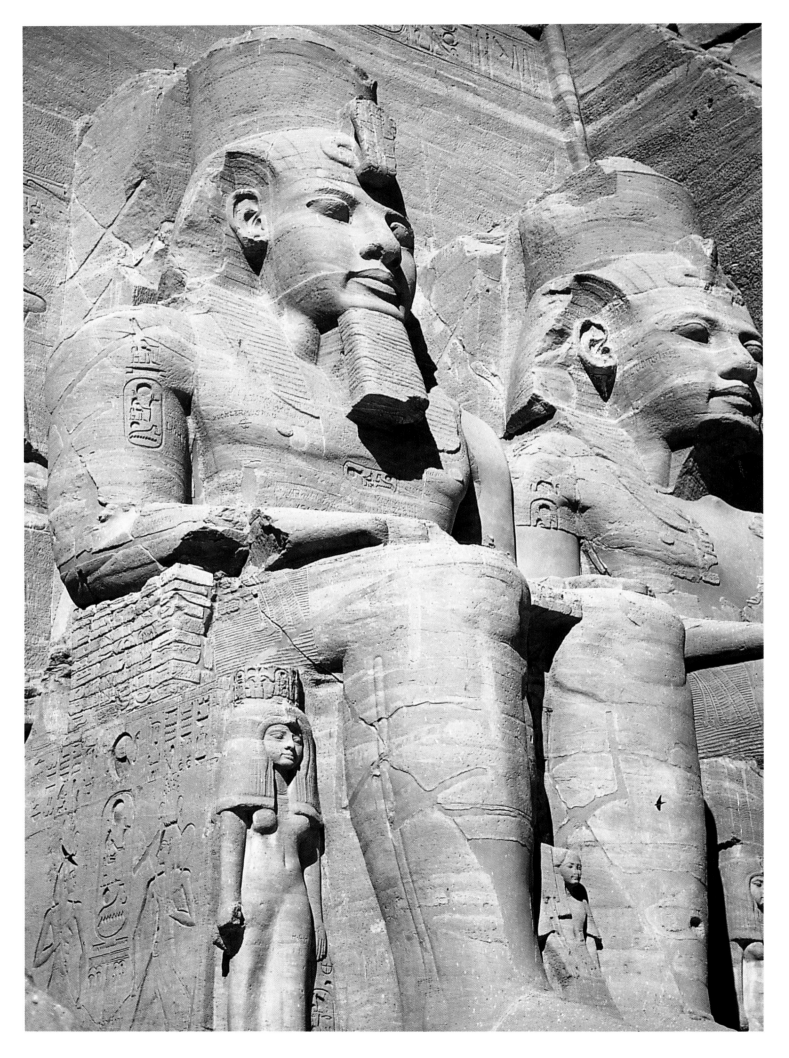

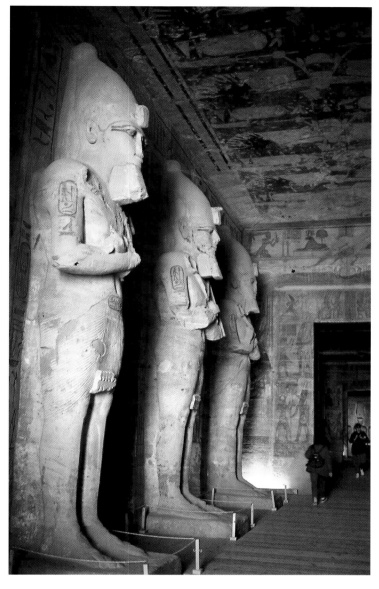

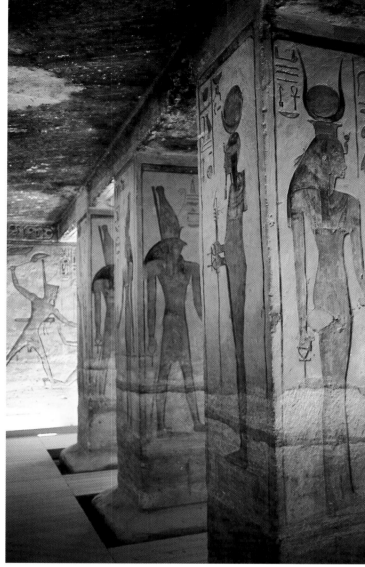

Abu Simbel and the Male and Female Principles

In majestic posture, four colossal figures sit on thrones (*left*); for thousands of years, three of them have gazed calmly over the Nile towards the rising sun. Shortly after the temple of Abu Simbel was completed, however, the head of the fourth figure was toppled by an earthquake; thereafter it lay before its stone body, face-down in the sand. To the Ramesside engineers who were unable to lift the head again, it seemed a bad omen and, in fact, the Egyptian empire did start to decline after Ramses' death. The head's unfortunate fate was preserved when the temple was relocated. With the temple of Abu Simbel (*above left*), ancient Egypt displayed its imperial power at its southern frontier. This demonstration of power must have made its point far into Africa. Pictures of power also decorate the inner walls of the temple. Inside the battle rages: with bow and arrow and driving a chariot with splendidly decorated horses, Ramses storms a Hittite fortress.

A remarkable counterpart to the great temple of Abu Simbel is the small temple just to the north, which Ramses dedicated to the goddess Hathor and to his wife Nefertari (*above right*). The male principle is stressed in the

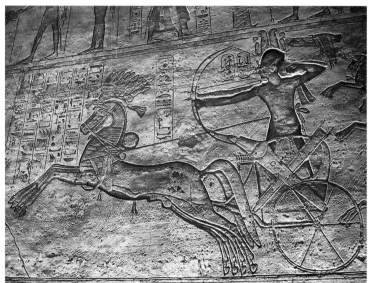

great temple through depiction of battle, whereas in the small temple the female principle dominates: pictures show the queen attending the goddesses of love and fertility. But since the temple had been erected by the power-conscious Ramses he could not help but show himself yet again slaying the enemy (*above right*, detail in background).

181

The Gate to Tropical Africa

The land and the architecture of Nubia display obvious differences from the Mediterranean-dominated north. Here, sub-Saharan Africa is much in evidence.

The many-branched doum palm, found occasionally in Aswan, is here seen everywhere. Many birds of tropical origin flock in the skies over Nubia. Here (*above right*) a white stork is pictured on its way to Africa. Great white herons, flamingoes, purple herons, night herons, pelicans, seagulls, and Nile geese populate Lake Nasser in huge flocks such as are found on the great lakes of tropical Africa. But these are only the first signs. Tropical Africa begins further south in Sudan but Nubia was always the trade route to the exotic treasures of the south such as ivory, rare woods, and strange animals and plants. Though much has been flooded by Lake Nasser, many way-stations on the old trade route are still visible, like this fortress, Qasr Ibrim, not far from old Aniba (*opposite, below*). Camel caravans (*below right*), which still come regularly from Sudan, were unknown to the ancient Egyptians. The dromedary was known in predynastic times in northern Africa, but for unknown reasons it disappeared from the region and was reintroduced only in the Persian Period around 500 BCE.

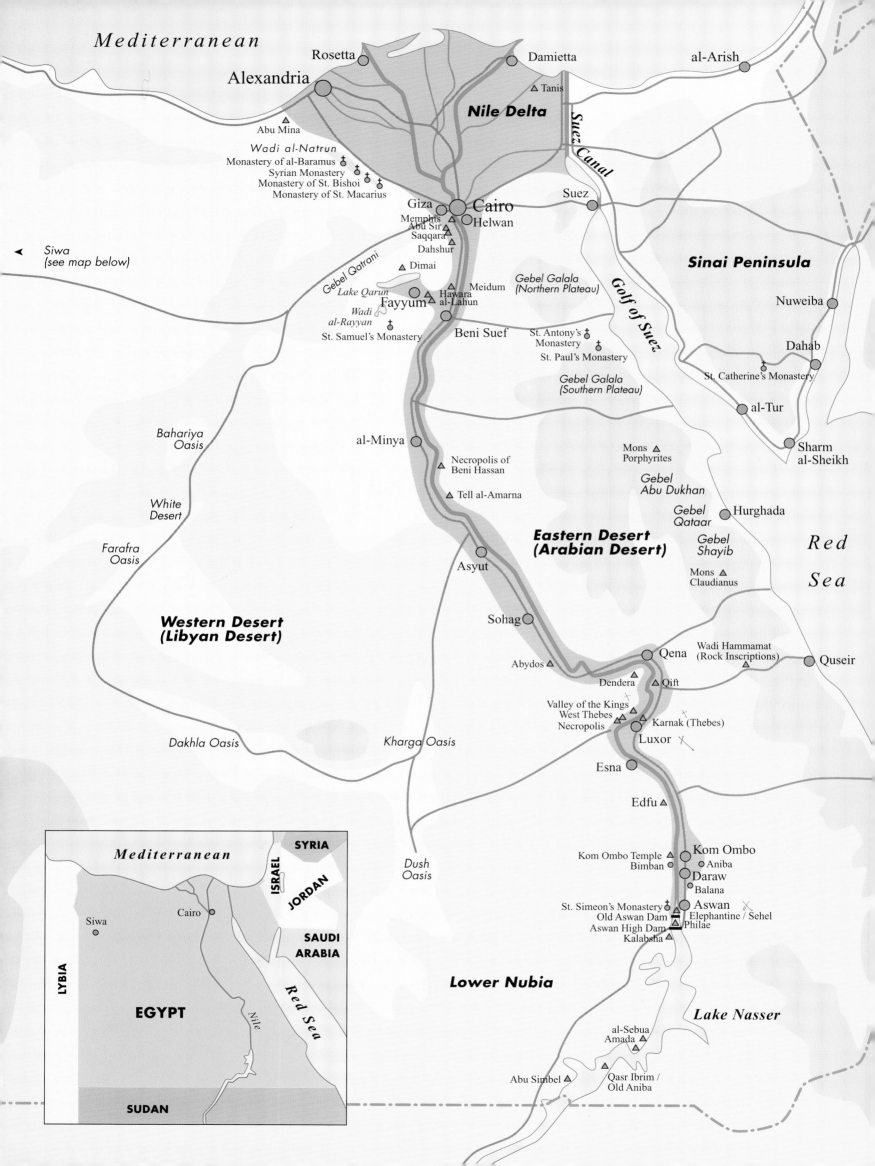

CHRONOLOGICAL TABLE

Dating of events in pharaonic times is seldom certain.

ANTIQUITY

Cultures and Dynasties	Known Rulers	Important cultural evidence	Pages	Historically important events
Prehistory c. 5500–3150 BCE				
Upper Egypt: Badari: c. 4500–4000 BCE Nagada I–III: c. 4000 – 3150 BCE		Stone tools, ceramics, rock pictures e.g. in Wadi Hammamat	12, 52–53, 63, 104	From 120,000 BCE first settlements in the Nile valley
Lower Egypt: Merimde, Fayyum A, Omari, Ma'adi				
Predynastic period c. 3150–3000 BCE				
Dynasty 0	Narmer = Menes?	First evidence of a script; Pit graves in Abydos; Narmer palette		c. 3000 BCE Union of Upper and Lower Egypt
Thinite period c. 3000–2700 BCE				
First Dynasty c. 3000–2925 BCE	Hor Aha = Menes?	Mastaba tombs in North Saqqara, Cenotaph in Abydos; Introduction of hieroglyphic script; formation of the Egyptian cultural style	10	Union of Upper and Lower Egypt; foundation of empire; foundation of Memphis. Rule of Thinite kings (after their home city Thinis)
	Semerkhe			
Second Dynasty c. 2925–2700 BCE				
Old Kingdom c. 2705–2137 BCE				
Third Dynasty c. 2705–2630 BCE	Djoser, Sekhemhet, Huni	Step pyramid of Djoser – world's first monumental structure of hewn stone; architect and sage Imhotep; oldest university in the world; introduction of the calendar	12, 121, 124–125, 128–129	Memphis is capital, Old Heliopolis (On) religious center
Fourth Dynasty 2630–2475 BCE	Snofru	Bent Pyramid, Red Pyramid	118, 112–125, 152,	
		Maidum Pyramid (?)	124–125	
	Khufu Khephren	Khufu (Cheops) Pyramid of Giza; Sphinx and Khephren Pyramid of Giza	8–9, 125	
	Menkaure	Menkaure (Mykerinos) Pyramid of Giza; Mastaba tombs for relatives of the royal family and dignitaries in Saqqara and Giza		
Fifth Dynasty c. 2475–2325 BCE	Userkaf Sahure Unas	Pyramid at Abusir; Unas (Wenis) Pyramid Sun temple at Abusir and Saqqara; relief art; Mastaba of Ti and Ptah-Hotep in Saqqara	104–105 58–59, 126–127, 140	Climax of the sun cult of Re, which becomes state religion; Heliopolis becomes district capital
Sixth Dynasty 2324–2200 BCE	Teti Pepi I Pepi II	Pyramids at Saqqara and Mastaba of Mereruka Mastaba of Idut; Pyramid texts	58, 59, 156 135, 156	Unrest leads to collapse of the state; provincial rulers become independent

| --- | --- | --- | --- | --- |

First Intermediate Period 2200–2040 BCE

Cultures and Dynasties	Known Rulers	Important cultural evidence	Pages	Historically important events
Seveinth – Tenth Dynasties	Numerous local rulers govern for short periods in Thebes and Heracleopolis (Fayyum)	Flowering of classical literature; tombs at Saqqara		Social, religious and spiritual quarrels; civil war, disintegration of central government

Middle Kingdom 2040–1785 BCE

Cultures and Dynasties	Known Rulers	Important cultural evidence	Pages	Historically important events
Eleventh Dynasty 2040–1991 BCE	Mentuhotep II	Tombs in western Thebes; grave mounds of Deir al-Bahari	146–147	Government of Theban princes and kings, reunification of the empire by Mentuhotep II c. 2025 BCE (capital Thebes)
Twelfth Dynasty 1991–1785 BCE	Amenemhet I	Pyramid of Lisht		Relocation of capital to Lisht; Nubia and Fayyum are colonized
	Senusert I	Obelisk in Old Heliopolis; Chapel at Karnak	12 58–59, 148	
	Amenemhet II	Pyramid at Dahshur		
	Senusert II	Pyramid at El Lahun	53,	
	Senusert III	Pyramids at Dahshur	53, 67	
	Amenemhet III	Pyramids at Dahshur and Hawara (with labyrinth)	122–123 125	
	Female pharaoh Sobeknoteru	Rock tombs of Beni Hassan, Aswan, Asyut, Nubian fortresses; gold jewelry		

2nd Intermediate Period 1785–1550 BCE

Cultures and Dynasties	Known Rulers	Important cultural evidence	Pages	Historically important events
Thirteenth Dynasty	About 50 pharaohs			Disintegration of the empire
Fourteenth Dynasty	Different small kings in Lower Egypt			
Fifteenth Dynasty	Invasion of the Hyksos from Asia			Lower Egypt: under rule of the Asiatic Hyksos
Sixteenth Dynasty	Under the rule of the Hyksos	Introduction of horse and carriage	127	In Thebes, rule of an Upper Egyptian dynasty
Seventeenth Dynasty	Kings in Thebes (princelings)	Tombs in Thebes in small brick pyramids		Restoration of the empire by princes from Armant, near Thebes; expulsion of the Hyksos

New Kingdom 1552–1069 BCE

Cultures and Dynasties	Known Rulers	Important cultural evidence	Pages	Historically important events
Eighteenth Dynasty 1552–1295 BCE	Ahmose	Alabaster chapel at Karnak;		Thutmose III – greatest strategist of ancient Egypt Nubia, Palestine, Phoenicia, Syria conquered
	Amenhotep (Amenophis) I	Obelisk at Karnak; Monuments and temple at	145	
	Thutmose (Thutmosis) III	Luxor and Karnak; temples at Medinat Habu and Amada	175	Egyptian empire extends from Fourth Cataract in Nubia to the Euphrates.
	Hatshepsut	Hatshepsut temple at Deir al-Bahari; Obelisk at Karnak	114–115, 144–147, 149	Thebes (Luxor) is royal residence; political, spiritual, and religious center under the imperial god Amun-Re
	Amenhotep (Amenophis) II and wife Ti	Temple of Amada Sphinx stele	175 121	Under Akhenaten a brief experiment with monotheism;
	Thutmose (Thutmosis) IV	Amada	175	the sun god Aten becomes state
	Amenhotep (Amenophis) III		149–151	god; New residence, further north
	Akhnaten and his wife Nefertiti	Tell al-Amarna	4, 116, 160	at Tell al-Amarna

Cultures and Dynasties	*Known Rulers*	*Important cultural evidence*	*Pages*	*Historically important events*
	Tutankhamen	Gold treasure from the tomb at Thebes	4	Reestablishment of polytheism under Tutankhamun
	Horemheb	Tomb of Horemheb at Saqqara; Civil servants' tombs in western Thebes, eg. Nakht, Ramose	103 152, 155	Horamheb stabilizes the system again
Nineteenth Dynasty 1295 – 1188 BCE	Ramses I Seti I Ramses II	Monuments at Karnak, temple at Abydos and Qurna; Ramses city in the delta, Monuments at Luxor and Karnak, temples in Nubia (eg. Sebua, Abu Simbel); Ramses statues at Memphis; tombs of kings and civil servants in western Thebes:	120–121, 149–151, 158–160, 172–173, 180–181	In the delta a new residence develops (Ramses city); War against the Hittites
Twentieth Dynasty 1188–1069 BCE	Setnakht Ramses III Ramesside rulers until Ramses XI	Monuments at Karnak Medinat Habu; Kings' tombs in western Thebes; private tombs at Deir al-Madina, eg. of Sennudjem; rock tomb of Pennut in Nubia	148–149, 153, 178–179	Cultural and economic decline; corruption; Uprising of the workers in Deir al-Medina; grave robbers' trials in Thebes Defense against the invasion of the Libyans and the Sea People

Third Intermediate Period 1069–715 BCE

Cultures and Dynasties	*Known Rulers*	*Important cultural evidence*	*Pages*	*Historically important events*
Twenty-first Dynasty 1069–945 BCE	Pharaohs in the delta: Tanites: Psusennes I At Thebes: ruler of the Amun priests	Grave treasure of Tanis	60–61	The empire disintegrates In Upper Egypt (Thebes): Theocracy of Amun In Lower Egypt (delta): dynasty of the Tanite rulers (capital Tanis)
Twenty-second– Twenty-third Dynasties 946–715 BCE	Tanites Osorkon II Bubastites: rulers from Libya	Monuments at Karnak	66–67	Nubia becomes independent with capital at Nagata

Late Period 747–656 BCE

Cultures and Dynasties	*Known Rulers*	*Important cultural evidence*	*Pages*	*Historically important events*
Twenty-fourth– Twenty-fifth Dynasties 747–656 BCE	Dynasty of the Kushites (Nubians) from Sudan Shabaka Shebitku Tantamani	Monuments at Karnak and Medinat Habu		Nubian king Shabaka unites the Egyptian empire Joint rule with the 'wives of god'
Twenty-sixth Dynasty 672–525 BCE	Ethiopian and Assyrian rulers	Traditional Egyptian culture experiences a renaissance (Saite Renaissance); Civil servants' tombs in western Thebes; Serapeum at Saqqara		Invasion of the Assyrians and conquest of Thebes (664 BCE); Egypt under Assyrian rule from Sais (in the western delta); First Greek settlers, e.g. in Memphis

First Persian period 525–404 BCE

Cultures and Dynasties	*Known Rulers*	*Important cultural evidence*	*Pages*	*Historically important events*
Twenty-seventh Dynasty	Under Persian rule	Building of the canal from the Nile to the Red Sea; Building of the fortification Perhapemon (later Greek: Babylon) in what is now Old Cairo	10, 20	The Persian king Cambyses takes power in Egypt in 525 BCE
	Darius I (521–486)	Hibis Temple in the oasis of Dakhla	84–85	Herodotus in Heliopolis and Memphis

Egyptian Rulers 404–343 BCE

Cultures and Dynasties	Known Rulers	Important cultural evidence	Pages	Historically important events
Twenty-eighth–Thirtieth Dynasties	Egyptian ruler from the delta Nectanebo I	Monuments at Medinat Habu, Dendera and Philae	128 168–169	

2nd Persian period 343–338 BCE

Thirty-first Dynasty 343–333 BCE	Under Persian rule Darius III			Second Persian conquest

Greco-Roman period 332–304 BCE

Macedonian Dynasty 332–304 BCE	Alexander the Great (332–323 BCE)	Tomb of Petosiris, Tuna al-Gebel	54–55 86–87	Conquest of Egypt by Alexander the Great 332 BCE Foundation of Alexandria as new capital
Ptolemaic Dynasty 305–330 BCE	Ptolemy I (305–285 BCE) Cleopatra VII (51–30 BCE)	Serapeum in Alexandria Kom Ombo Edfu Philae Dakka Pharos (lighthouse) of Alexandria Dimai	55 156–157 13, 129, 154 168–169 174–175 55 62	Ptolemy I becomes first Macedonian ruler of Egypt; founds dynasty of the Ptolemies; Alexandria is capital of Egypt and spiritual center of Hellenism; Cleopatra VII (51–30 BCE) commits suicide after Roman leader Octavian gains victory
Roman period 30BCE–395 CE	Augustus (27 BCE – 14 BCE) Claudius (41–54) Nero (54–68) Trajan (98–117) Diocletian (284–305)	Philae Stone quarries and mines in the Eastern Desert; Esna Dendera Philae Kom Ombo Monasteries in the E. Desert Monasteries in Wadi al-Natrun Roman Theater in Alexandria Dimai Abu Mina pilgrimage center	168–169 98–99 106–109 142 128–140 143 168–169 156–157 112–113 92–93 54–55 62 94–95 12	Egypt is Roman province (Rome's granary) Beginnings of Christianization of the country from the bishopric of Alexandria

Byzantine period 395 – 640

Byzantine rule	Arkadios (395–408)	Coptic churches and monasteries, necropolis of al-Bagawat in the oasis of Kharga	84–85	Egypt is province of the Eastern Roman empire (Constantinople) Christianity becomes state religion, Alexandria becomes religious center; 451 (Council of Chalcedon) Egyptian Christians split from the patriarchate of Constantinople to become the independent Coptic church

Cultures and Dynasties	Known Rulers	Important cultural evidence	Pages	Historically important events
ISLAMIC PERIOD				
Orthodox Caliphs 640–661	Caliphs – Successors of Prophet Muhammad (died 632 in Madina)	Building of the mosque of 'Amr Ibn al-'As (641)	15	640 conquest of Egypt by 'Amr Ibn al-'As, general of Caliph 'Omar Ibn Khattab (victories at Babylon, Alexandria) 641 Foundation of al-Fustat; Egypt as far south as Philae becomes an Islamic province; governors of the caliphs reign
The Ummayads 661–750	Under the reign of the Ummayad caliphs from Damascus 'Abd al-Malik (658–705) Walid (705–715)	Expansion of al-Fustat as Arab capital of Egypt Foundation of St. Simeon monastery at Aswan	163	Spread of the Arabic language and Islam
Abbassid period 750–868	Under the rule of the Abbassids of Baghdad; Harun al-Rashid 786–809	Foundation of new capital of Egypt, al-Askar (750)		Baghdad founded as new residence city of the Abbassid caliphs; in Egypt, Abbasid governors rule
Tulunid Dynasty 868–905	Ahmad Ibn Tulun 868–883	Foundation of al-Qatai (879); Ibn Tulun mosque (876–879)	16–17	Ibn Tulun becomes ruler of Egypt and founds the Tulunid dynasty
Second Abassid period 905–935	Again under Abbasid rule			Again ruled from Baghdad by governors
Ikhshid Dynasty 935–969	Muhammad al-Ikhshid (935–946)			Muhammad al-Ikhshid founds an independent dynasty in Egypt
Fatimid Dynasty 969–1171	Al-Hakim (966–1020)	The golden age of Arab Egypt; Al-Azhar mosque, al-Hakim mosque, Bab al-Futuh, Bab Zuwayla, al-Aqmar mosque; 983 foundation of the oldest Islamic university al-Azhar; reconstruction of the Coptic 'hanging church'	10–11, 18–19, 43, 20–21	Conquest by the Fatimids under general Gawhar al-Siqilli; Foundation of al-Qahira (Cairo) as residence city of the Fatimid caliphs (969); advance of the Crusaders; destruction of al-Fustat; relocation of the Coptic patriarchate from Alexandria to Cairo
Ayyubid Dynasty 1171–1250	Salah al-Din (1169–1193) Al-Kamil (1218–1238)	Building of the citadel; mausoleum of Imam Shafi'i City consolidation; madrasa mausoleum of al-Salih Nagm al-Din Ayyub; Nasr al-Din mosque in al-Qasr	24–25 82	Victory over the Crusaders and ending off of the European invasion from the Holy Land; Introduction of the Sunni religious doctrine and the madrasa (Qur'an school) in Egypt

Mamluk dynasties 1250–1517

Dynasty of Bahri Mamluks 1250–1382	Al-Zahir Baybars (1250–1276) Al-Mansur Qalawun (1279–1290) Al-Nasr Muhammad (1293–1341) Al-Nasr Hassan (1347–1351, 1354–1361)	Madrasa mausoleum of al-Mansur Qalawun; Madrasa of al-Nasr Muhammad Sultan Hassan mosque;	26–27, 29 26–27 30–31	Former slaves of the Ayyubids (Turks, Greeks, Kurds, Turkomens, Circassians) win military power and found their own dynasty; battle against the Crusaders, ward off the storm of the Mongols; exploitation of the population; significant building activity by successive sultans

Cultures and Dynasties	Known Rulers	Important cultural evidence	Pages	Historically important events
Dynasty of the Circassian Mamluks 1382–1517	Farag Ibn Barquq (1382–1389, 1390–1399)	Madrasa and mausoleum of Barquq	32–33	
	Al-Ashraf Barsbay (1422–1438)	Mausoleum of Barsbay	33	
	Al-Ashraf Qaytbay (1468–1496)	Mausoleum of Qaytbay	11, 24, 55	
		Qajmas al-Ishaqi mosque-mausoleum	34	
	Qansuh al-Ghuri (1501–1516)	Ghuriyya (madrasa and mausoleum)	35	
		Al-Mu'ayyad mosque	18–19	
		Flowering of Islamic culture	11	
The Ottomans 1517–1805	The Mamluk beys rule under the Ottoman governors	Public fountains eg. Sabil-Kuttab of 'Abd al-Rahman Katkhuda	38	Ottoman emperor Selim I makes Egypt an Ottoman province (1517)
		Palaces, eg. Bayt Suhaymi, faiences, e.g. in the Blue Mosque (al-Sunqur Mosque); mashrabiyya	36–37 38–39	
French occupation 1798–1805		French scientists begin research of Egyptian geography and archeology; foundation of Egyptology; deciphering of hieroglyphs	37	Napoleon's campaign in Egypt (1798); Victory over the Mamluks in the Battle of the Pyramids. Egypt temporarily under French rule

MODERN PERIOD

Muhammad 'Ali Dynasty 1805–1953

Khedives 1805–1882	Muhammad 'Ali (1805–1848)	Muhammad 'Ali Mosque	40–41	Egypt under Ottoman rule; Muhammad 'Ali becomes viceroy (Khedive); founds family dynasty Beginning of industrialization, agricultural development, economic improvement, Egypt opens up to the West.
	Ismail (1863–1882)	Mausoleum Hosh al-Basha		
British occupation 1882–1922	Hussein Kamil (1914–1917)	Neo-Mamluk buildings: Rifa'i Mosque, Sayyeda Zaynab Mosque	30–31 42–43	Intervention of the British in Egypt (1882); Official independence from the Ottoman empire; Egypt becomes British protectorate (1914)
	Ahmed Fu'ad (1917–1922)	The Belgian Baron Edouard Empain builds Heliopolis as a new quarter of the city and his villa in the style of a Hindu temple	48–49	
Constitutional monarchy 1922–1952	King Fu'ad I (1922–1936)	Significant artists of Egyptian modern period: 'Abd al-Hadi al-Gazzar, Hamed Nada	46–47	Britain declares Egypt an independent state (1922)
	King Farouk (1936–1952)			
Republic since 1952	Muhammad Naguib (1952–1954)	Building of the high dam at Aswan (1964–1970) and the Cairo Tower (1957)	48–49	1952: Uprising and great fire of Cairo; Revolution under Nasser; King Farouk abdicates; Declaration of the Republic
	Gamal 'Abdel Nasser (1954–1970)	Naguib Mahfouz receives the Nobel prize for literature (1988)	44–45	
	Anwar al-Sadat (1970–1982)	New opera house (1988)	48–49	
	Muhammad Husni Mubarak (since 1982)			

BIBLIOGRAPHY

Aling, C. F.: *Egypt and Bible History*, Cairo 1992.

Baines, J. and J. Málek: *Atlas of Ancient Egypt*, Oxford 1988.

Beaux, N.: *Le cabinet de curiosités de Thoutmosis III*, Leuven 1990.

Behrens-Abouseif, D.: *The Minarets of Cairo*, Cairo 1985.

Boulos, L. and M. N. el Hadidi: *The Weed Flora of Egypt*, Cairo 1984.

Breasted, J. H.: *A History of Egypt*, New York 1912.

Brewer, D. J. and R. F. Freidman: *Fish and Fishing in Ancient Egypt*, Cairo 1989.

Clark, R. T. R.: *Myth and Symbol in Ancient Egypt*, London 1978.
Coptic Orthodox Monastery of St. Paul. Red Sea, Egypt.
Coptic Orthodox Monastery of The Virgin St.Mary (Baramous). Wadi El Natrun, Egypt.

Dittrich, P. (ed.): *Biologie der Sahara*, Munich 1983.

Empereur, J.-Y.: *The Graeco-Roman Museum Alexandria*, Alexandria 1995.

Fakhry, A.: *Siwa Oasis*, Cairo 1993.

Fathy, H.: *Architecture for the Poor*, Cairo 1989.

Faulkner, R. and O. Goelet: *The Egyptian Book of the Dead*, Cairo 1998.

Forster, E. M.: *Alexandria –A History and a Guide*, London 1982

al-Gazzar, 'Abd Al-Hadi, 1925/1966, Cairo.

Geiser, P.: *The Egyptian Nubian*, Cairo 1989.

Grimal, N.: *A History of Ancient Egypt*, Oxford 1994.

Grossmann, P.: *Abu Mina*, Cairo 1986.

Grossmann, P.: *Abu Mina 1: Die Gruftkirche und die Gruft*, Mainz 1989.

Haag, M.: *Alexandria*, Cairo 1993.

Hadidi, M. N. and L. Boulos: *Street Trees in Egypt*, Cairo 1979.

Hepper, F. N.: *Marao's Flowers*, London 1990.

Herodotus: *The Histories*, Hamondsworth 1954.

Hobbs, J. J.: *Bedouin Life in the Egyptian Wilderness*, Cairo 1990.

Hoffman, M.: *Egypt before the Pharaohs*, London 1980.

Houlihan, P. F.: *The Birds of Ancient Egypt*, Cairo 1992.

Houlihan, P. F.: *The Animal World of the Pharaohs*, Cairo 1995.

Jahn, W. and R.: *Sinai the Red Sea*, Cairo 1997.

Jockel, R. (ed.): *Islamische Geisteswelt: Von Mohammed bis zur Gegenwart*, Wiesbaden 1981.

Kamil, J.: *The Ancient Egyptians*, Cairo 1997.

Karnouk, L.: *Modern Egyptian Art*, Cairo 1988.

Kennedy, J.: *Nubian Ceremonial Life*, Cairo 1978.

Konzelmann, G.: *Der Nil*, Munich 1985

Konzelmann, G.: *Die islamisch Herausforderung*, Hamburg 1980

Lane, E. W.: *Manners and Customs of the Modern Egyptians*, London 1989.

Lane, M.-E.: *Guide to the Antiquities of the Fayyum*, Cairo 1985.

Lethmate, J.: *Paläobiologie der Fayum-Primaten*, Tübingen 1990.

Life of St. Antony, St. Antony's Monastery, Red Sea

Lings, M.: *The Quranic Art of Calligraphy and Illumination*, Brooklyn, New York 1987.

Lyster, W.: „*The Madrasa of Sultan an-Nasr Muhammad*" in *Cairo Today*, 8/1988

Mahfouz, N.: *Adrift on the Nile*, Cairo 1993.

Mahfouz, N.: *The Harafish*, Cairo 1994.

Mahfouz, N.: *Midaq Alley*, Cairo 1985.

Mahfouz, N.: *Miramar*, Cairo 1978.

Mahfouz, N.: *Palace of Desire*, Cairo 1997.

Mahfouz, N.: *Palace Walk*, Cairo 1997.

Mahfouz, N.: *The Search*, Cairo 1987.

Mahfouz, N.: *Sugar Street*, Cairo 1997.

Mahfouz, N.: *The Thief and the Dogs*, Cairo 1984.

Mahfouz, N.: *The Time and the Place and other stories*, Cairo 1991.

MacKenzie, N. D.: *Ayyubid Cairo*, Cairo 1992.

Malek, I. (ed.): *Cradles of Civilization – Egypt*, Cairo 1993.

Manniche, L.: *An Ancient Egyptian Herbal*, London 1989.

Mehanna, S., R. Huntington, R. Antonius: *Irrigation and Society in Rural Egypt*, Cairo 1984.

Meinardus, O. F. A.: *The Holy Family in Egypt*, Cairo 1990.

Meinardus, O. F. A.: *Monks and Monasteries of the Egyptian Deserts*, Cairo 1992.

Meinardus, O. F. A.: *The Historic Coptic Churches of Cairo*, Cairo 1994.

Osborn, D. l. and I. Helmy: *The Contemporary Land Mammals of Egypt (Including Sinai)*, Chicago 1980.

Posener, G. (ed.): *Knaurs Lexikon der ägyptischen Kultur*, Munich 1978.

Randall, I. E.: *Red Sea Reef Fishes*, London 1986.

Rogers, I. M.: *Islamic Art & Design*, London 1983.

Safadi, Y. H.: *Islamic Calligraphy*, London 1978.

Sald, R. (ed.): *The Geology of Egypt*, Rotterdam 1990.

Schiffers, H.: *Die Sahara und ihre Randgebiete*, Munich 1971.

Schleich, H. H., W. Kastle, and K. Kabisch: *Amphibians and Reptiles of North Africa*, Königstein 1996.

Schulze, P. H.: *Frauen im Alten Ägypten*, Bergisch Gladbach 1993.

Schulze, P. H.: *Hatschepsut. Herrin beider Länder*, Bergisch Gladbach 1980.

Shedid, Abdel G.: *Die Felsengräber von Beni Hassan in Mittelägypten*, Mainz 1994.

Stewart, D.: *Great Cairo: Mother of the World*, Cairo 1996.

Tackholm, V.: *Students' Flora of Egypt*, Beirut 1974.

Vine, P.: *Red Sea Invertebrates*, London 1986.

Vivian, C.: *Islands of the Blest*, Maadi 1990.

Weir, H.: *Medieval Cairo*, Cairo 1983.